The Watercolour Painter's Handbook

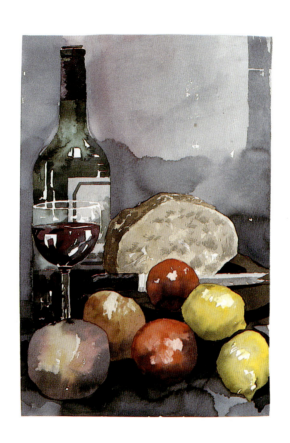

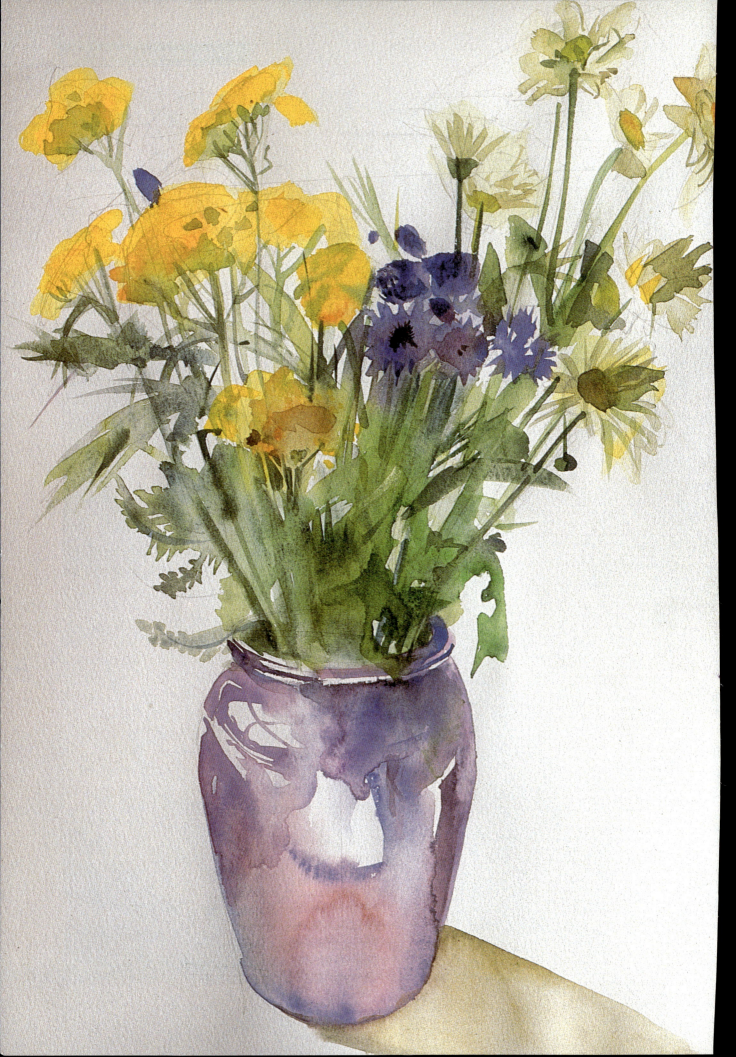

The Watercolour Painter's Handbook

Patricia Monahan and
Jenny Rodwell

STUDIO
VISTA

ACKNOWLEDGEMENTS

The authors and publishers would like to thank the following artists who have
allowed us to use their work in this book: Charles Bartlett, pp. 158, 174–175;
Gordon Bennett, pp. 198–199; Francis Bowyer, p. 48; Martin Caulkin, p. 177;
Trevor Chamberlain, pp. 132–133; Anne Cherry, pp. 176–177; David Curtis,
p. 169; Shirley Felts, pp. 41, 51, 148–149; Sarah Holliday, pp. 99, 112, 113;
Sophie Knight, pp. 130–131; John Lidzey, p. 102, 103, 159; Ronald Maddox,
pp. 186–187; Richard Pikesley, pp. 240–241; Ian Sidaway, pp. 16–17, 18–19,
52–53, 169, 246–247, 248–249; Adrian Smith, pp. 15, 16, 20–21, 53, 74–75,
167, 250–253; Stan Smith, pp. 14–15, 17, 19, 21, 49, 50, 66–67, 108, 109, 111,
115, 120, 121, 123, 178–179; Tig Sutton, pp. 170–171; Grahame Sydney, p. 5;
Bill Taylor, pp. 168–169, 242–243, 244–245.
Special thanks are also due to Winsor & Newton for technical advice and
generous help with materials; to Francis Bowyer, Adrian Smith, Stan Smith and
Albany Wiseman for their artwork and step-by-step demonstrations; and to
Fred Munden for taking the photographs.

STUDIO VISTA
a Cassell imprint
Wellington House, 125 Strand
London WC2R 0BB

First published in this edition 1996

British Library Cataloguing in Publication Data
A catalogue record for this book is available from the British Library
ISBN 0-289-80136-2
The moral rights of the authors have been asserted

Distributed in the United States by
Sterling Publishing Co. Inc.
387 Park Avenue South, New York, NY 10016–8810

Distributed in Australia by
Capricorn Link (Australia) Pty Ltd.
2/13 Carrington Road, Castle Hill
NSW 2154

Typeset by Litho Link Ltd, Welshpool, Powys, Wales
Printed in Hong Kong by Dah Hua Printing Co Ltd

CONTENTS

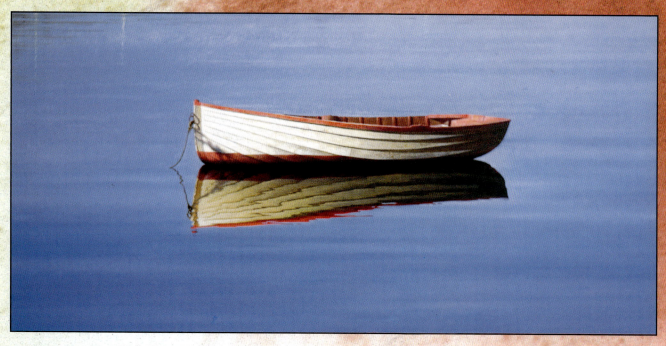

PAINTING LIGHT IN WATERCOLOUR

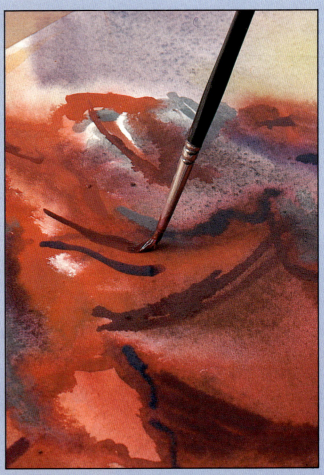

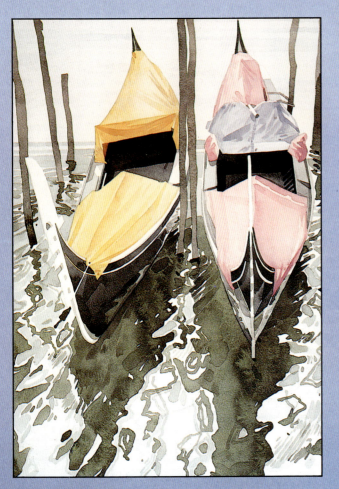

**PAINTING LANDSCAPE
IN WATERCOLOUR**

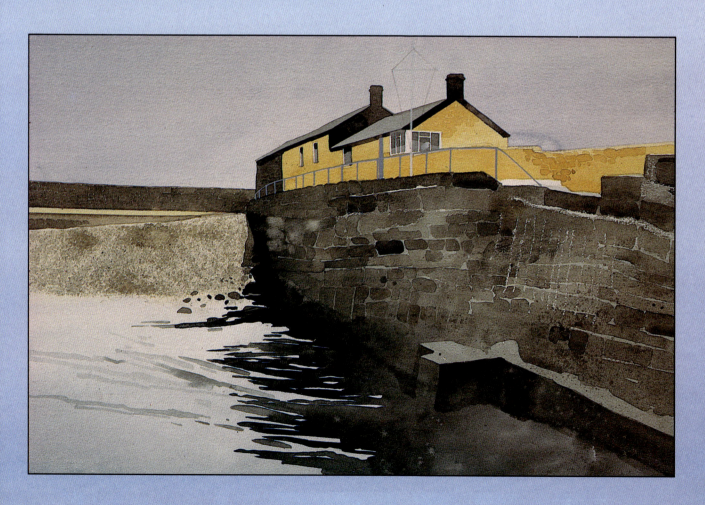

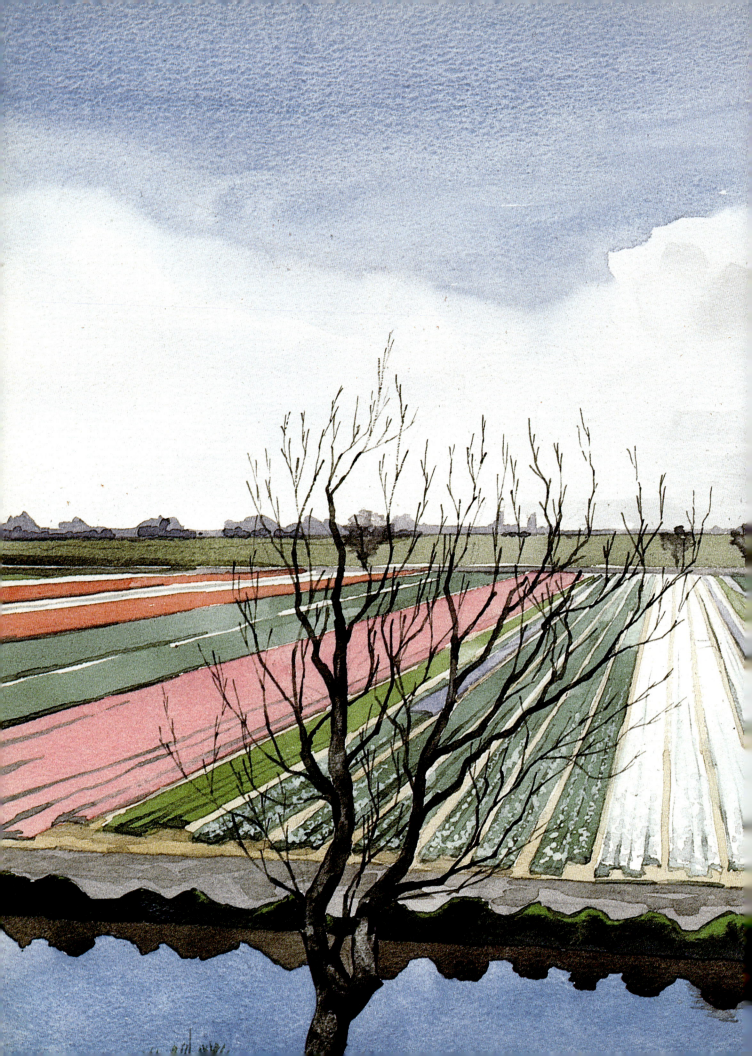

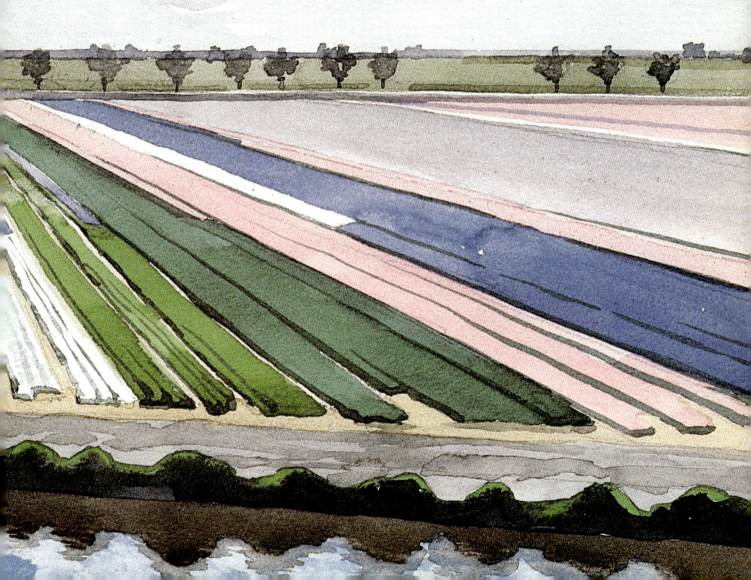

Painting in Watercolour

Jenny Rodwell

The world of watercolour

Watercolour has tempted more people to try their hand at painting than almost any other medium. There is something infinitely attractive about the fresh, glowing colours of many watercolour paintings. They look light and effortless. They make you want to have a go. Watercolour painting can be as easy as it looks, provided you follow a few simple rules.

Watercolours often look splashy and spontaneous. They can give the impression that watercolour is an instant medium and that a picture need take only a few minutes to complete. This is usually far from the truth. Watercolour calls for patience and a systematic approach. Trying to do too much too quickly has led to more failed paintings than anything else.

The main difference between watercolour and all other paints is that watercolour is transparent. Try to think of a watercolour painting as a series of layers – one thin wash of colour over another. To a certain extent, the colour underneath will show through the one above, so that the picture is gradually built up. Even the loosest, most abstract watercolour still needs careful planning.

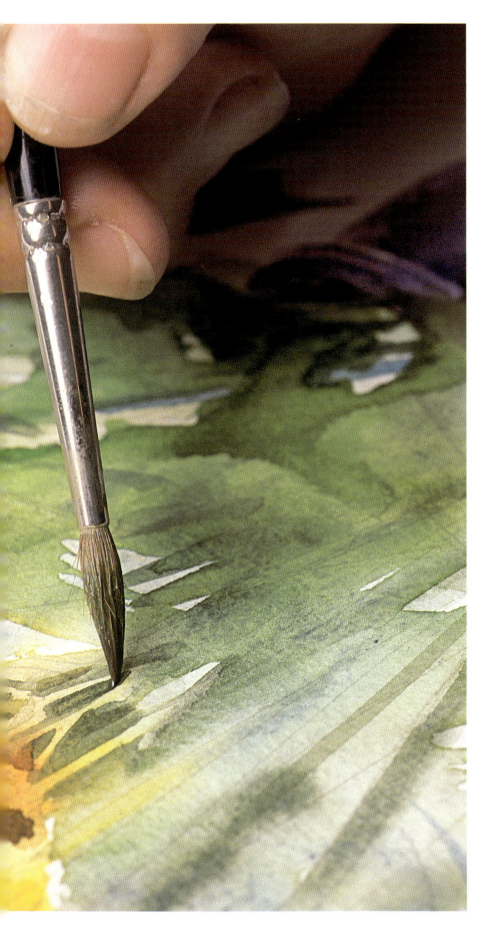

Transparency and versatility have been constant factors in the development of watercolour from the earliest times to the present day. Here the artist makes full use of these qualities when building up loose layers of shimmering colour in a flower painting.

ABOUT THIS BOOK

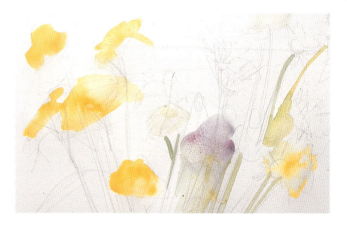

This book assumes no previous knowledge of watercolour painting. Its aim is to cover the absolute basics, from equipping yourself, choosing a subject and stretching a sheet of paper to mixing and applying the colours.

The basic techniques are explained simply and clearly in Chapters Four and Five. Follow these and you will avoid frustration and disappointments.

Demonstrations

As well as describing the principle techniques of watercolour, the book shows in photographed, step-by-step demonstrations how certain key techniques are used in an actual painting.

The demonstrations have been kept as straightforward as possible to show clearly how the painting develops. Captions describe what is happening at each stage. Although you may like to paint a similar picture, and learn by following literally the example set by the artist, it is envisaged that these step-by-step projects will also serve as a starting-off point, a practical inspiration for your own paintings.

What shall I paint?

Choosing a subject should present no real problem. Most people know what they find attractive and what sort of subject appeals to them most. The first advice is to keep it simple. Most of the subjects used by the artists in this book are either still-life arrangements or landscapes. Both these subjects are easily accessible and both can be painted in a straightforward and uncomplicated way.

Landscape is, and always has been, a particular favourite with watercolourists. The transparent colours lend themselves to the subtle effects of sunlight, transient clouds and the changing face of nature. As a subject, landscape often seems more daunting than it actually is, mainly because there are so many different elements to consider. That is why, in the final chapter of this book, the artist

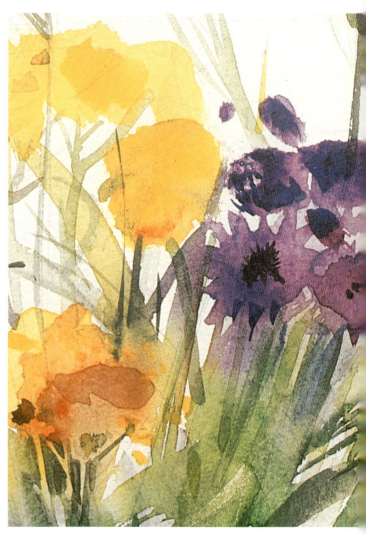

△ **Projects** *These are designed to take you step by step through the picture-making process. The first project is simple, showing how to start a painting with a coloured outline. Thereafter, each new project features one or two new techniques as well as techniques already covered. This detail of a flower painting shows how a painting develops and how it is photographed, stage by stage.*

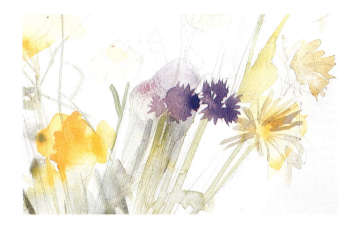

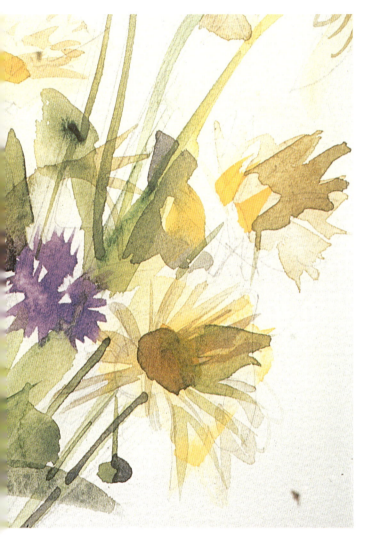

▽**Techniques** *Each watercolour technique is demonstrated and photographed in easy-to-follow stages. The technique pages are followed by projects in which the artist applies the technique to an actual painting. This sequence shows how to create a texture by painting over wax crayon.*

looks at some of these elements separately – skies, clouds, trees and water – and demonstrates in a clear, simple style some of the ways in which they can be painted and how they can be incorporated into a composition.

Figures and portraits have been deliberately omitted from the practical chapters of this book. This does not mean that you should avoid them altogether, but in the very early stages of learning to use watercolour, it is best to try out your techniques on subjects that are more readily accessible for longer periods and can be studied at leisure.

THE POSSIBILITIES

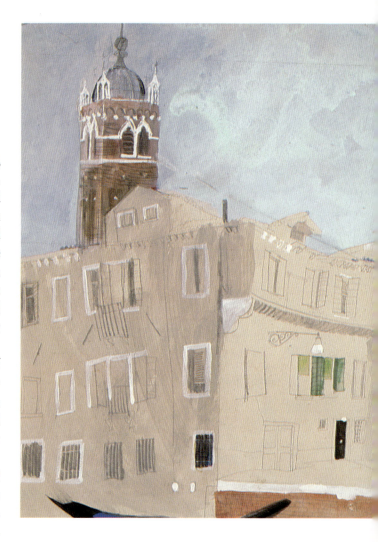

No painting medium has been more widely used, and in so many different fields, as watercolour. When the Stone Age cave artists painted animal pictures in their underground caverns more than 20,000 years ago they used ground pigments mixed with a binding medium not unlike the colours we use today. The ancient Egyptians employed a form of watercolour on their papyrus scrolls and later, in the Middle Ages, monks illuminated their biblical texts and manuscripts with vivid watercolour decorations, often embellished with gold leaf.

Since the eighteenth century, the history of professional watercolour painting has been closely linked with the history of landscape painting. On the occasions when it was used for figures and portraits, these were frequently done as preparatory colour sketches for a final picture, usually in oils.

Amateur painters have exploited the scope of watercolours as much as professionals. During the last 200 years, and particularly before cameras were generally available, a portable box of paints was an essential piece of equipment on family holidays, on the European Grand Tour and on voyages of discovery. Scientists and their assistants did on-the-spot watercolours of scientific specimens, especially the flora and fauna of newly explored lands; soldiers near the front line of battle often painted watercolour sketches of their surroundings to show family and friends back home.

Contemporary uses

Watercolour has never lost its appeal and its popularity has increased, first as a sketching medium and then soon afterwards as a medium in its own right. Today it is used in almost every field of the visual arts. Watercolour is popular with illustrators and graphic designers, not only for its intrinsic lightness and colour quality, but also because it reproduces well and always looks good on the printed page. Modern printing techniques capture exactly the effect of transparent colour over white paper and a quality reproduction is often virtually indistinguishable from the actual painting.

For the fine artist, the scope is enormous. Watercolour works well on any scale. On a large sheet of paper, using big brushes, you can paint as loosely and be as expressive as you like. Yet it is equally suitable for tiny pictures. Many miniaturists work in watercolour, painting with the finest of sable brushes and the help of a magnifying glass to capture the detail needed for such small-scale pieces.

Mixed media

Many early watercolourists used the medium on its own or, occasionally, with pen and ink. Most of them had a rather rigid attitude about the purity of watercolour and were particularly strict about not combining it with opaque paints such as gouache, which they felt detracted from the transparent quality of pure watercolour.

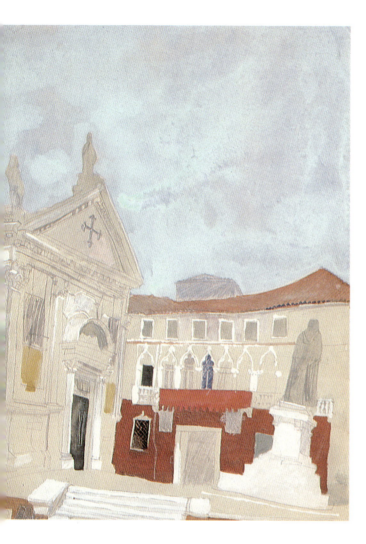

Today's painters are more experimental and, thankfully, have a less purist approach. They mix their media quite happily in a creative rather than a surreptitious way. When we see watercolour and gouache used together in the same painting it has usually been done deliberately in order to exploit the contrast between the transparency and opacity of the two paints, rather than as an apologetic touching-up.

The emphasis in this book is on the basic techniques of watercolour used on its own. However, it is worth remembering that you are working with an extremely sympathetic and versatile paint. It can be used with a number of other materials, including coloured pencils, dip pen and ink, and pastels, as well as the many technical and fibre-tipped drawing pens now on the market. So keep an open mind and do not be afraid to experiment.

△**Mixed media** *This lively painting of Venice is done in watercolour, gouache and pencil on a tinted paper. The drawing is light and loose, and the artist has used the paper tone to represent the stonework of the building. Other selected areas are painted as flat shapes in gouache and watercolour.*

▽**Abstract** *A royal burial site inspired this pair of paintings titled 'King and Queen'. Layers of paint, built up to create rich and colourful images, also symbolize the archaeological layers of the ancient grave. The subject – the figures and the artefacts buried alongside them – were used as a starting-point only. Thereafter, the artist was mainly concerned with the abstract qualities of the painting. The subjects themselves are barely discernible in the finished paintings.*

15

CHOOSING A SUBJECT

Start with a very simple subject. A few objects against an uncomplicated background make an ideal starting-point and will enable you to concentrate on the basics instead of having to worry too much about complicated colours, patterns and composition.

Initially, an arrangement of two or three vases or a limited selection of fruit will give you the opportunity to practise some of the basic watercolour techniques. Once these are mastered, you will move on to other, more ambitious subjects with greater confidence.

The secret of successful watercolour painting lies in simplicity. A practised artist can look at any subject and simplify it into essential areas of colour and tone, often portraying the most complicated subject with just a few strokes of paint. Detail is suggested rather than copied; at close quarters many watercolour paintings look like mere splodges of paint, the subject completely unrecognizable.

Be selective

But this ability to simplify a relatively complicated subject comes only with practice. For a newcomer to the medium, still learning how to use the paint, it is far better to begin with a simple subject. How to set about achieving a simplified representation of a complex subject is something that is learned gradually.

A good rule of thumb is to tackle a detail of what you can see rather than attempt the whole thing. For instance, when confronted by a rural landscape with hills, trees, stream, footpath and gate, don't attempt to include all of them in one painting. Be selective and choose, say, the gate, with a little surrounding foliage, or a few trees silhouetted against a wide expanse of sky. Similarly, avoid the temptation to paint a whole room or complex still life. Pick a fragment of the total composition and you will be surprised at how a straightforward subject can make an effective painting.

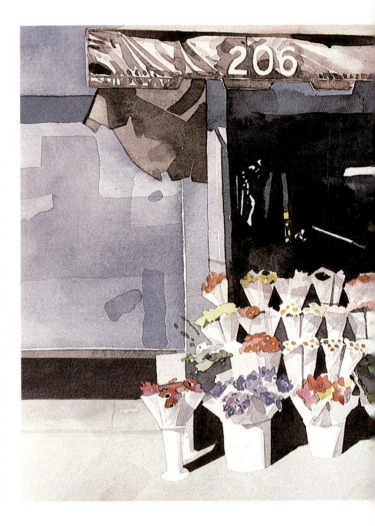

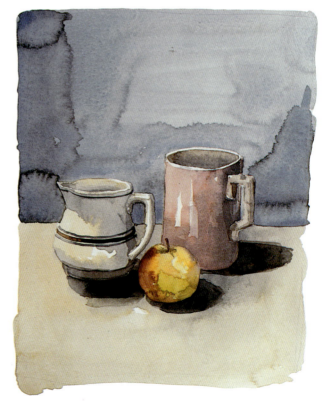

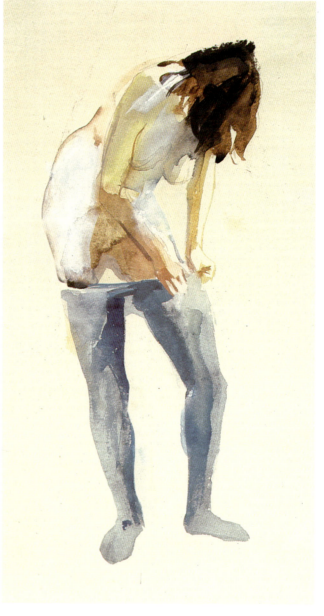

▽**Figure** *Movement is the essential element in this colour sketch. The woman is dressing and the artist must work quickly to capture the moment. The painting therefore has no outline, no preliminary drawing and no detail. Instead, the moving figure is simplified and expressed in washes of colour, applied directly to the paper.*

△**Urban landscape** *A scene which could well have intimidated an inexperienced artist has not daunted Ian Sidaway. Instead, he has successfully simplified the subject and painted it as a series of simple shapes and in a limited range of colours and tones. The flowers are depicted as bright blobs of colour; pavement, paper wrappings and vases are all left white; while other elements are painted in three tones of grey. The scene is further simplified by being painted 'head on' – in other words, there is no perspective, and the building and pavement run absolutely parallel to the bottom edge of the picture.*

◁**Still life** *A few objects against a simple background make an ideal 'starter' subject, enabling you to concentrate on the basics without the distraction of a complicated composition or confusing surface patterns. As you will see from this painting of a jug, apple and mug, a very ordinary subject can be painted in an interesting and animated way by applying colour freely, with broad, lively brushstrokes.*

17

SUBJECT TOPICS

Practical considerations are often the deciding factor when it comes to choosing a subject. If the weather is good, it is tempting to work out of doors; if you have a willing sitter, this might seem a good opportunity to try your hand at a portrait or figure painting. Otherwise, flowers, plants and domestic objects are accessible and attractive possibilities.

Choice of subject is very personal, so pick something you like and find inspiring – even if this is not attractive in the conventional sense. For instance, many artists find urban and industrial landscapes more exciting than rural scenes. Others are more interested in mechanical objects. The choice is wide and infinitely varied.

Whatever you decide to paint, the approach is the same. Treat the subject exactly as you would if you were painting a single, simple object. In other words, start by looking at what is front of you and decide how it can be made less complex.

Light and weather
If you are working indoors, good lighting is essential, so make sure the light source is strong enough to enable you to work comfortably. Light changes rapidly, both with the weather and gradually throughout the day. Daylight bulbs are a good alternative to natural light – either as a replacement for it or to supplement fading light.

Painting outdoors can be stimulating and rewarding because the translucency of watercolour is ideal for capturing the effects of natural light and the bright colours of nature. Make sure you are well prepared when you set out on an outdoor painting trip. Weather is unpredictable, so take waterproof coverings for yourself and your painting. You should also be prepared for wind, so arm yourself with clips for fixing the paper to the board. Many artists find string and wooden pegs make useful guyropes for fixing the easel to the ground. For long painting sessions, you will also need a folding stool.

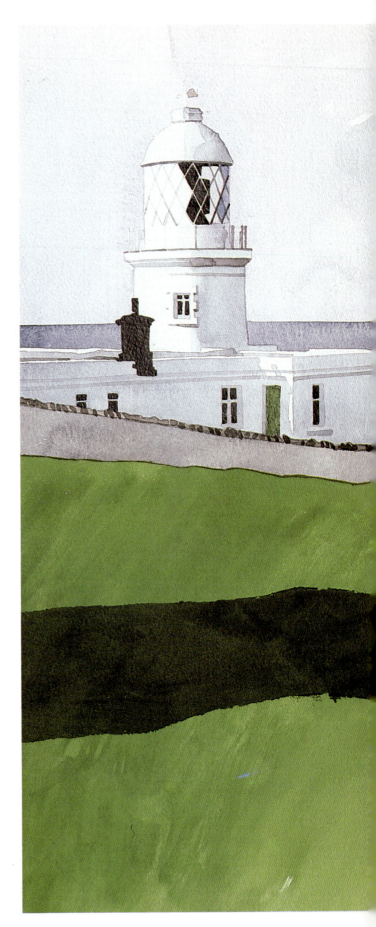

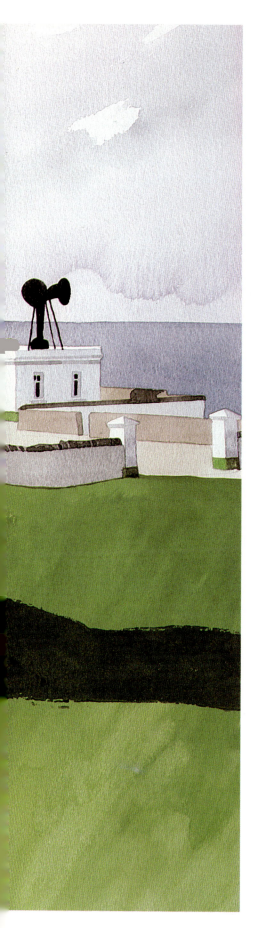

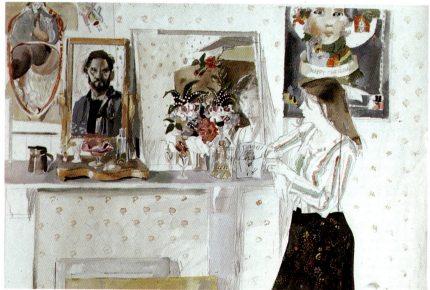

◁**Painting outdoors** *The weather was blustery and changeable when the artist, Ian Sidaway, decided to paint this seaside scene. He got round the problem by taking photographs of the subject, and then did the painting in his studio later. Simplified shapes and colours lend a strong graphic quality to the finished painting: the grass is painted in a single green, enlivened by coarse brushstrokes and a stark shadow; the lighthouse is depicted using white and two tones of grey.*

△**Figure painting** *The artist's wife is the model here; the background is the sitting-room mantelpiece. It is essentially a 'busy' painting, with lots of background pattern, ornamental shapes and other decorative elements. As with all figure painting, accurate observation is important. To accentuate some of the decorative elements, the artist, Stan Smith, uses splashes of bright, opaque gouache.*

SKETCHING AND DRAWING

Many people are put off painting in watercolour because they feel their drawing is not good enough. This is a pity, because drawing is a skill which can be learned and it has as much to do with observation and accuracy as with natural ability. Like all skills, drawing can be improved with practice. While it is true that a bad drawing will usually be reflected in the painting, it is also the case that the more painting and drawing you do, the more proficient you will become at both.

Sketchbooks

It is an excellent idea to carry a small sketchbook around with you and take every opportunity to make quick on-the-spot drawings of anything that catches your interest during the day. Busy people are rarely able to put time aside for sketching, but a pocket-sized sketchbook can be used in trains, waiting rooms, parks, cafés and many other places where you might happen to be and where there is lots going on. Apart from improving their drawing skills and powers of observation, many artists find their sketchbooks an invaluable source of reference and inspiration. They depend on them for ideas on what to paint and also for specific reference, such as what a particular type of tree looks like, or how different people sit, walk and stand.

Sketching also helps you to remember what you have seen. If you have to look at something closely enough to make a drawing of it, this commits the image to memory and often enables you to paint directly from memory afterwards.

Recording colour

Colour sketches are particularly useful if you are working outdoors and don't have time to finish the painting. You can make a very quick colour sketch of the subject and take this home to work from in the studio. It is surprising how much information can be contained in small, accurate colour sketches and how precisely they can show tone, colour and

atmosphere. Some artists also take a camera when they go out painting, finding that the combination of a colour sketch and a photograph contains enough information to work from at home. Many places now process and print photos within the hour, so this method is particularly efficient. Strangely enough, a photograph on its own is rarely sufficient to work from because it usually flattens the subject and changes the colours and tones.

An artist's sketchbook frequently tell more about the painter than the finished paintings. Certainly, watercolour sketches have freshness and spontaneity that a more finished work often lacks. Many artists are well aware that their larger, completed paintings run the risk of looking stiff compared with the sketches they were painted from, and they take steps to avoid this. One way to re-create the freshness of the small sketch is to work quickly and to paint with a large brush.

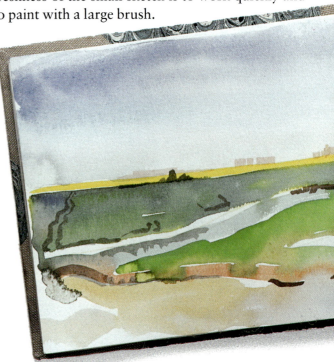

△**Colour sketch** *A sketchbook is a vital piece of equipment for Adrian Smith, who, like many artists, prefers to work either directly from the subject or from his own notes and sketches. This horizontal landscape took just a few minutes but it captured the colours and atmosphere of the scene and was the basis of many watercolours done later in the studio.*

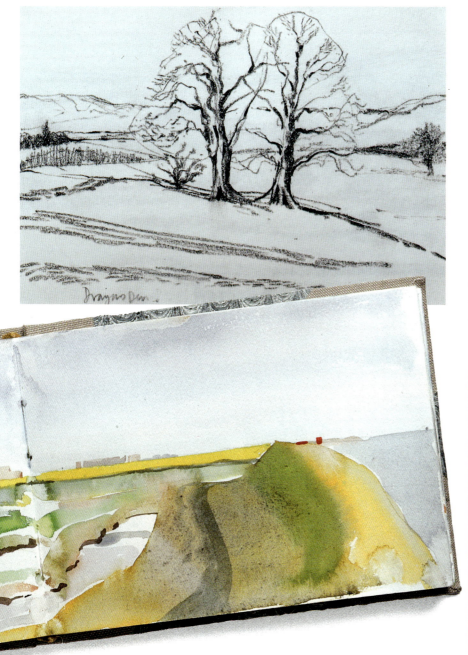

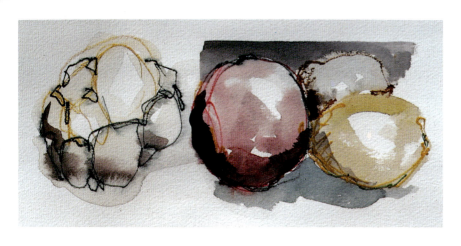

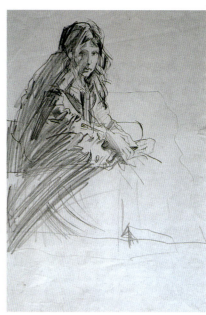

◁**Winter landscape** *Skeletal shapes of trees in winter are sketched in black pencil. The drawing, which took just a few moments, is minimal but accurate. Like most of his sketches, the artist envisages using it as a reference for future paintings.*

▽**Figure in sunlight** *Light and shadow are inconsistent and this can be a problem when painting directly from the subject. This lively, bold pencil sketch captures a moment in time as the sunlight casts strong shadows and highlights across the woman's figure. The sketch was an important reference in a finished painting.*

◁**Still life** *This rapid colour sketch was done in watercolour wash and crayon. Made prior to an actual painting, its purpose was to give the artist an opportunity to work out which colours and materials to use in the final picture.*

21

Materials

●

CHOOSING THE RIGHT EQUIPMENT should be pure pleasure. There are so many excellent materials around that there is little chance of not being able to find what you want. It is really a question of getting advice on how to choose from such a vast selection, and of knowing what is essential.

The needs of the watercolour artist have changed little in hundreds of years. Now, as then, the basics are brushes, paints, paper and easel. The various media and additives can be introduced as you become better acquainted with the skills of watercolour painting.

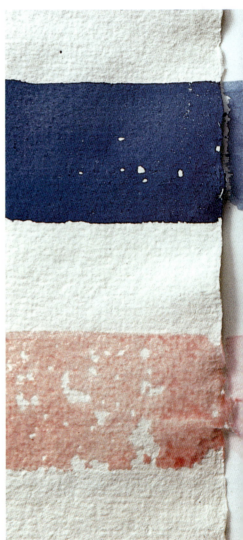

The difference between us and our ancestors is that we have a wider choice of materials and can get hold of them far more easily. Early watercolourists had to grind and mix their own paints from a limited range of pigments; we simply walk into a shop and make our selection.

The following pages contain a guide to paints, brushes and other useful watercolour equipment. A good art shop will stock everything. With care, paints and brushes should last a long time, so buy quality materials from the start. Your initial outlay will be amply rewarded with many happy hours of painting.

●

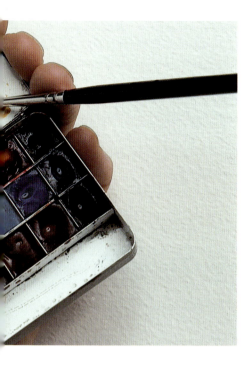

◁ A paintbox that can be slipped into your pocket for painting and sketching trips is invaluable. Such boxes are available from art shops and contain artists'-quality paint in replaceable containers. The lid can be used as a palette.

▽ Watercolour papers vary in texture and weight. Here the artist demonstrates the effects of colour on seven different types. From left to right the papers are: handmade rag, technical, hot pressed, rough, watercolour board, 'not' hot pressed and cartridge.

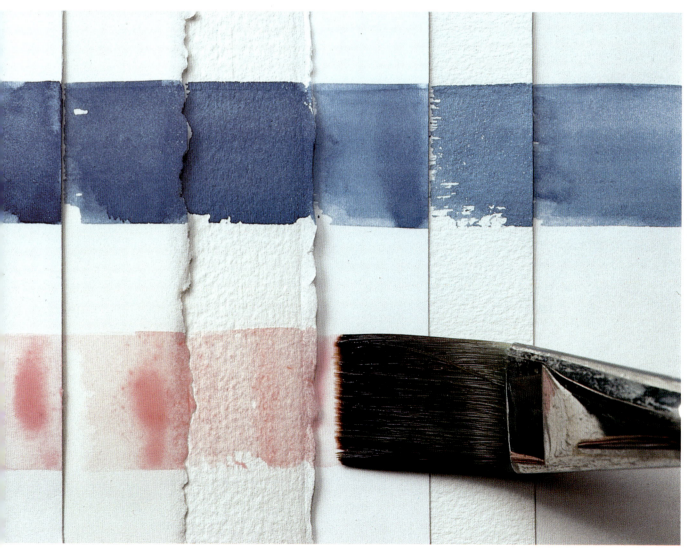

PAPERS

Watercolour papers – or supports, as they are often called – come in a range of surface textures from very rough to smooth, and the type you use will depend on the effect you want. A very rough texture has a pitted surface which often shows up as tiny white flecks in the paint. These flecks give the colour an attractive shimmering appearance, and are a characteristic of many watercolour paintings.

Smooth papers produce a flatter effect and are usually chosen for more controlled, detailed work.

The very best papers are handmade from pure linen rag, and these have a noticeably irregular surface. Handmade papers are a delight to paint on, but they are expensive and this makes them impractical for the beginner who is still learning and experimenting with painting techniques. The majority of papers for general use are machine-made.

Hot, 'not' and rough

Three types of machine-made paper are available to the watercolour artist: hot-pressed, cold-pressed (sometimes called 'not' paper, because it has not been hot-pressed) and rough. The smoother papers are those which have been hot-pressed; cold-pressed paper are semi-rough; and rough, as the name suggests, have a very textured surface. Good watercolour papers are sealed on the painting side with size, which creates a good, receptive surface

A landscape painted across some commonly used papers shows the difference between the surface textures: (from left to right)

Rough rag paper

Illustration card

for the wet colour. If you cannot tell the sized side by looking at it, look for the manufacturer's name – either embossed or watermarked – which reads correctly (the right way round) on the painting side of the paper.

For the beginner, a medium-textured, cold-pressed paper will probably produce the most immediately pleasing results, because the surface helps keep the painting alive and fresh. However, any textured paper takes a little getting used to and you will need to practise. For one thing, the brush must be well loaded with colour and applied with confidence, otherwise the painting will look dry and scratchy. Nor is it easy to get a flat wash on a very textured paper, so if you particularly want a flat background, choose one of the smoother hot-pressed papers.

Papers are graded by weight per ream (500 sheets). Thus a lightweight paper is around 40 lb (18 kg) and a very heavy paper is 400 lb (182 kg).

'Not'

Any paper weighing less than about 150 lbs (68 kg) will buckle and wrinkle when wet and must therefore be stretched before use (see overleaf); otherwise you can normally work directly on to the support. When you buy watercolour papers in art shops, the name and weight of the sheet is always given.

Blocks of paper

Watercolour paper is also available in blocks. The sheets are gummed together at their top edges and a painting can be completed, then lifted off. The sheets are mounted on stiff cardboard backing and are thus particularly useful for working outdoors, because they can be used without a drawing board.

Cheap cartridge papers and other drawing papers are not a good idea. Apart from buckling badly when wet, the surfaces tend to disintegrate as you work – obviously a disheartening experience. As a general rule, buy the best paper you can afford.

Hot pressed

STRETCHING PAPER

Lightweight papers should be stretched and allowed to dry before you start to paint on them. If you do not do this, the chances are that your paper will wrinkle as soon as you wet it and your painting will be spoilt.

To stretch a sheet of paper, wet it thoroughly, either by wiping it with a damp rag or sponge or by immersing it in water. The wet paper must then be taped to a board and allowed to dry. Do not remove the paper from the board but work on the stretched sheet while it is still taped down.

Even with stretched paper, you will often find wrinkles appear when you apply the paint, but these will smooth out as the painting dries. Only when the painting is finished and completely dry should it be removed from the board.

Saving time
Stretching is a very simple process but it can be irksome if you have to stretch a sheet every time you want to do a painting. The answer is to stretch several sheets at the same time, so that you have a supply of supports ready to work on. You should never try to speed up the process by drying the stretched paper with a hairdryer or by placing it against a radiator. It must be allowed to dry naturally; otherwise it will dry too quickly and tear.

Ask a timber supplier for offcuts of sturdy plywood to use as boards (hardboard and other flexible materials are not suitable because they will bend as the paper dries). The stretched paper can remain taped to the plywood ready for use, and you will be able to use these inexpensive boards over and over again.

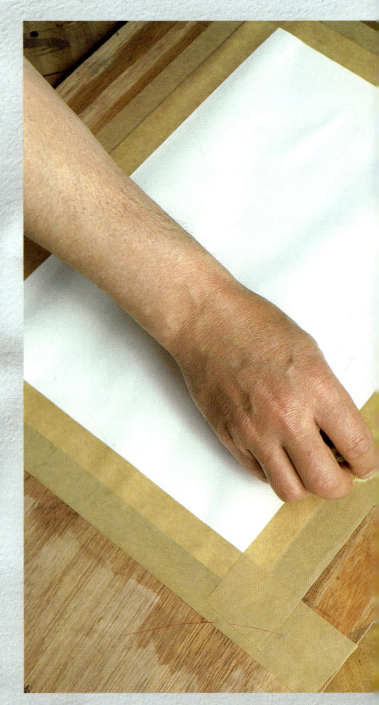

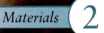

Stretching paper

△ 1 *Start by thoroughly wetting the paper, either with a sponge or large brush or by immersing the sheet in clean water.*

◁ 2 *Use gummed paper tape to stick the wet sheet to a flat board. The tape should overlap both paper and board by ³/₄ in (2 cm) all round. If your tape is not wide enough for this, use two or three widths of tape.*

△ 3 *Corners are the most vulnerable areas because they occasionally pull away from the board as the paper dries. It is therefore a good idea to anchor and strengthen the corners with drawing pins.*

27

BRUSHES

Buying brushes is probably the most difficult part of setting up. Such a wide variety is now available, in so many shapes, sizes and materials, that choosing the right ones can seem a bit of a gamble.

For watercolour painting, brushes must be soft. They are made of animal hair or a synthetic equivalent. Some artists will use only the traditional natural brushes; others find good-quality synthetic brushes are springier to use and keep their shape better. Natural or manufactured is a question of personal preference, and the only way to discover which suits you best is to try them both. Cheap brushes should be avoided because of their inferior shape and texture, as should the so-called 'craft'

Natural hair *The large wash brush is made from squirrel; the smaller brushes from pure sable.*

Mixed fibre *The bristles are a mixture of sable and synthetic materials.*

Brushes
Watercolour brushes are soft and made with natural or synthetic bristles. A brush may have either a round or flattened head of bristles, and this shape determines the mark the brush makes. 'Rounds' hold more colour and, depending on the size, are used for painting undulating lines and detail as well as large areas of colour. 'Flats' are useful for painting wide lines and for blocking in broad expanses.

brushes. These are intended for children, model-makers and other types of hobby workers, not for serious watercolour painting.

The best natural brushes are made from sable or kolinsky. Only the tip of the tails of these small mammals are used in the finest brushes and, provided they are well looked after, the brushes will remain tough yet soft, and retain their superior shapes for a long time. Oxhair and other hair mixtures are also used in the production of watercolour brushes.

Synthetic brushes *The bristles are manufactured and contain no natural fibres.*

In a good-quality brush, the ferrule (the metal tube that holds the bristles in place) is constructed in one piece and has no seam. This ensures that the bristles and handle are held firmly in place with none of the stray hairs or wobbliness often found in cheaper products.

Shapes

Watercolour brushes are made either with a traditional round ferrule or with a slightly flattened ferrule to produce a chisel-shaped bristle head. Some painters work with the round brushes only, finding them versatile enough to produce all the marks and effects they want to make. Others find a combination of both types gives them greater flexibility. A round brush with long bristles is known as a rigger and is useful for thin, undulating lines. Special fan-shaped brushes are made for blending colours together.

For laying washes you will need a large, round-headed brush. Some artists prefer to use a broad, flat-headed brush for laying washes but, although this may sound a more logical choice, it holds less paint than a traditional round brush and is no easier to use. By all means try both, and use the one that suits you best. A good wash brush is not cheap but it is a necessary investment, so buy a quality one and look after it carefully. It will last you a long time.

Sizes

Brushes come in a wide range of sizes, from the very largest, used for laying broad washes, to the tiniest, which are used for spotting in colour. Sizes depend on the manufacturer, but generally run from 0 to about 16 and larger. The largest wash brushes frequently have no specific size. The smaller spotting brushes are 0, 00 and 000, or -1, -2 and -3. Again, this depends on the manufacturer.

29

CHOOSING BRUSHES

A few well-chosen brushes are all you need to start with, especially as you do not really know what suits you best until you have tried it. For instance, it is unlikely you will need any brush smaller than a 1 or 2. Anything less than this is used mainly for technical work, such as retouching photographs or mechanical illustrations.

The marks they make

A round watercolour brush has a fine point, whatever its size, and this can be used for quite delicate work. In some of the demonstrations that appear later in this book you will see that just one or two brushes have been used – neither of them particularly fine – and detail has been added with the tip of the brush. The artist says that should a situation arise where only one brush is allowed, this one would be a Number 10 round, because it could cope with both broad areas and with detail.

Round brushes are more versatile than flat ones, because they enable you to paint a regular line by applying an even pressure as you go along, yet they also allow you to vary the thickness of the line by pressing lighter or harder. A flat brush, on the other hand, makes it easier to paint a regular line but more difficult to achieve a flowing or undulating one, because the width of the line is limited by the width of the bristles.

Keeping colours separate

As you progress, you will find that possessing several brushes has a definite advantage. Throughout a painting, it helps to keep the same brush for the same colour, or group of colours, helping them to stay bright and clear. For example, if you have strong reds and greens in the subject, these can become muddy if you switch constantly from one to the other using the same brush, because any trace of red in green, or green in red, can eventually turn both colours into a dingy brown. It is also useful to have clean, dry brushes to hand for soaking up excess colour.

▷**Large round** *Probably the most versatile of all brushes, a large round holds enough colour to cover large areas, yet has a point which can be used for detail and fine lines. Here the artist applies pressure to create a line that swells smoothly from fine to chunky.*

Making brushes last

Good brushes last a long time if you look after them properly. Wash all brushes carefully after use. Gently reshape the bristles while they are still wet and allow them to dry naturally. Never stand brushes bristles downwards in the water, even for a short time. Once its bristles have become flattened or splayed, a brush never regains its former shape.

Choosing your brushes

A good, all-round basic selection would include a wash brush for flat backgrounds and large areas of colour; a few rounds – say, Numbers 2, 4 and 6; and a rigger for linear work, such as tree branches. You might also wish to include one or two flat brushes – say Numbers 2 and 6. Obviously, as your needs increase, this basic selection can be supplemented to suit your own requirements.

◁ **Rigger** *A rigger has long, flexible bristles which allow the artist to paint regular, fine lines with a natural, flowing feel. It is also useful for adding final, linear detail.*

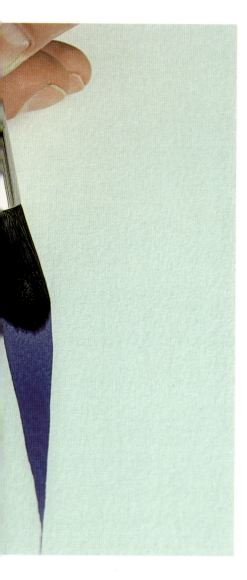

▽**Flat brush** *Broad, regular strokes of colour are best applied with a flat brush. The bristles are cut to create a chisel-effect that gives the artist a great deal of control over the painted line. A flat brush can be turned to create a narrower though more irregular mark.*

▷**Small round** *Finer brushes should be used to supplement larger sizes, and are good for fine lines and detail. For beginners, there is a tendency to work with brushes that are too small for the purpose, and for paintings to become tight and overworked. A good rule of thumb is to use large sizes for all but the final touches.*

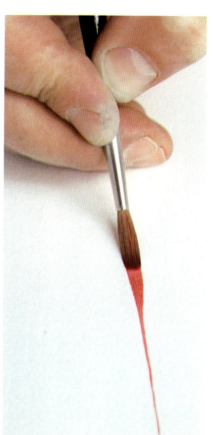

31

PAINTS

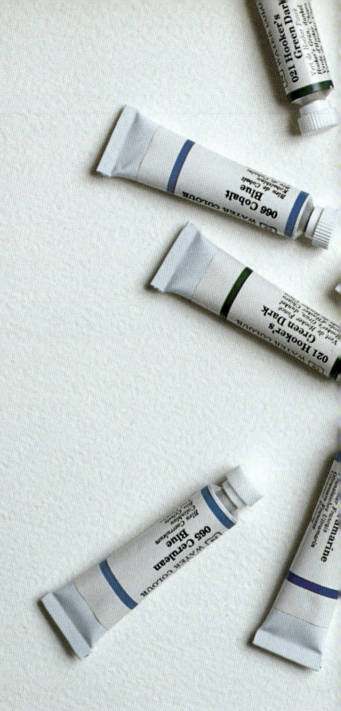

Colours come either in tubes, pans or half-pans. Tube paint is more fluid, and is squeezed out on to the palette before use. It is then diluted before being applied with the brush. Pans and smaller half-pans are solid and semi-moist and the colour has to be released by adding water. The paint is taken to the palette or paper with a brush – as with the boxes of paints used by children.

The type of paint you choose is a question of personal preference. Initially, tubes are probably the most convenient, although there is always a certain amount of wastage – there is always some unused paint when the picture is finished. It is a good idea to experiment, trying both pans and tubes in order to see which suits you best.

It is unlikely that any artist has used the whole of the vast range of watercolour pigments now available. Depending on the manufacturer, there are between sixty and eighty colours to choose from, and the number is increasing all the time. Most painters develop their own favourites and work with less than a quarter of the colours available; some use far less.

Sets and boxes

Pans and half-pans are available in boxes, making them handy for carrying around. The pans are removable, so when a colour runs out you can simply buy a replacement. With most metal paint-boxes, the lid doubles up as a mixing palette, and some boxes also contain a built-in water container. These all-in boxes are very compact and can be slipped into your pocket for sketching and small-scale outdoor work.

Tube paints are also available in sets, usually containing a selection of ten or twelve colours and often a palette, brush and painting pad. The sets make welcome gifts for someone interested in learning how to paint, but a prolific painter will very soon find it necessary to supplement the contents with more brushes and a wider range of colours. Given the choice, it is probably better to make your own selection in the first place.

Colour and quality

Paints are produced in two grades: quality 'artist's' colours and a less expensive range, some of which are made with cheaper pigments. Although the quality paints cost more, any artist will tell you that the extra expense is well worth it – the colours are stronger and more vivid, the results more satisfying. And when you consider just how far a small amount of paint will go, and just how long one tube or pan will last, it is generally best to opt for the superior product.

Certain pigments are more long-lasting than others which fade over the years as they are exposed to the light. The degree of colour per-

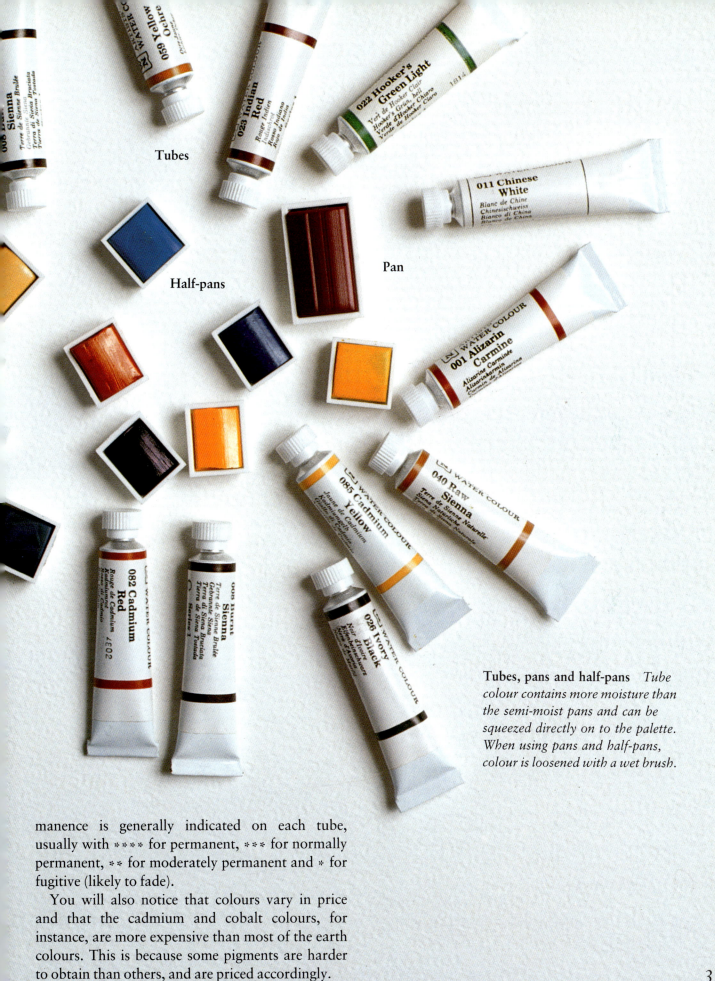

Tubes

Half-pans

Pan

Tubes, pans and half-pans *Tube colour contains more moisture than the semi-moist pans and can be squeezed directly on to the palette. When using pans and half-pans, colour is loosened with a wet brush.*

manence is generally indicated on each tube, usually with **** for permanent, *** for normally permanent, ** for moderately permanent and * for fugitive (likely to fade).

You will also notice that colours vary in price and that the cadmium and cobalt colours, for instance, are more expensive than most of the earth colours. This is because some pigments are harder to obtain than others, and are priced accordingly.

CHOOSING AND USING PAINTS

Most artists work within a personal colour range, using colours that have become favourites over a period of time. Some colours – such as black and white and the primaries red, blue, yellow – are common to almost every palette; others are less common, used only occasionally or by relatively few painters. To help you decide which colours you like, it is a good idea to start with a basic selection, or palette, and introduce one or two new colours from time to time.

A 'starter' palette

The following is a standard beginner's palette, recommended on many art courses and containing a basic range of colours to get you going: cadmium red, cadmium yellow, French ultramarine, cerulean blue, yellow ochre, lemon yellow, raw umber, burnt sienna, crimson alizarin, viridian, Chinese white and ivory black. You will be surprised how versatile these twelve colours are, and how many other colours can be mixed from them.

Early follow-ups are likely to be Payne's grey, cobalt blue, cobalt violet, rose madder, Indian red and Hooker's green 1 and 2.

The projects and step-by-step demonstrations in this book are all done with the above colours.

Mixing paints

Watercolour painting requires an orderly approach, especially when it comes to mixing colours. However creative you are, and however uninhibited your painting, a few minutes spent laying out the brushes, colours and palettes before you start will help you keep control of your work and generally make life a lot easier. It is absolutely essential to wash your brush thoroughly between colours and to change the water frequently.

To mix enough of one colour to cover a fairly large area, or of a colour that you will need frequently, use a single mixing-dish like the one shown in the photographs here; otherwise use a white saucer or small dish. For small amounts of

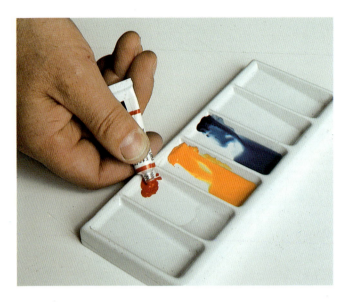

Mixing from tubes
△1 *Squeeze the colours you require on to the palette. A palette with separate mixing compartments, like the one shown here, will allow you to squeeze several colours at the same time.*

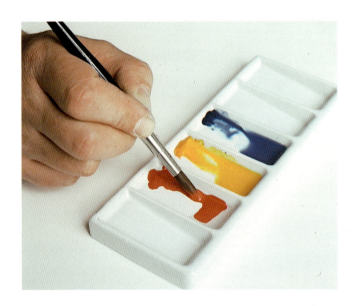

△2 *Add enough water to make the paint workable with a brush, then mix the colours in exactly the same way as for pans and half-pans.*

colour, the mixing method depends on the type of paint. If you are using tubes, squeeze a little of the colours you will need on to the palette or plate, then mix each new colour as you need it. When working from pans, simply mix each new colour as required by lifting the colours to be mixed from the pan with the brush and transferring these to the mixing palette.

Colours change as they dry, so keep a sheet of paper to hand for testing the mixed paint. Allow each test to dry before applying the colour to the painting. A hairdryer will speed up this process.

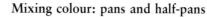

Mixing colour: pans and half-pans
▽**1** *Dip your brush in clean water and work this into the paint until it softens. Transfer the first colour to the mixing dish or palette with the brush. If you want to mix a fairly large quantity of colour, you will need to do this several times.*

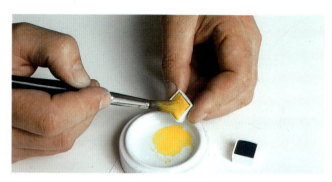

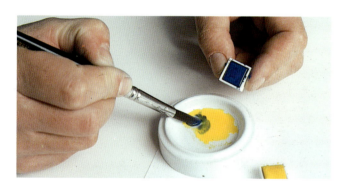

△**2** *Wash the brush thoroughly in clean water and add a second and subsequent colours in the same way. The brush should be washed before you return to the pan for more colour.*

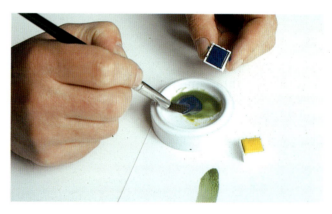

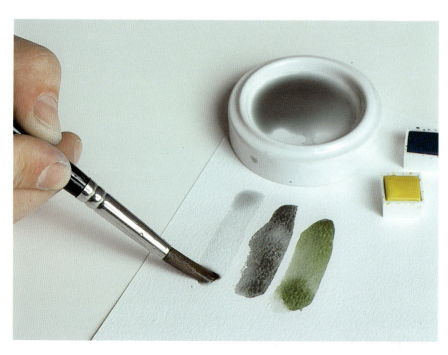

△**3** *Continue adding paint until you have the colour you require. Watercolour always looks darker in the mixing dish than it does on paper, so keep a scrap of paper handy for testing your colours.*

◁**4** *Continue mixing and testing your colour until you are happy with the result. The more water you add, the paler the colour becomes. Watercolour tends to dry lighter, so for an accurate indication of how a colour will look, you must wait for the test to dry.*

WATERCOLOUR ADDITIVES

Various substances can be added to watercolour, varying the consistency of the paint to produce a whole range of textures and finishes. The additives can open new vistas to the adventurous painter who likes to experiment and create new effects. When used selectively, they can also enliven traditional painting techniques and give a lift to work which has started to go flat or dull.

It must be stressed, however, that no medium is a substitute for the paint itself. You can improve the surface texture, give an added glow to the colour, and create certain patterns and effects that would not be possible using paint alone. But you cannot depend on an additive to compensate for lack of painting skill, to disguise a bad composition or to rescue a painting that has already been ruined by impatience or overworking. Additives should be regarded as occasional enhancers to your work, and should not be overdone.

Masking fluid *A liquid rubber solution, the fluid is used for masking areas of work to protect them from subsequent layers of colour. Masking fluid is normally pale yellow, although colourless versions are also available.*

Watercolour medium *This transparent medium binds the colours and improves the flow of the paint. It can also be applied to wet colour to create texture and pattern.*

Gum arabic *A slightly viscous medium, gum arabic binds and thickens colours, which then dry with a glossy sheen. It can also be applied to wet colour to produce patterns and textures. Gum water is a thinner version of gum arabic and produces similar effects.*

Ox-gall liquid *A wetting agent used to improve the flow of colour, ox gall makes it easier to apply watercolour across the paper surface.*

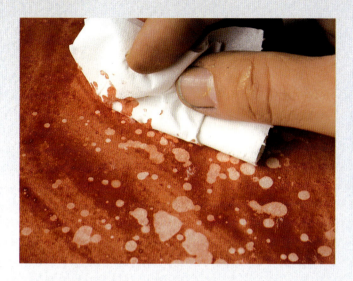

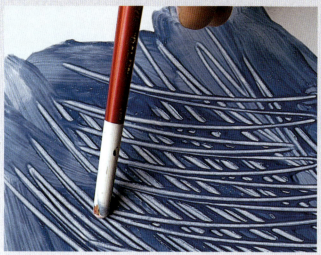

Gum Arabic
△Normally mixed with the paint to brighten and enhance the colour, gum arabic can also be used to create a variety of textures. Here the artist flicks drops onto an area of dried colour to get a mottled effect.

Texture Paste
△A clear, jelly-like substance, texture paste is mixed with the paint in order to thicken it without affecting the transparency. Scratched patterns can be made in the wet, thickened colour to reveal the paper or underlying colour used for scratched patterns.

Experiment first
The most common additives are oxgall, gum water and gum arabic, watercolour medium and texture paste. Masking fluid is not actually added to the paint but is applied separately. With all these substances, it is important that you know how to use them – to understand exactly what the possibilities and limitations are – and this can be done only by practice. Certainly, you should never attempt to introduce any of them into a painting unless you have first tried them out.

Aquapasto This transparent texture paste is mixed with watercolour to give a thick consistency. The colour retains the shape and texture of the brush marks and enables the artist to scratch back into the paint to reveal the paper or underlying colour.

EASELS AND OTHER EQUIPMENT

Some watercolour equipment can be improvised, but not your easel. It is especially essential if you are going to work out of doors. As this is the largest item on your equipment list, it is worth getting a good one.

Mixing dishes

The right easel

A proper watercolour easel is adjustable, enabling you to work at any angle, including horizontally – essential when you are using a lot of wet colour, otherwise the paint just runs down the paper. A sketching easel has a certain amount of tilt but does not adjust to a full horizontal position.

Try to find an easel which is sturdy yet light enough to be easily portable. The majority come in beech or other hardwoods, but there are some made in lightweight metal which fold up very compactly. Your easel should have telescopic legs to adjust the height and enable you to work standing or sitting. It should also be stable. Some artists like to work with the board almost horizontal on the easel; others like to paint at an angle, a tilt of around 45 degrees being the most usual. Many find it easier to sit at their painting with their materials spread out on the ground, so make sure your easel allows you to do this.

Other equipment

If you are working on sheets of paper as opposed to a block or pad, you will need a drawing-board and clips for holding the paper in position. You will also need a folding stool and a bag to carry paints and equipment.

Cotton buds

Standard drawing-boards can be bought at any art or graphic supplies shop. A good one will last a lifetime, provided you look after it and don't use it as a cutting-board. Some boards are far too big and heavy to carry around, so choose one which is best suited to your needs. A cheap, lightweight alternative is a sheet of plywood, available from your local timber shop.

Watercolour painting requires a lot of clean water, a point often forgotten. Plastic bottles with screw tops are useful water-carriers when working away from home. You should also take plenty of clean rag or tissue with you. As with water, take more than you think you will need.

Natural sponges

Erasers

△*A lightweight sketching easel (left) can also be used for watercolour. The angle is adjustable, but it cannot be adjusted to a horizontal position. Adjustable, telescopic legs make the easel compact and easy to carry. The portable watercolour and sketching easel (right) is similarly compact and can be adjusted to a horizontal painting position.*

Palettes

Colours

●

COLOUR IS AN exciting and magical phenomenon. Mysterious, perplexing and constantly changing, it provides artists with their greatest thrills . . . and greatest challenges.

Everything we can see has a colour, even if it is black and white, or grey. You can't paint colour until you learn really to 'see' it. When you start looking at the world with the eyes of an artist, you'll find that things aren't what you thought they were! Black isn't simply black: there are warm reddish blacks, transparent blacks and cool blue-blacks. The yellow of a lemon is different from the yellow of a banana or a melon. Flesh isn't pink, grass isn't always green and the sky is only rarely blue!

Good pictures don't just happen; they are made or composed. Artists organize the elements of light, tone and colour within the rectangle of the support in order to create an image that has unity and impact, and effectively expresses whatever they are trying to communicate. Composition is about making decisions, selecting, editing and emphasizing in order to create an image that you find satisfying.

'Tulips' by Shirley Felts. The artist has used carefully controlled washes of fresh, clear watercolour to build up this exuberant picture of tulips. The delicate, bright colours of the flowers make considerable demands on the artist, who must keep the colours fresh, yet orchestrate all the tonal values so that the characteristic forms of the flower heads are depicted accurately.

In this painting Shirley has drawn attention to the decorative qualities of the subject, cropping in close to emphasize the patterns made by the flowers on the picture plane. The background is densely patterned, forcing itself on to the picture plane so that the spatial elements are played down.

●

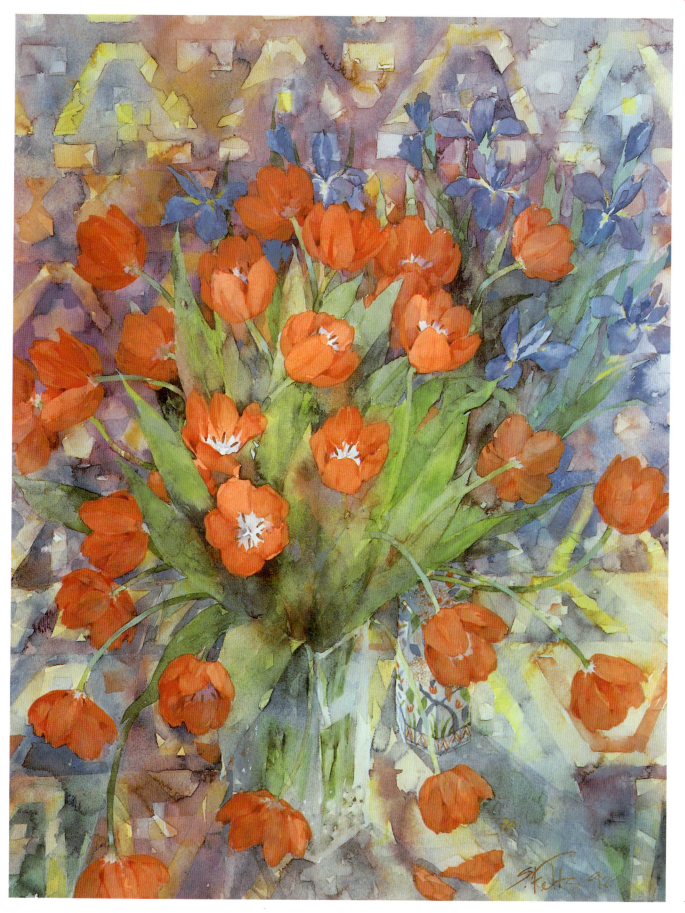

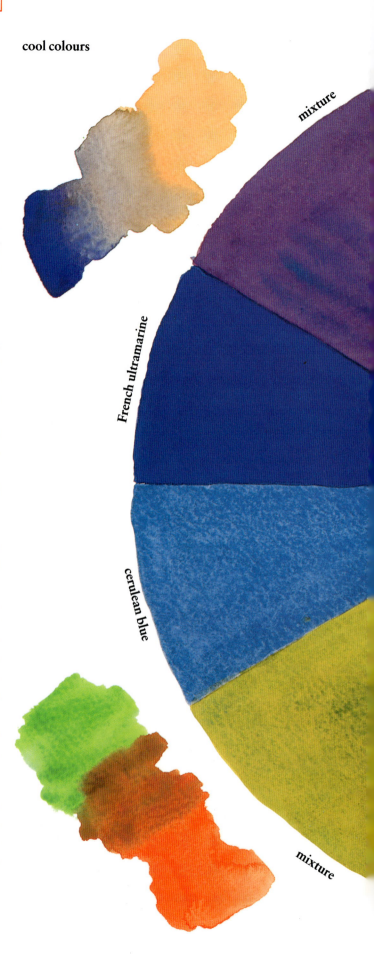

cool colours

mixture

French ultramarine

cerulean blue

mixture

TECHNIQUES

THE LANGUAGE OF COLOUR

Your ability to use colour will improve immensely if you understand some of the basic concepts of colour theory. The colour wheel or colour circle is a device that makes understanding colour and colour relationships easy. It also helps you to remember some of the terms.

The first three colours to look at are the *primaries*: red, yellow and blue. These are important because they cannot be mixed on the palette from other colours and, in theory, every other colour can be mixed from them.

Separating them, you will find orange, green and violet. These are called the *secondaries*, because they are derived from the primaries: red and yellow give orange; yellow and blue give green; red and blue give violet.

The *tertiaries* are produced by adding a primary to a secondary. They are useful colours like bluish green and yellowy green; reddish orange and reddish violet.

Every colour has four qualities: hue, tone, intensity and temperature. Artists use the word *hue* rather than colour to describe a pure colour, a colour that has not been lightened or darkened in any way. *Tone* describes the lightness or darkness of a colour. A *shade* is a hue that has been darkened; a *tint* is a hue that has been lightened. *Intensity* describes the purity, brilliance or saturation of a colour. The most intense green is the purest, brightest green possible. As soon as you start mixing hues, you reduce their intensity.

All colours have a *temperature*. Some colours look warm and others look cool, and there is a general consensus about which is which. Here the colour wheel is helpful. It can be divided into two halves. In one half we find the warm colours: yellows, reds and oranges. On the other side are the cool colours: blues, violets and greens.

alizarin crimson

warm colours

cadmium red

mixture

cadmium yellow pale

lemon yellow

43

MIXING COLOURS

Colour mixing is a visual skill which cannot effectively be learned from books and charts. The only way to find out about it is to get out your paints and have a go. By trying out all possible combinations, you will not only discover what the possibilities are but you will also remember the properties of the colours you use.

The colours shown here are the suggested basic palette on page 34. They are an excellent starting-point, and from these foundations you can go on to mix an almost infinite variety. Try making your own colour chart, taking one colour at a time and mixing it with each of the other colours on your palette, in varying quantities. Very soon you will have at your fingertips a comprehensive repertoire of your own colour recipes.

Cadmium Red

Cadmium Yellow

Cerulean Blue

Yellow Ochre

Raw Umber

Burnt Sienna

Crimson Alizarin

Cobalt Blue

Cobalt Violet

Rose Madder

ench Ultramarine

Lemon Yellow

The important greens

For the landscape painter, green is one of the most important colours. Many of the ready-mixed greens, particularly viridian, are too strong to match the subtleties of most landscape subjects, although a strong green is often useful for brightening up an otherwise dull green. In nature, greens are often dominated by another colour, such as blue, violet, lemon, golden yellow, red or brown, so to assume that green is a simple mixture of blue and yellow is far from the truth. You can paint the leafiest landscape without any green in your palette.

Similarly, you should not assume that the only way to get orange is to mix primary red with primary yellow, or that primary blue and primary red make the only possible violet. Try using the many reds, yellows and blues shown here, and you will be surprised at the rich assortment of oranges and violets you get.

◁ *The colours shown here are those in the suggested 'starter' palette on page 34.*

iridian　　　　　　Ivory Black　　　　　　Payne's Grey

dian Red　　　　　　Hooker's Green 1　　　　　　Hooker's Green 2

LIGHTS, DARKS AND NEUTRALS

Some colours are dark; others are pale. For the artist this simple, obvious fact is important because the arrangement of light and dark shapes in a painting can be as crucial as the colours themselves.

Tones

The degree of lightness or darkness of a colour is known as a tone or tonal value. Thus yellow, pink and other pastel shades are all pale tones, while the darker colours are all deep tones.

When using watercolour the palest tone is the white paper, the darkest is black or near-black. If a painting gets overworked, the lights and darks start to merge. The painting loses its sharpness and you can end up with a rather flat-looking picture.

Similarly, if you work only in bright colours, the vividness of each individual colour is diluted because it is cancelled out by its neighbour. For example, a bright red looks particularly vivid if it is surrounded by greys and neutral colours, but when painted next to other equally vivid colours it might not be noticed at all.

Neutral colours

When painting from a subject, it is helpful to remember that we rarely see pure colours around us. We may know that a particular vase is bright yellow, but what we actually see is a mixture of other colours in the form of shadows, highlights and reflections that pick out the surrounding colours – in other words, colours that tone down, or neutralize, the yellow of the vase.

'Neutrals', therefore, play an important part in painting and should not be overlooked in your colour mixing. A neutral colour is one that has been toned down by mixing with another colour. A true neutral has no identifiable colour at all. It has a slightly greyish appearance – an equal mixture of primary red, blue and yellow produces a neutral grey. But practically speaking we also use the term neutral to describe a colour which has been toned

down with another pigment. For example, red and yellow with a touch of blue will produce a neutral orange; blue and yellow with a touch of red will make a neutral green; and so on.

As with all colour mixing, it is not possible to be absolutely precise. The purpose of neutral colours is

Tone and Colour

◁ *Every colour can be mixed to obtain lighter and darker tones. The addition of black produces a deeper version of a colour: diluting the colour with water gives you a paler tone. In the central column of this chart are the primary and secondary colours; in the adjacent columns are two darker and two lighter versions of each colour.*

to give harmony and depth to a painting by bringing the other colours together, and at the end of the day it is what works in the painting that is important. So spend time experimenting. Invent your own neutral colours and try introducing them into your paintings.

47

TECHNIQUES

EXPLOITING COLOUR TEMPERATURE

Colour temperature refers to the degree of warmth or coldness of a colour. This concept is invaluable to the artist. However, colour temperature is relative, so you'll find that some yellows are warmer than others. If you look at the colour wheel, you'll find that the pairs of pigments I have selected can be classed as warm or cool. Taking the reds, alizarin crimson is cooler than cadmium red, which has an orange bias, whereas the blue of ultramarine is cooler than cerulean blue, which has a greenish bias.

The temperature of colours has several practical applications for artists. First, there is the psychological aspect of colour: colour can be used to create mood in a painting. The warm colours are associated with energy, heat and aggression, with sunlight and fire. Cool colours are more tranquil and relaxing; they are typically the colours of snow, sea and sky, and moonlight. These associations are very strong. In one experiment people in a blue room set their central heating thermostat four degrees higher than others in a red room even though the temperature in both rooms was the same. Exposure to red has been shown to increase muscular tension, respiration, heart rate, blood pressure and brain activity. Blue has the opposite effect, and can make you feel relaxed and quite sleepy. If you want your painting to express heat and excitement, you would naturally tend to select reds, oranges and warm earth colours. A chilly winter landscape or a sad, introspective image would call for a cooler palette.

Colour also affects our spatial perceptions. Warm colours are said to advance, while cool colours recede. Place a patch of red and a similar-sized patch of blue on a canvas. The red will draw the eye and appear to be located further forward on the picture plane. It will also appear to take up more space than the patch of blue.

Interior designers use colour to make rooms seem larger or smaller, to make a ceiling seem higher or lower. By painting the walls of a large room in a rich red or russet, you can make them close in so that the room feels small and cosy. Conversely, pale blue can be used to visually push back the walls of a small room so that it feels more spacious and airy.

These qualities can be manipulated to enhance the illusion of three-dimensional space. Cool colours are used on the horizon, and warmer colours in the foreground in order to suggest the effect of recession and depth in a picture.

You can also use colour as a compositional device, drawing attention to an important feature by adding a touch of a colour that is warmer than the surrounding colour. As temperature is relative, a touch of ultramarine will sing out in a field of cool cerulean or Prussian blue. Warm colours are also insistent. A small touch of scarlet will be sufficient to enliven quite a large area of green.

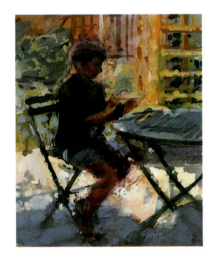

▲ *In this painting by Francis Bowyer, the figure is seen 'contre-jour', against the light. The light throws the figure of the child, the table and chair into dramatic silhouette. The contrast between the cool blue shadows and the warm yellows and ochres in the areas of direct sunlight heightens the sense of brightness and warmth. Notice that the shadows have a definite colour value; they are not painted black or grey.*

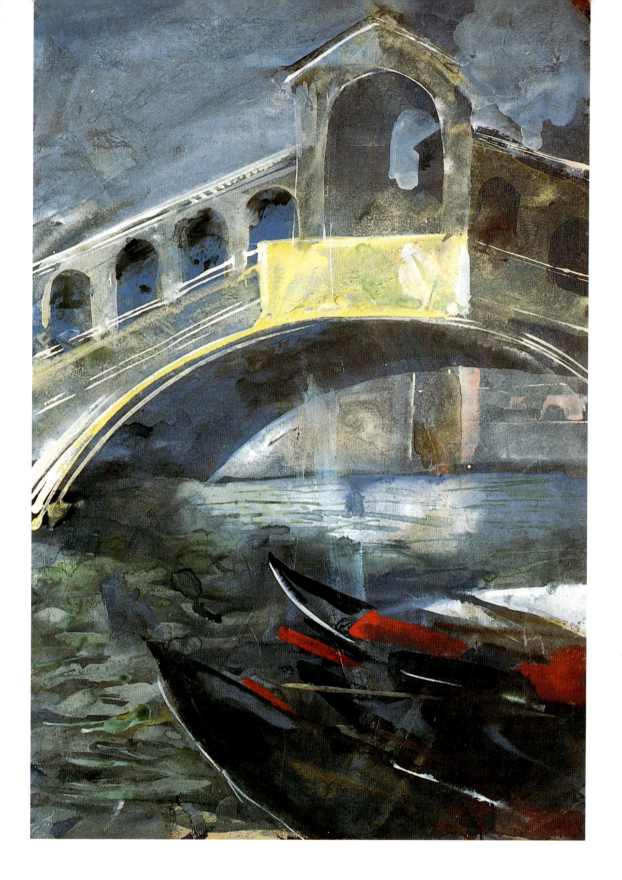

▲ In this painting of the Rialto Bridge in Venice, Stan Smith has used cool blues and greys to create an image that captures the watery, otherworldly atmosphere of the city. The colours used are primarily cool, but the energy of the paint application, combined with the touches of yellow and vivid red gives the painting a liveliness.

49

TECHNIQUES

EXPLOITING OPPOSITES

Probably the most important colour 'relationship' is between complementary pairs – the colours that appear opposite each other on the colour wheel. It was only in the nineteenth century that scientists really began to understand how complementary colours affected each other, although artists have always been intuitively aware of the power of the relationship. This can be seen in the work of the Old Masters, particularly in the juxtaposition of complementary pinks and greens to create lively flesh tones.

The complementary of a primary is always a secondary, and the complementary of a secondary is the primary not included in its mixture. The six-colour colour wheel gives you the following complementary pairs: red–green; blue–orange; yellow–violet.

One of the most dramatic manifestations of the power of the complementary relationship is the 'afterimage'. Try this experiment. Paint a square of red on a sheet of paper. Stare at the red square fixedly for at least ten seconds from a distance of about 50 centimetres. Now quickly transfer your gaze to the sheet of white paper. Almost immediately a greenish afterimage of the square will appear. If you repeat the exercise with the green square, you will see a pinkish afterimage, while the afterimage of the yellow square is pale violet.

Complementary colours are important to artists because they do two important and apparently contradictory things. When placed side by side they enhance each other; and when mixed together they neutralize each other.

In the first case, because complementary colours offer each other the maximum contrast, colours appear most intense when placed alongside their complementary partner. Green looks its greenest when contrasted with a complementary red; blue looks bluer when it is contrasted with orange. This has many practical applications. By introducing a touch of the complementary into an area, you can make that area richer and more vibrant – touches of earth red will make grass or foliage look brighter.

In the second case, complementary pairs can be mixed together to create a range of beautiful greys (cool neutrals) and browns (warm neutrals), very different from the rather dull shades produced by mixing black and white. Experiment with mixes of red and green, blue and orange, yellow and violet. By adjusting the proportions of each, you will produce a wonderful range of warm and cool neutrals, earthy pinks and browns and pearly lilacs and greys. Use these colours in shadows, flesh tones and as a foil for more strident colours. Study the work of the great colourists like Walter Sickert (1860–1942), and you will find that these coloured or neutral greys play an important part. If a colour seems strident, you can 'knock it back' by adding a touch of its complementary.

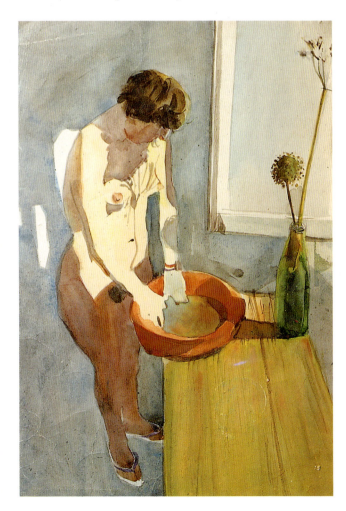

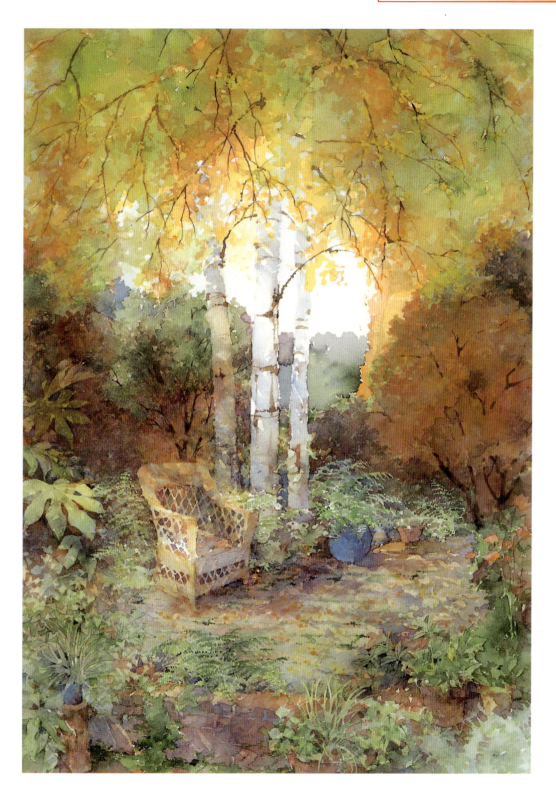

◄ *In this painting of a woman with a washing bowl, brilliant sunlight floods in through an open window, creating striking patterns of light and dark on the figure. The figure is the focus of the painting, but the artist, Stan Smith, draws attention to the still life on the table by carefully balancing the red of the bowl with the complementary green of the bottle.*

▲ *'The Wicker Chair in Autumn' by Shirley Felts. In this delightful painting the artist captures the particular light of a sunny autumn day. The glorious golds and oranges of the foliage are set off perfectly by cool shadows in complementary blues and lilacs, giving the painting a shimmering quality and providing a pleasing balance of warm and cool colours.*

51

The basics

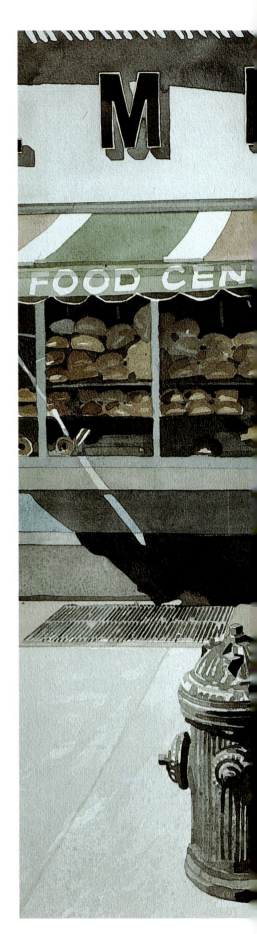

A SUCCESSFUL WATERCOLOUR is rather like a patchwork quilt – built up piece by piece, each an integral part of the finished product. With patchwork, the pieces are sewn together, edge to edge; with watercolour painting, they are usually juxtaposed or overlapped. But each stage, each piece, must be planned and executed with the same amount of patience and precision.

Once you get used to building up a painting and – if necessary – waiting for the colour to dry between stages, the process becomes very much easier.

The first 'piece' to go into many watercolours is the background or, in the case of landscapes, the sky. This is usually done by laying an area of thin, flat colour known as a 'wash'. This should present no problem provided you follow the step-by-step demonstrations and work in a logical and systematic way.

Whether you paint on to the wash while it is damp or wait until it is dry depends on the effect you want a crisp shape, or the colours run slightly for a softer effect. Before embarking on an actual painting, it is a good idea to try painting on to surfaces that differ in their degrees of dampness so you know exactly what the results will be.

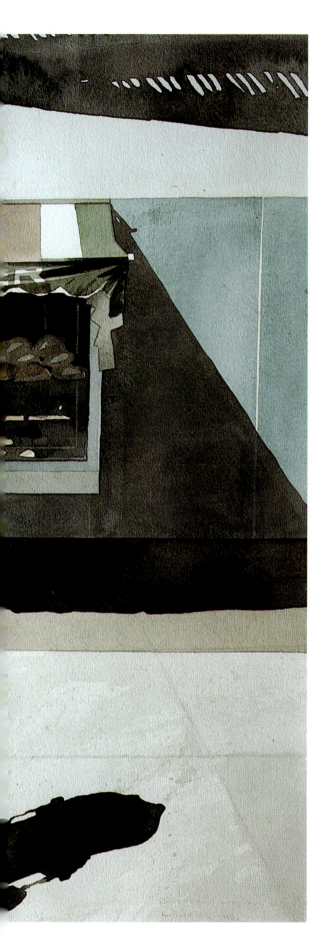

▽ **Wet on wet** *A misty morning in Venice is captured in washes of mixed greys. To achieve this hazy, undefined effect, the artist painted on to wet paper, allowing the colours to run and mix freely.*

◁ **Wet on dry** *Hard shapes and crisp details are used to depict this urban street with its picturesque bakery. The clear shapes are the result of allowing each colour to dry before applying subsequent colour.*

LAYING A WASH

Laying a wash is the most fundamental of all watercolour techniques, useful for backgrounds, skies and any other wide expanses of colour. Strangely enough, it is the one technique which seems to cause the most problems although it is actually very simple to do.

Use quality paper

Use a fairly heavy, good-quality paper. The paper will get completely saturated so anything less than 150 lb (68 kg) must be stretched. The brush must be well loaded with colour when you paint each strip,

so a large brush is essential. A standard wash brush has a round ferrule because this holds more paint than the flat variety. However, some artists get better results with a flat brush, so it is worthwhile experimenting and finding out which works best for you.

Technically you should be able to produce a flat wash which is completely even with no tidemarks or drips in the colour. However, watercolour painting rarely calls for such a pristine effect, so unless that is what you particularly want, don't worry if your wash looks a bit patchy. In any case, much of the unevenness disappears when the colour dries. Whatever happens, never tamper with the wash once it has been laid. It is always a mistake to go back and try to paint over what you have done, and you will almost certainly end up having to do the whole thing again.

Occasionally a wash can turn out rather grainy,

Laying a wash

▷1 *Mix enough colour to cover the area you are painting. Watercolour tends to get lighter as it dries, so test your colour on a sheet of paper and allow the test to dry before committing the colour to your painting.*

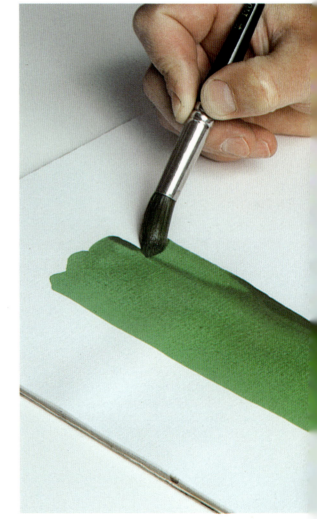

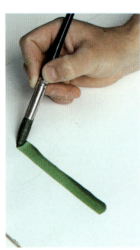

▷2 *Before starting to paint, tilt the board sufficiently to allow the colour to run slowly downwards. Load your wash brush with plenty of paint and apply the first stripe across the top half of the wash area.*

with particles of pigment floating around in the colour. Certain colours are more prone to this granular effect than others, and some blues seem particularly inclined to separate in this way. Usually the wash will look better once the paint has dried and, in any case, a few grains are rarely detrimental to the finished painting.

Tilting the board

A wash is laid in a series of broad, slightly overlapping strips. As the artist paints each new strip, surplus colour from the preceding strip is

▽ 3 *Continue with the wash, reloading the brush for each new stripe and allowing each stripe to overlap the preceding one. This allows the brush to pick up residues of colour collected on the lower edge of the preceding stripe.*

collected up with the brush. The angle of the support is all-important. It should be tilted enough for the paint to collect at the lower edge of each strip ready to picked up, but not be so steep that the colour runs down the paper in an uncontrollable way. Never attempt to lay a wash with the board placed on a flat surface.

Watercolour is soluble, so even after it has dried, there is a danger involved in laying more wet colours on top. Watercolour has a tendency to dry considerably lighter than it looks when freshly applied. So if your wash turns out to be too pale, you cannot put another wash on top of it and hope to get a flat colour. The colour beneath will be disturbed and the result will be blotchy. It is therefore important to get the right consistency in the first place. Not only must you test your colour on a separate piece of paper; you must also wait for the test to dry.

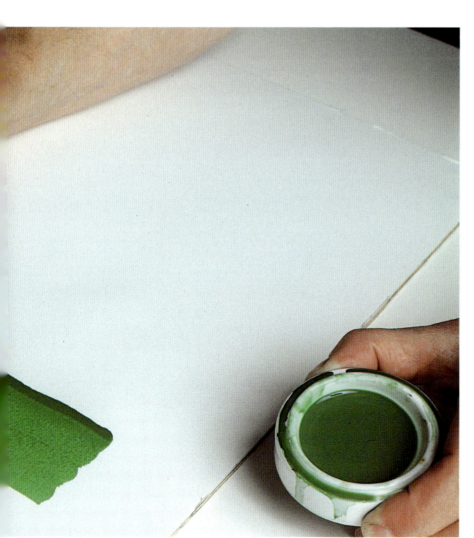

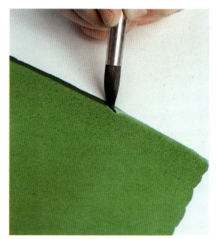

▽ 4 *When you have covered the required area, wash the brush and squeeze out excess moisture. Drag the clean brush along the bottom of the last stripe, collecting final residues which may otherwise run or dry too dark.*

The quality of the finished wash depends to a large extent on the quality of the paper, which should be heavy and good. Never be tempted to touch up or work into a wash, because this will inevitably ruin what you have done.

TECHNIQUES

GRADED WASH

A flat wash painted on to white paper is often the starting-point for a watercolour, but there are exceptions. Sometimes, a flat wash proves an unsuitable starting-point for a painting; once you have painted an even colour all over the paper, you will not obtain absolute brilliance from subsequent layers because of the universal underlying tone. You will therefore often need to lay a base colour that is less even and leaves an area of unpainted paper. In cases like this the artist will often employ what is known as a 'graded' wash.

If you are using a wash as a background to a still life, figure or landscape painting, you will often look for an effect that fades out towards the bottom half of the paper, leaving you with plenty of white space on which to develop the main subjects. For example, if you are painting a landscape and lay a bright sky colour across the whole page, it will affect the greens and other landscape colours which have to be painted over it. It is better to allow the sky colour to fade out gradually towards the horizon, so that the lower part of the paper is white enough to be painted on without affecting the colours.

The method for laying this fading, or graded, wash is almost the same as that for laying a flat wash, except that water is gradually substituted for colour as you proceed down the paper.

Laying a graded wash
▷**1** *Mix enough paint for the job, then apply a broad stroke of colour along the top of the area to be painted.*

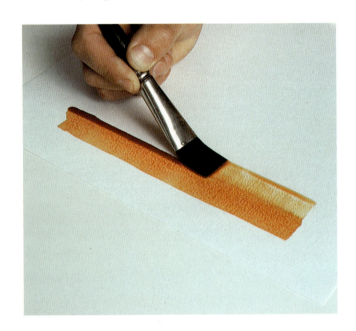

▷**2** *Working quickly, wash the brush and drain it slightly. Run the wet brush along the lower edge of the stripe.*

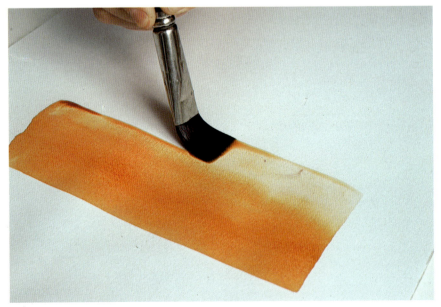

Wet wash

You might find it easier to paint a graded wash if you dampen the paper first. To do this, apply the water with a sponge – the surface should be damp, not wet – and make sure the board is tilted at an angle of at least 60 degrees. Load the brush full of colour and apply in strips, starting at the top. The damp surface absorbs the colour, which gradually loses its strength as you work down the paper.

For larger areas, an alternative way is to apply the colour with a sponge instead of a brush. Wet the sponge and squeeze out any excess water. Load it with diluted colour and apply this in slightly overlapping strips, starting at the top. As the colour gradually runs out, it becomes fainter and you are left with a graded sheet of paper.

Variegated wash

By working with more than one colour you can create a variegated wash. Do this by mixing two or more colours and overlap these across the dampened paper.

Variegated washes are highly unpredictable because the colour does not dry in even stripes but tends to form its own patterns and shapes. They can, however, be very beautiful and unusual, and can often form the basis for further painting.

▽ 3 *Again, dip the brush in clean water, drain it slightly, then pull it along the bottom of the last stripe.*

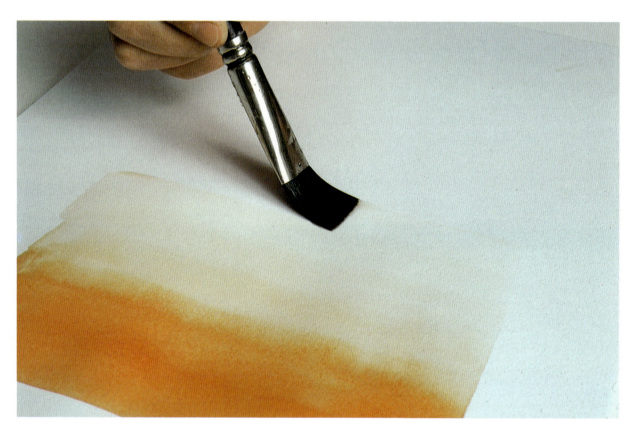

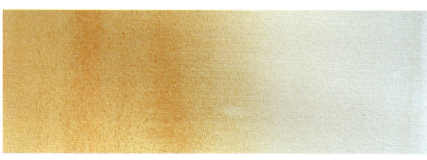

◁ 4 *Continue working in this way until the colour completely disappears or until you have covered the area required.*

TECHNIQUES

WET AND DRY EFFECTS

There are two distinct approaches to watercolour painting, each producing very different results. One involves painting on to a wet surface, either wet paper or wet paint, allowing the colour to run and form its own fluid patterns. The other involves applying the colour to a completely dry surface, so that the brushmark retains its shape.

Wet on dry
Painting on to a dry colour gives absolute control over the paint, and is perhaps the easiest approach to watercolour painting. The secret is to allow every colour to dry completely before laying other colours.

When painting on to dry colour or a sheet of dry paper, the paint sits on the surface in exactly the place you apply it. You can paint up to a drawn line with great precision, but the technique should not necessarily limit you to working precisely. You can paint 'wet on dry' very loosely with a large brush or use broad areas of overlaid and overlapping colour to create free patterns and shapes.

The transparency of watercolour means that the underlying colour will always affect the newly applied one. Yellow over red will produce orange, yellow over blue will produce green, and so on. Depending on the staining power of the colours you use – some are stronger than others – the top colour will usually dominate the underlying one. Thus red over yellow will produce a darker, more reddish orange than yellow over red.

As you do not have to wait for each colour to dry naturally, a hairdryer can speed up your work.

Wet on wet
This is the term used when colour is applied to a wet surface – to the paper, deliberately dampened to receive the paint, or to an area of wet colour. The

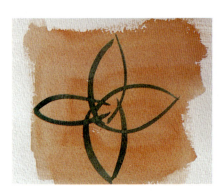

1 *Painting on to dry colour*

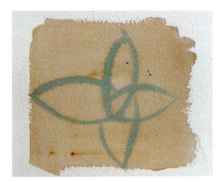

2 *Painting on slightly damp colour*

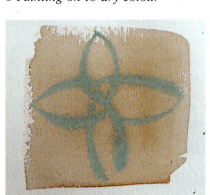

3 *Painting on to very damp colour*

4 *Painting on to wet colour*

△**Wet on wet** *Painting wet on wet produces an amorphous, watery image, slightly 'out of focus'.*

colour bleeds and runs as it comes into contact with the wet surface, giving a soft, amorphous shape.

A picture painted entirely wet on wet has no hard lines and no structured shapes. This is fine if it is particularly what you are aiming for, but such a lack of control can be rather alarming and for this reason wet on wet is usually done in selective areas of a painting. This allows the artist both to control the forms in the picture and to introduce spontaneous runs of mixed colour.

The degree of dampness of the paper is important here. Working on very wet colour allows almost no control and the colours and shapes are entirely random – although sometimes very beautiful. On the other hand, if the paper or underlying colour is just slightly damp, the painting can be fairly specific but the shapes of colour will look slightly out of focus. Practice will tell you just how damp your support should be to obtain a particular effect.

▽ **Wet on damp** *Painting onto slightly dampened paper gives control over the colour, but shapes have a soft edge.*

▽ **Wet on dry** *The same subject, painted wet on dry, is crisp with sharply defined shapes, colours and patterns.*

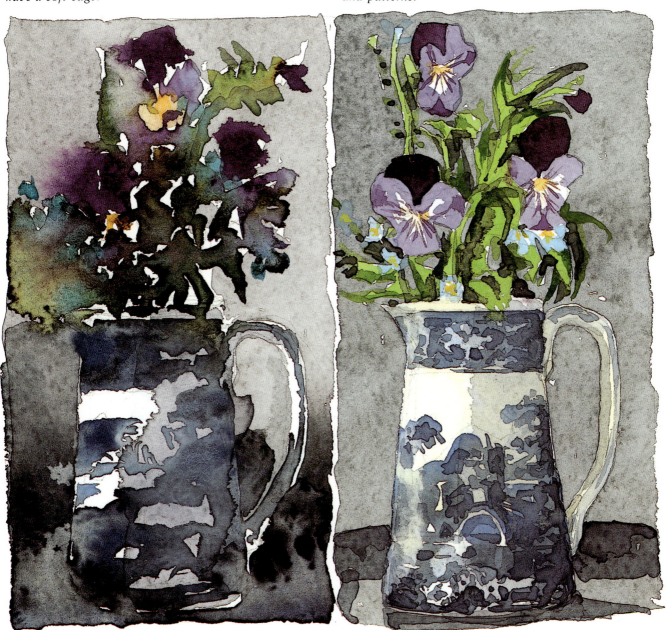

DRAWING FOR PAINTING

Before you can start painting, you will generally have to make a drawing of the subject. This does not have to be complicated – indeed, the simplest of outlines usually produces the best results – but it does have to be accurate. The drawing must also contain enough information to act as a guide once you start painting.

When planning your painting, try to leave a broad margin of paper around the proposed picture area. This gives you the opportunity to change the composition and size of the painting even after you have drawn the subject.

For instance, if you mark out the rectangular shape of your painting lightly in pencil but then decide the subject looks cramped, you can make the picture larger by simply redrawing the edges. Conversely – and this is a far more common mistake – you might decide your subject is too small in relation to the picture size. In this case, you can crop the picture to make the composition more compact.

Pencil drawing

Drawing for watercolour is traditionally done with graphite pencil. This is probably still the most popular method because the lines can be drawn so

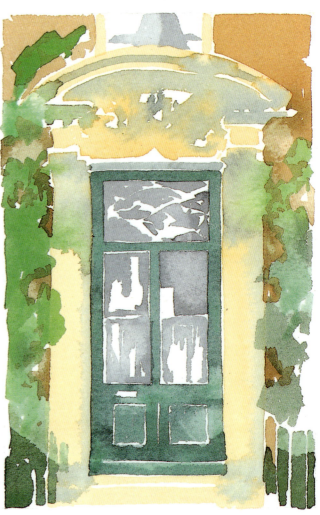

△**Watercolour** *Colour is sometimes applied without a preliminary drawing.*

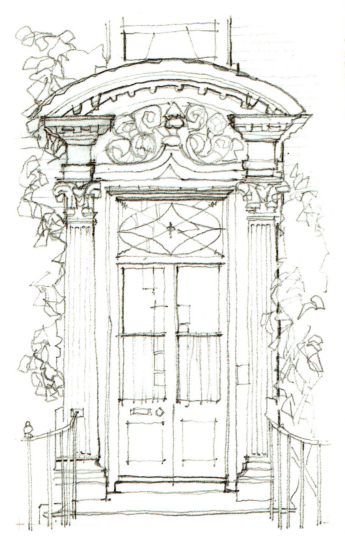

◁**Pencil** *Soft pencil lines can be erased when the painting is complete.*

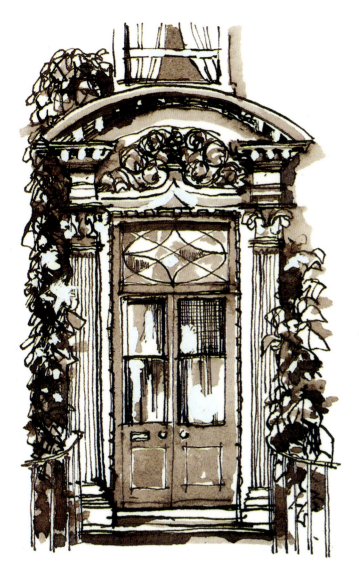

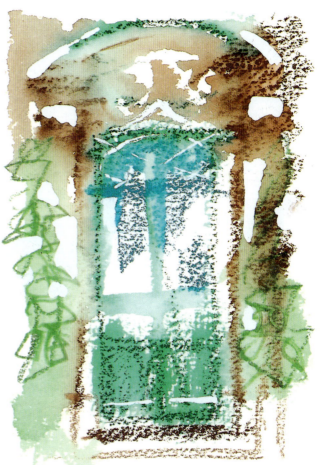

▽ **Resist** *Wax crayon resists a subsequent watercolour to give a textural effect.*

△ **Pen and wash** *Traditional dip pen and ink work well with watercolour wash.*

lightly they do not show through the paint, or at least they can be rubbed out. Many artists find it difficult to make an accurate drawing that is also simple enough for watercolour, but using pencil enables you to make a lot of lines, and to redraw and correct mistakes. You can rub out all but the essential lines before starting to paint. For this reason, the newcomer to watercolour will find pencil a sympathetic drawing medium.

Positive outlines

Another way of working is to be deliberately bold with the outlines, incorporating them into the painting and even making a feature of them. For

instance, pen and wash has been a favourite with painters and illustrators for centuries. In this case, the drawing is usually in waterproof ink, often brown or sepia, and colours and tones are washed in lightly with watercolour after the ink has dried.

Some artists begin by making a drawing with the paint itself. This can be done very lightly in the local colours of the subject, so that the outlines eventually become blended into the rest of the painting or you can use one colour for the whole drawing, painting the outlines quite boldly so that they become a unifying feature in the finished painting.

A similar effect can be achieved with coloured pencils or even wax crayons. Again, you can use lots of colours in the one painting, or you can pick one colour and make this into a feature. Crayons, coloured pencils and other chunky drawing materials also lend a contrasting texture.

61

INTERIORS

Wet and dry

An interior often looks complicated, but it is usually easier to paint than most subjects, provided you tackle it in a systematic way. This room is typical of many, with furniture, ornaments, prints and patterns. It all looks much more difficult than it really is. When confronted with such a subject, do as the artist does in this painting: block in the main shapes and simplify the patterns to give an approximation.

Blocking in

The term 'blocking in' describes the early stages of a painting, when the main shapes are established. Before detail is added, these areas should be painted so that they are approximately the right colour and tone in relation to each other. It is often helpful to look at the subject through half-closed eyes, eliminating detail and enabling you to see the overall colour.

Watercolour tends to lighten as it dries, so in this painting each blocked-in area is allowed to dry thoroughly before adjoining areas are painted. This not only establishes the tones in relation to each other but also ensures that the paint does not run and spoil the hard edges of the blocked-in shapes.

If the blocked-in colour is too flat in the early stages, it can make for a boring picture, so use different thicknesses of paint to suggest shadows or colour variations. Notice how the reflections on the lacquered cabinet are painted as loose, washy patches compared with the deeper local colour.

Wet on wet

Large areas, such as the pink wall, are blocked in with a wash. Here the wallpaper has a large, pale, floral design which affects the overall tone of the wall, so the wet paint is dabbed with a sponge to give a general impression of the pattern.

The curtain, flowers and other selected areas are painted wet on wet, a fluid approach that counteracts the tighter painting of the blocking-in stages.

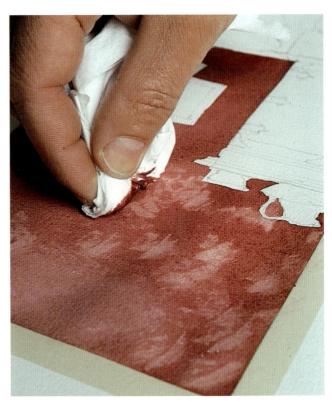

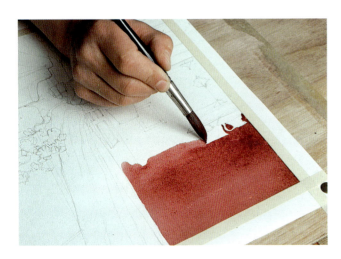

△1 *Having decided which section of the room to include in the picture, the artist starts by making a light line drawing with a 2B pencil. Working from a palette of cadmium red, cobalt violet, Payne's grey, cobalt blue, lemon yellow, burnt sienna, alizarin crimson, black and rose madder, the artist applies a flat wash to the main wall with a mixture of alizarin crimson and black.*

2 *The large floral pattern on the wall is suggested rather than painted, and the artist creates an overall effect by dabbing the wet colour with a tissue.*

◁4 *The chair is painted in Payne's grey mixed with cobalt blue and a little lemon. For the surrounding shadow, the artist adds Payne's grey to the pink wallpaper colour.*

△3 *When the red is completely dry, the adjoining curtain is painted with a thin grey wash. The wet paint is then dabbed off with tissue to indicate where the light falls from the window.*

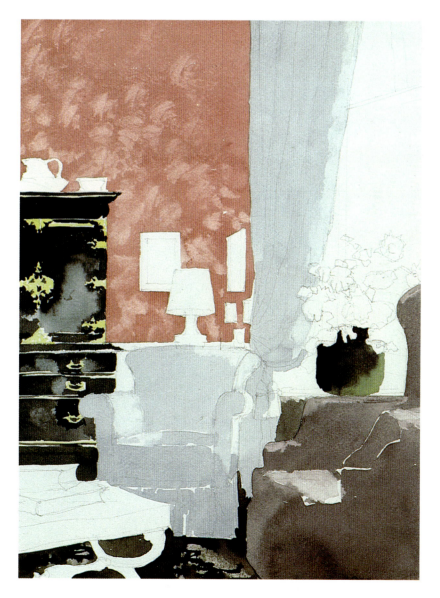

▷5 *Furniture, floor and walls have been partially blocked in as shapes of colour and tone. Yet space and form are suggested in the way the colour is applied. The chairs look solid and real because surfaces which catch the light are left white or very pale. Similarly, the cabinet is painted in black on to wet paper with large patches left white to indicate the glossy reflections.*

▽ 6 *Bright-orange flowers are painted on to damp foliage, encouraging the colours to merge and blend on the paper.*

△ 7 *The curtain pattern is painted, first in broad grey stripes and then, while the paint is still wet, with patterns in red and blue. Again, the colours are encouraged to run and create their own shapes.*

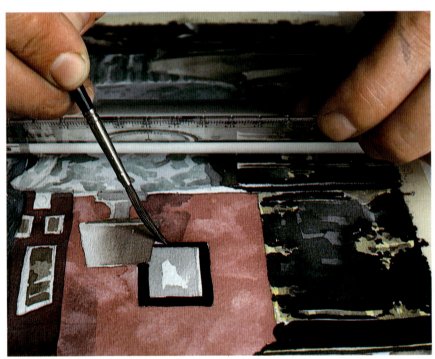

▽ 8 *The picture is nearing completion, with the main areas now blocked in. Patterns on the chairs, wall and curtain are not painted specifically, but are suggested to give an impression of the overall effect.*

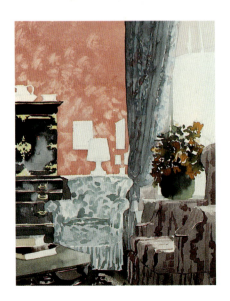

△ 9 *Smaller objects are added, wet on dry. Here the artist paints a picture frame in dark grey, taking care that the tones blend with those already established elsewhere in the painting.*

▷ 10 *The completed picture looks far more complicated than it really is. Viewed from close quarters, there is very little real detail in the painting. Yet seen as a whole, it looks remarkably realistic, with blobs of runny colours creating an illusion of printed fabrics and flowers.*

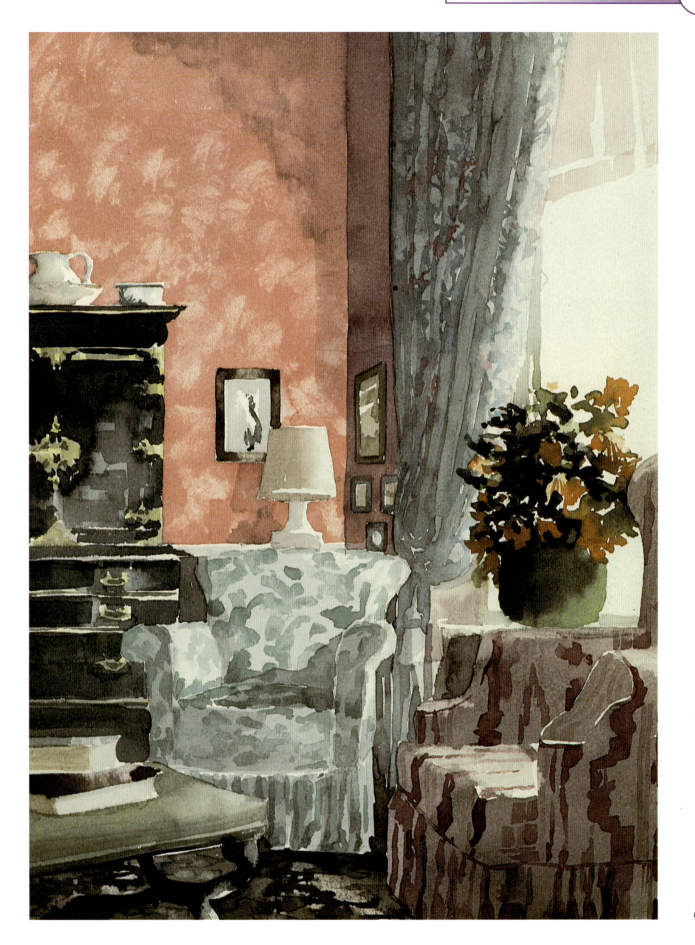

Basics plus . . .

●

ONE OF THE most encouraging aspects of watercolour painting is that most of the techniques can be learned and, once learned, they can thereafter be improved with practice.

It is comforting to realize that while some artists are indisputably more able than others, their ability often lies in a particular direction. A great number of eminent artists have had to work extremely hard to correct a particular weakness or bridge a gap in their artistic abilities. For instance, one painter may be a natural colourist but weak on drawing, while another will be good at drawing but have a poor sense of tone, and so on.

The classical approach to watercolour is to work from light to dark. This is the logical way to work when painting with transparent watercolours, and once understood and mastered, the technique will come easily and automatically.

Often, but by no means always, it is the colour of a particular subject which first attracts. Tones and colour temperature come later, when we start to paint. Again, recognizing and using these elements in your paintings are good professional habits which can be developed with practice, if you begin by consciously noting warms and cools.

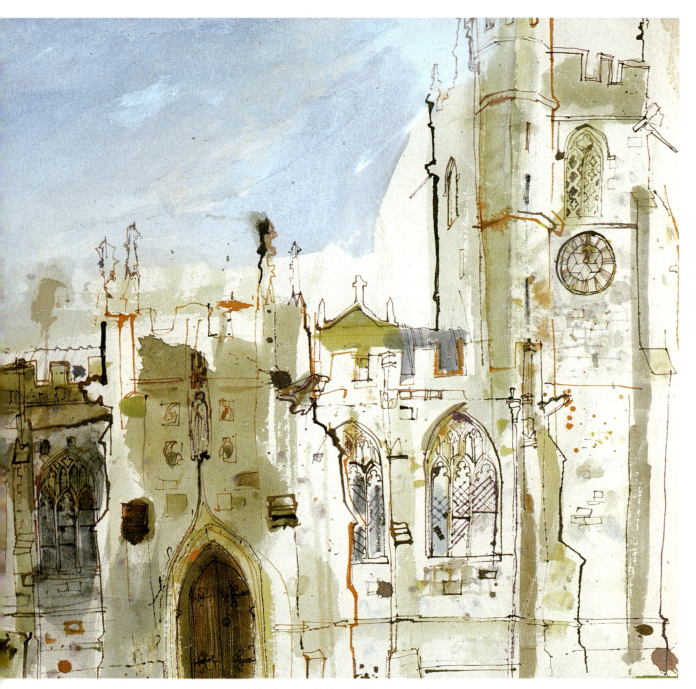

Dark over light *This watercolour and mixed-media painting of a cathedral is built up with overlaid colour and dark outlines. The resulting empty white spaces play an important part in the composition, emphasizing both the loose, jagged style of the drawing and the patches of coloured wash.*

TECHNIQUES

DARK OVER LIGHT

Painting in watercolours calls for a particular way of thinking – a sort of planning in reverse. The paint is transparent, so you cannot cover anything up once it has been painted. This is one of the most difficult concepts to grasp when you embark upon watercolours.

Perhaps many people are confused at first because they began, from school age, with powder paints, which are opaque. As with oil paints, you may have become used to covering up and hiding parts of the painting with new layers. Painting a

Building up layers *This landscape shows four distinct stages of watercolour, working from light to dark.*

▽**1** *The first is pale washes, representing the palest areas. Highlights are left as patches of white paper.*

highlight, or reflection, with opaque paints is a relatively simple matter of blobbing on some white paint. But with transparent watercolours, you cannot do this. You must know from the outset where the highlights are going to be, and leave these as patches of white paper. However, once you have grasped this basic principle, the back-to-front approach will become automatic.

The principle means always working from light to dark. You have to think in advance where the lightest areas are and paint those first.

White as a last resort

One of the great charms of watercolour lies in its transparency, and if you have to use a lot of white paint to re-establish highlights and pale areas that have become lost in the painting, you inevitably lose the transparent quality of the medium. Those with traditional, purist attitudes to watercolour painting tend to frown on the use of white paint or any other opaque white for this reason. Taken literally, this means that if you forget to leave the light areas light and the white areas white then you are stuck with the mistake and cannot correct it.

▽**2** *At this stage, the artist knows exactly where the pale areas will be in the final painting and avoids touching these when applying medium tones which include certain shadows and darker stonework areas.*

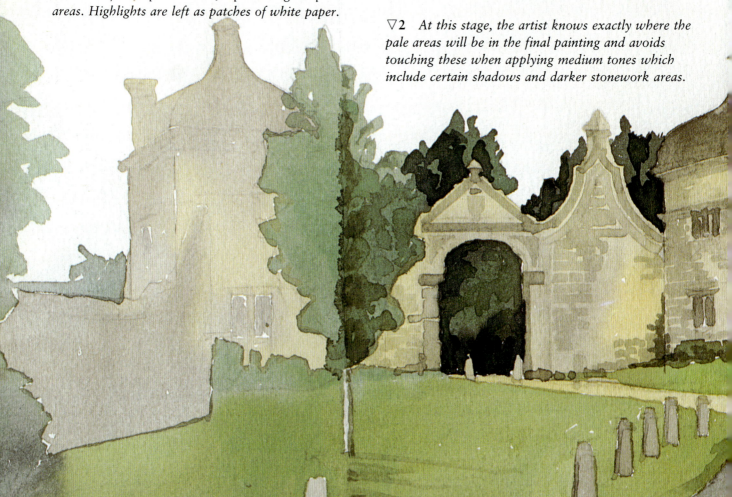

Adding water

Ideally, you should not have to use white paint at all. Pale and pastel colours are mixed by simply adding more and more water. Thus pink is diluted red, light green is diluted green, and so on. Mixed in this way, the colours remain transparent, whereas added white makes them opaque and chalky.

Obviously a rigid attitude is counterproductive, and in reality even the most experienced water-colour painters occasionally resort to touching up and masking out with white. But too much white does detract from the quality of the painting and you should aim to use it as little as possible.

Broadly speaking, the procedure is this. You should work out where the white areas and highlights are and leave these as patches of white paper. Next, apply the very lightest tones across the rest of the painting. Paint the medium tones into the light tones, and finally add the darkest tones.

▽3 *Next, selected deep tones are laid and allowed to dry. Again, the pales and mediums are left untouched as the artist paints in some of the deeper shadows.*

▽4 *Finally, the artist simultaneously adds the darkest areas to every part of the picture, bringing together the separate elements – the stonework, grass, trees and road. Any colour or tone that is too light or too dark in relation to its neighbour is corrected at this stage.*

PROJECTS

NARCISSI

Light to dark

When watercolour is painted directly on to white paper the white glows through, making the colours much brighter than they would be if they were painted over another colour. Even the palest tinted paper can destroy this characteristic glow, and this is why true watercolour supports are always white or nearly white.

The translucent petals and leaves of flowers, a traditional favourite with watercolour artists, make them the perfect subject for the vivid and shimmering effect of transparent paint over a bright-white paper.

The background

The artist wanted a dark background yet with bright flowers and leaves, so a background wash was painted around the shape of the subject, leaving the white paper on which to paint the flowers and vase later.

When painting around a subject like this, you must work quickly to prevent the colour drying in

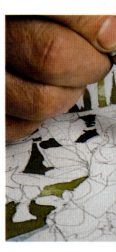

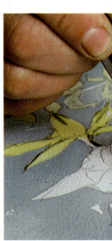

△2 *Because the artist worked quickly when he was laying the background, the colouring is reasonably even. The grey wash is taken right up to the drawn outline, leaving the flowers and vase as a white shape ready to receive colour.*

obvious tide-marks. Keep the paint moving as you go around the outline. The colour probably won't dry completely flat, but this does not usually matter.

Flowers and leaves

Two basic techniques are employed: wet on dry, to establish the delicate but crisp shapes of the leaves, stems and petals, and wet on wet, for the softer patches of colour within the flowers themselves.

All the colours are painted from light to dark, in the classical watercolour manner. The palest greens of the foliage and the lightest yellow of the narcissi are blocked in first, and then the image is built up gradually from light to dark.

Most of the work is done with a Number 6 round brush. The artist likes to simplify life by using as few brushes as possible and finds a medium-sized round is the most flexible. Its size is good for painting large areas, and the bristles can be shaped into a point and used for fine, linear work.

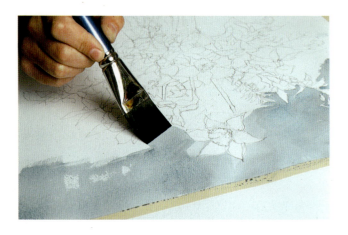

△1 *This flower subject was painted from a palette of cerulean, cobalt blue, burnt umber, raw umber, cadmium red, lemon yellow, viridian and Payne's grey. The artist starts with a light pencil drawing, and then blocks in the background with a wash mixed from Payne's grey and a little cerulean.*

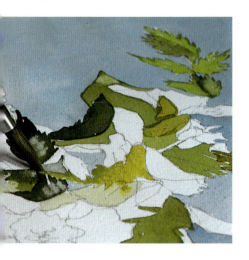

▷3 *The light foliage tones are painted in a mixture of cobalt blue, Payne's grey and lemon; medium tones are the same colour with added Payne's grey and a little cadmium red. Using variations of the basic colour mixtures, the artist continues to block in and develop the leaves and stems. Darker shapes in the foliage are created by overlaying various tones of green. Colour is allowed to dry between stages, and subsequent paint is applied wet on dry.*

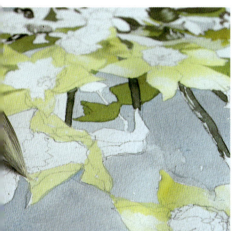

▷4 *Except for a few very dark areas, the greens are now virtually complete – the lightest, a pale greenish yellow; the darkest, almost grey. Note how the artist has simplifed a complex mass of foliage and stems into three or four basic colours, choosing the appropriate one for each area.*

▷5 *The narcissi are blocked in with a pale wash of diluted lemon yellow mixed with a touch of Payne's grey.*

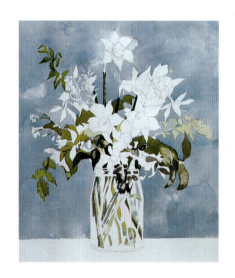

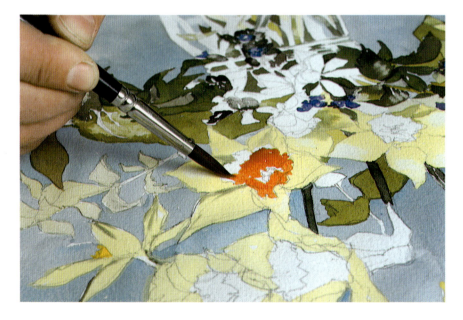

▷6 *When the yellow is completely dry, the bright-orange centres are blocked in with a mixture of lemon yellow and cadmium red.*

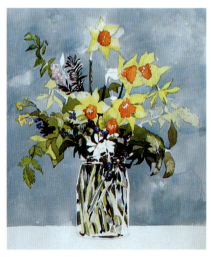

▷7 *So far most of the subject has been established. Certain areas, such as the leaves, are nearly complete; other parts, including the narcissi and blue flowers, have been blocked in and await development.*

71

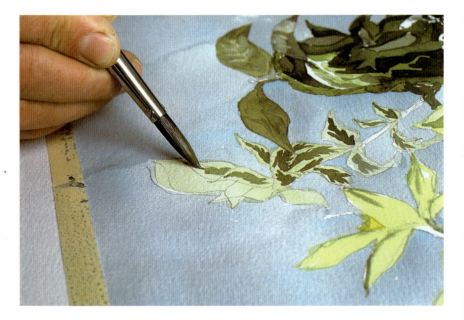

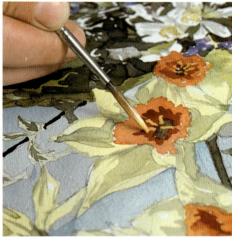

△8 *Before proceeding further with the flowers, the artist adds some final dark tones to the foliage. Here, the deep-green shapes on the variegated leaves are being defined.*

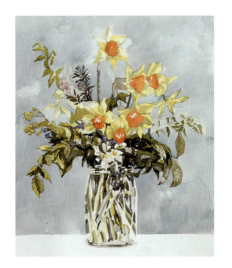

▷9 *Working from light to dark, in the classical watercolour manner, the artist has developed the darker tones of the flowers; grey shadows are painted on to the yellow petals of the narcissi, and deep shadows worked into the smaller blue flowers.*

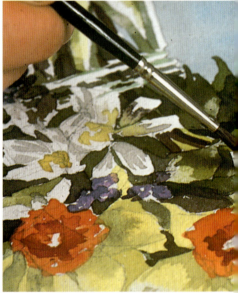

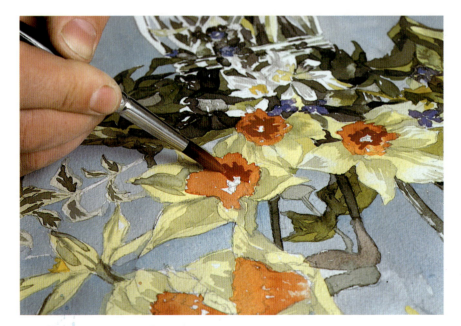

▷10 *Dark-orange shadows help to describe the trumpet forms of the narcissi centres. This is mixed from the former orange with added cadmium red.*

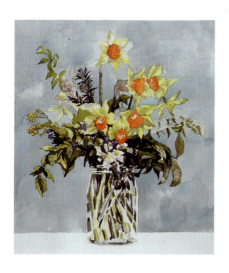

◁ **12** *The flower centres are much paler than their orange backgrounds, so the artist adds Chinese white with a little of the orange flower mixture to produce a pale, opaque colour. The point of the brush is used to apply these details to the centre of each narcissus.*

△ **13** *The flowers and foliage are now complete, and the painting is almost finished. Even at this late stage, the absence of any background shadow makes the painting look rather flat.*

△ **11** *The painting is almost complete, and the artist allows the colours to dry before adding the finishing touches.*

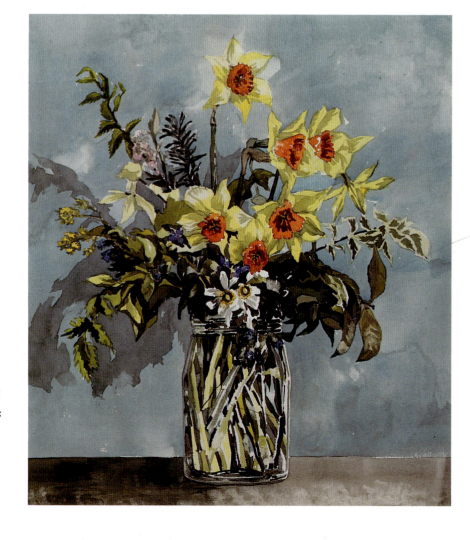

▷**14** *Finally, the strong background shadow of the vase and its contents is blocked in. This shadow defines the depth of space behind the subject, so bringing the subject to life by placing it in three-dimensional space.*

Texture and landscape

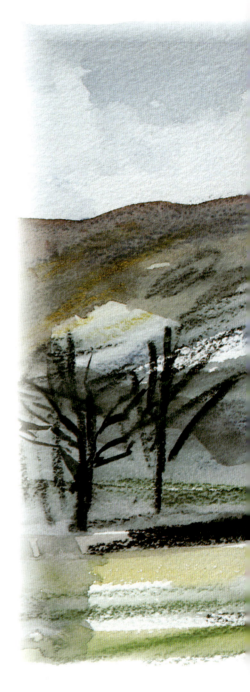

T HE WORLD and its landscapes are made up of textures and patterns so familar that we often don't notice them until we try to paint them. The notion that flickering light, crumbling concrete, dry stone, foliage, bark, reflective water surfaces and a million other diverse effects can be captured with mere paint and paintbrush seems remarkable. But it can be done.

For the watercolourist, the secret is to simplify. Look at what is in front of you and think how a similar effect can be created with the tools available. The following pages give a few ideas; the rest is a question of experiment.

Most watercolour textures have a literal use, but they can also be applied imaginatively to less obvious subjects. Spattering, for example, as the artist demonstrates on page 95, can also be used to give the impression of shingle, sand, pebbledash and even wild flowers in a field. Random runs of colour that often happen accidentally look exactly like marble and can be used as such, but a two-tone mottled texture can also represent the reflections of a wet surface or the flickering lights and darks of leaves moving in the breeze.

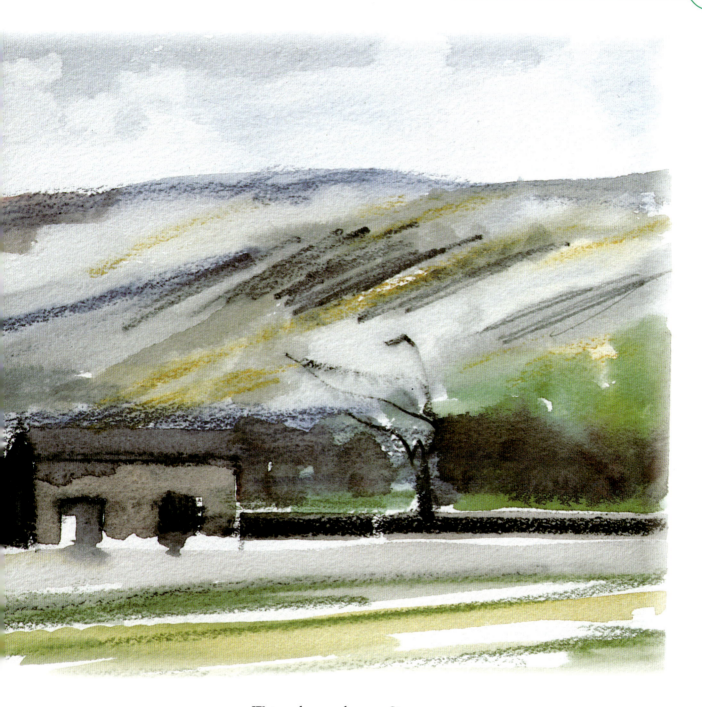

Watercolour and wax *Strong directional brushstrokes are combined with pastel and wax crayon to create this bleak, windswept landscape. Much of the texture is the result of the wax crayon resisting the paint.*

TECHNIQUES

TEXTURE MAKING

Apart from the tide-marks and colour variations that can occur spontaneously, there is remarkably little texture in many watercolours. Unlike oil paintings, which often have a rugged surface made with thickly applied paint, watercolour has little actual surface texture. Generally, this does not matter because we choose watercolour for its other qualities – its glowing colour, its transparency and the beautiful and accidental effects of painting wet on wet.

Occasionally, however, you might want to introduce a few textural effects into your picture, either to depict a pattern or texture in the actual subject, or to enliven the picture surface, and it is useful to have a few tricks at your fingertips.

A porous brick wall, a rendered building, a pebble beach – all these have surfaces that are difficult to portray in washes of watercolour. They call for special treatments, for surface textures that will give an impression of the real surfaces.

Creative texturing
The secret of successful texture-making is to be selective. It is how and where you use the technique

Wax crayon
△1 *Draw on to the paper with wax crayon. Use either the tip or broad side of the crayon, depending on the texture you want.*

▷2 *When watercolour is applied over the drawing, the wax resists the paint and the textured drawing shows through the colour.*

Spatter painting
△1 *Dip the tips of a toothbrush into the mixed paint. Hold the brush above the paper and spatter the colour by pulling your finger backwards across the bristles.*

▷2 *Spattering can be built up in layers, and there is no real limit to the amount of colours you use.*

in the painting that are important, rather than how accomplished you are at the technique itself. For instance, it is not difficult to get a speckled effect by spattering the paint. However, the ability to apply the spattering as the artist does in the painting of a rough sea on page 95, aimed at achieving exactly the effect of foaming sea spray, requires both imagination and considerable restraint.

Wax 'resist' is good for breaking up and adding interest to large areas of colour. This effect relies on the principle that water and wax do not mix. So, if you paint over marks made with wax crayons or even a domestic candle, the wax will resist the wet paint and show through the colour. You can make lines with the wax or, alternatively, you can create areas of texture by scribbling or by using the broad side of the crayon or candle. Note that the colour of

the wax crayon will show through the paint, whereas if you use a white wax candle, it is the colour of the paper underneath the paint that shows through.

Another time-honoured technique, popular with many of the early watercolourists, is 'drybrush'. Here, the artist squeezes most of the wet colour out of the bristles before dragging the semi-dry brush across the surface of the paper. The starved bristles catch on the rough surface of the paper, producing a broken, scratchy effect through which the white paper is clearly visible. The coarser the paper, the more effective the texture.

Dry brush

◁1 *Dip the tips of a dry or almost-dry brush in the colour. Spread the bristles with your thumb, then drag the brush across the paper.*

▽2 *Depending on the texture required, dry brush can be applied criss-cross or in short, directional strokes. You can also use two or more colours on top of each other.*

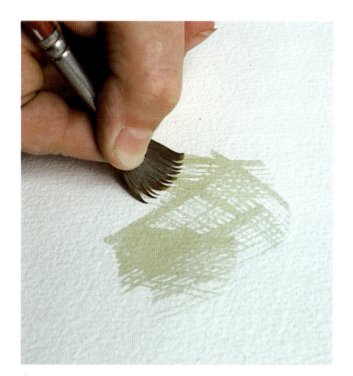

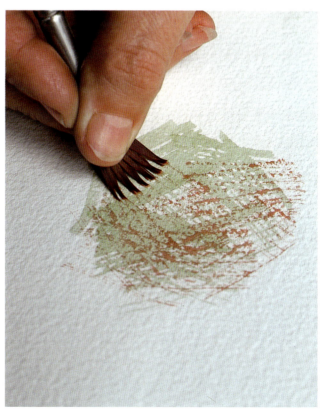

TECHNIQUES

CREATING WHITE

All white paints are opaque, and if you mix white with any other watercolour you will get a pale but chalky colour which is not transparent. Traditionalists do not approve of the addition of white paint to watercolours for this very reason, because it interferes with the transparency of the colours. But there is a lot of white in any subject – if you were painting with oils or acrylics, for instance, you would use more white than any other colour – so whites have to be created in some other way.

We have already seen how the whiteness of the paper can be used instead of white paint, both for white areas and highlights, and to create pale colours. But there will inevitably be times when you will want to add white in the later stages of a painting, either to correct a mistake or because you want to sharpen the shapes or to add details.

There are various ways of introducing white into a watercolour painting. For small areas you can use white paint. The classic watercolour pigment is Chinese white, and this is the one to use if you really have to mix a pale colour in order to cover another colour. It can also be used for touching up and spotting out smudges and mistakes. White gouache is more opaque and very good for touching

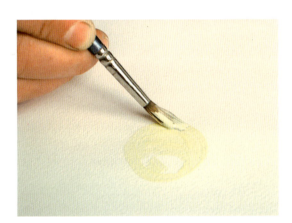

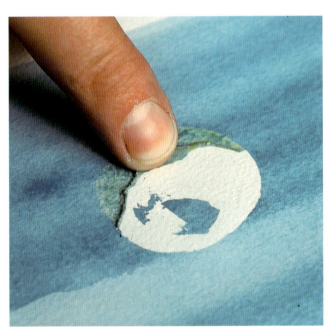

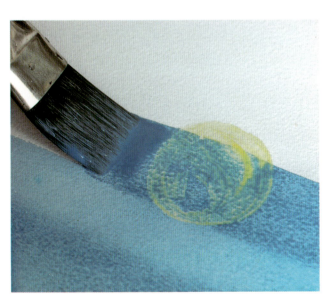

Masking fluid

◁△**1** *Paint the masking fluid over the areas you want to remain white (use an old brush, because the rubbery solution can ruin the bristles).*

◁**2** *Allow the masking fluid to dry thoroughly, then apply colour over the masked area.*

△**3** *When the paint has dried, remove the masking fluid by rubbing with your finger or a clean eraser.*

up, but it should never be mixed with watercolour to create a lighter tone of a colour because this really does deaden the quality of the paint.

Masking fluid

If you know from the outset that you want hard shapes of white in the final painting, then masking fluid is perhaps the best way of achieving this, because it protects the paper however much colour you paint over it. The dried fluid is easily removed when the final paint is dry. Masking fluid takes a little getting used to. It leaves a very stark shape when it is removed. You may have been painting the rest of the picture, carefully gauging the tones, and then be surprised at the glaring whiteness when

you rub away the masked areas. Also, masking fluid is better on smaller than larger areas.

Other techniques

Otherwise, cotton buds or tissue can be used to soak up wet colour to give you patches of white with blurred edges – useful for soft textures and marbled or mottled effects. Another way is to paint household bleach on to an area of dried paint, but pigments with a particularly strong staining power resist the bleach and become paler rather than disappearing. To make white lines and sharper textures, you can scratch through dried paint with a scalpel or other sharp instrument to reveal the white paper underneath.

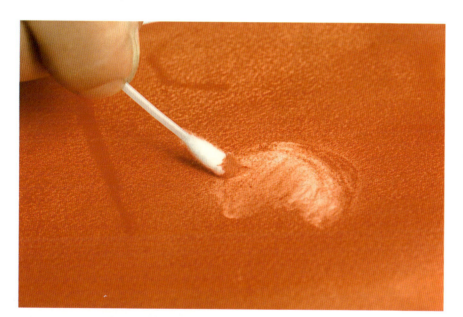

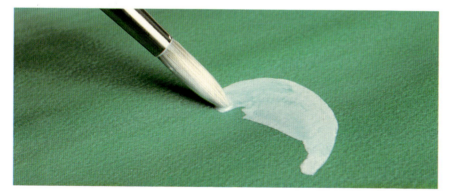

Blotting

◁1 *Wet colour can be absorbed with a cotton bud or by dabbing with tissue.*

▽2 *The resulting patches will be white or pale depending on the strength of the colour you are blotting.*

White paint

△1 *For touching up small areas, the best way to create white is to use paint. Gouache, poster colour,* process white and Chinese white watercolour are all suitable, although the watercolour white is less opaque than the others.

△2 *One coat of white is generally sufficient to cover a pale colour; otherwise you may need a second application.*

79

PROJECTS

SKY AND CLOUDS

Look carefully at a bright blue sky, and you will see that the colour is not flat and even but varies considerably, getting lighter as it goes down towards the horizon. You can test this by holding a sheet of white paper up to a cluster of white clouds; you will realize that the clouds are not actually white at all; but are a blurred mass of light greys, yellows and other pale colours.

A cloud with the sun directly behind it has a stark, sharply defined edge, but otherwise clouds are soft and amorphous without any clear shape. They have depth and density but no outline.

Graded colour

For the watercolour artist, this makes skies and clouds very paintable indeed, because working wet on wet naturally produces effects which capture exactly the graded colour of a clear summer sky or the soft, voluminous quality of cloud formations. Night skies are obviously darker, and the light comes from the moon instead of the sun, but the approach is exactly the same. Again, the sky becomes lighter towards the horizon, which at night is often tinted with the orange background glow of neighbouring cities.

Soft outlines

Every sky is different, so look carefully before starting to paint. Although clouds are generally undefined, some are clearer than others. Remember, the wetter the paper, the less definition you will get. Once you have applied the broad shapes, allow the colours to find their own shape on the damp paper.

Overcast sky

▷ **1** *An overcast sky can be painted using just Payne's grey and water. Start by applying the diluted paint. Allow the grey to form dark blotches in some areas, and leave occasional patches of white paper in others.*

You can spoil the effect by overworking. If you prefer working on to a dry support, an alternative method is to apply colour and then quickly soften the hard shapes with clean water before the paint dries.

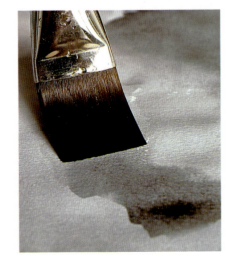

The best skies are painted very quickly. The more you work them, the less convincing they become. Big brushes and spontaneous strokes of colour are more appropriate than meticulous rendering.

◁**4** *Do not overwork the paint. With landscape pictures, it is usually best to paint the sky first. Other colours and tones can then be related to this important element.*

◁**2** *Soften the brushmarks and any hard edges by dabbing with a tissue.*

▷**3** *While the paint is still wet, work more colour into the dark areas and soften the edges by blotting with a tissue.*

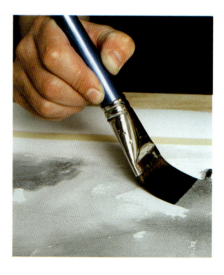

Cloudy sky

▷ **1** *The sky is painted with a mixture of cerulean and cobalt blue, applied with a large, round brush. Paint loosely and quickly, without going back to tidy up the shapes.*

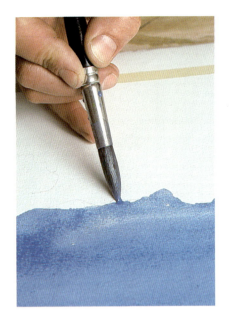

▽ **2** *Load the brush with clean water and flood the edges of the wet blue to soften the shape.*

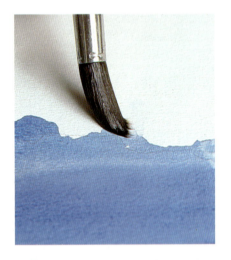

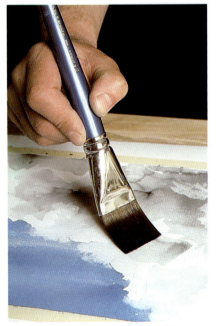

△ **3** *Work into the white clouds with diluted Payne's grey, allowing the colour to form soft, irregular shapes. Use a tissue to soften the strokes and remove excess colour.*

◁ **4** *Apply more of the diluted Payne's grey, concentrating on the underside of the clouds. Again, excess paint can be softened by blotting with a tissue.*

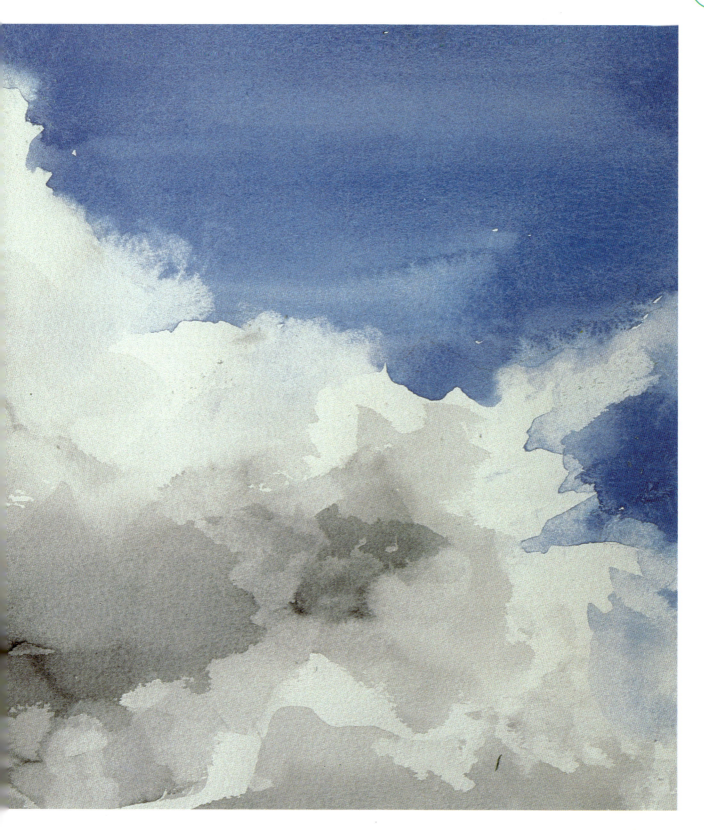

△5 *By varying colours and shapes,*
you can apply this basic formula to
any type of sky, including night
skies. On no account try to rework
or improve on the finished sky.

TREES IN SUMMER AND WINTER

Masses of foliage and tiny branches look daunting, but if you use a big brush and ignore the thousands of leaves and tiny branches, trees are no more difficult to paint than anything else. If you half-close your eyes, this will help block out these details, and you will see only main areas of light and dark colour.

Trees with foliage

Don't make trees too green. Greens in nature usually contain a lot of ochres, blues and yellows, so it is generally better to mix some of the greens from these colours rather than to start with a pre-mixed green that is too bright for the subject. Autumn colours are easier because they are generally a mixture of warm rusts, browns, yellows and pinks.

Start by painting the blocks of light tones very broadly, working mid and dark tones into this while the colour is still damp. Unless you are painting certain evergreens with a fairly dense form, trees are rarely solid but have patches of sky or background colour between the blocks of foliage.

The trunk is often similar in tone and colour to the foliage. Trunks usually have a green or grey appearance, so avoid the common mistake of painting them a conspicuous dark brown. A trunk in the shadow of the leaves is often dark and nearly invisible, and can be seen only where the light falls on it.

Trees in winter

In winter, deciduous trees become leafless skeletons of twigs and branches and your approach will obviously be different. Work on to dry background colour and choose your brushes carefully. Here, the

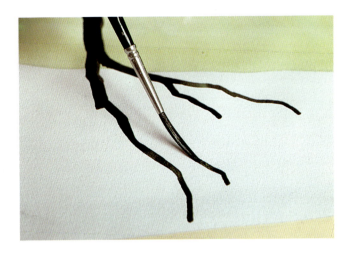

Winter trees
△1 *The artist started by painting the background in simple washes of blue and green and allowed these to dry. When painting winter trees against a coloured background, always start with the background – it is virtually impossible to add this once the trees are painted. The tree trunk is painted with a flat brush, the smaller branches added with a round and a rigger.*

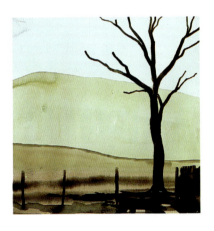

△2 *The tree trunk and larger branches are now established. When painting and drawing trees it is important to remember that the trunk, branches and twigs taper as they grow – in other words, all the shapes get thinner.*

artist uses a flat brush for the trunk, a medium-sized round for the branches and a rigger for the small, tapering branches.

Winter trees often look like silhouettes, but they never appear completely flat. They are three-dimensional. Branches radiate at different angles. The trunk and larger branches contain different tones, often with highlights and reflections.

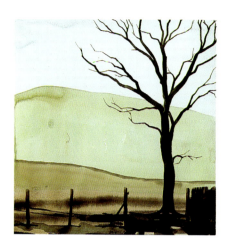

△3 *Smaller branches have been painted with a rigger, the long, thin bristles allowing the artist to taper each twig to a point.*

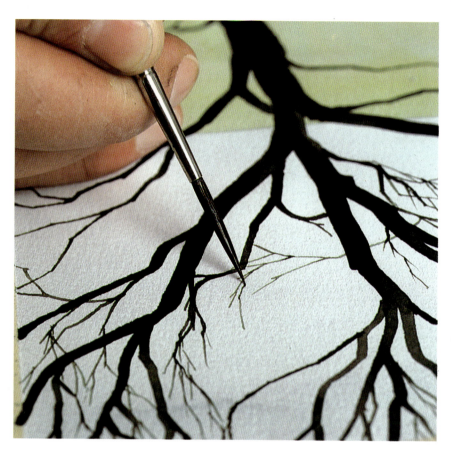

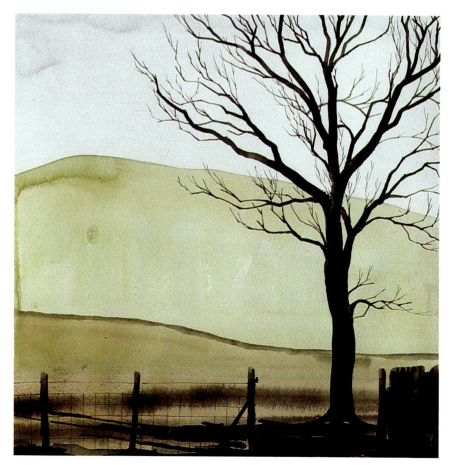

△4 *Still working with the rigger, the artist adds the finest twigs. These are painted in a diluted version of the main tree colour and, again, each twig dwindles to a point and fades out.*

◁5 *A tree is usually painted in context – in this case, it is part of a simple landscape. Notice how the tone of the tree relates to the darker areas of its surroundings, thus avoiding the common mistake of making trees too prominent.*

85

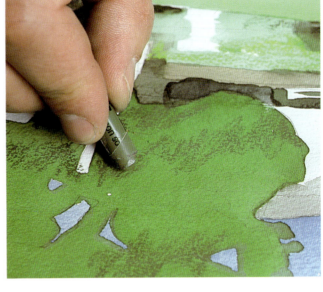

Trees with foliage

△1 *Before starting to paint, the artist makes a simple pencil drawing, plotting the position and outline of the main shapes. Wax crayon is then applied to selected areas. The crayon resists subsequent overpainting, adding a textural variety into the finished painting.*

▷ 2 *Various shades of Hooker's green are applied to the main tree shapes. The artist takes the colour washes right up to the edge of the light blue sky.*

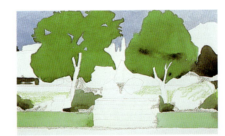

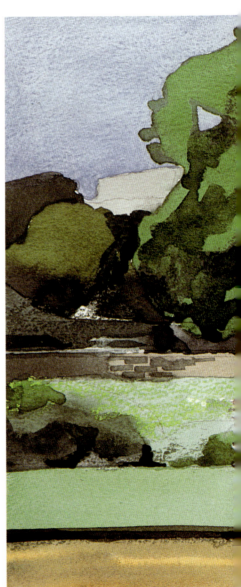

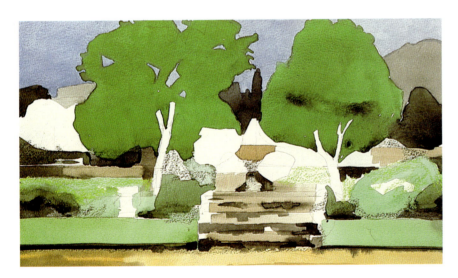

△3 *Grass and the first pale foliage colours are blocked in as flat shapes. The greens in the paintings are mixed mainly from viridian and Hooker's green – dark and light. A touch of cerulean blue is added to make the blue-greens, and cadmium orange for the warmer greens.*

◁ 4 *Here the artist uses wax crayon on top of the flat, dry watercolour to create a foliage-like texture.*

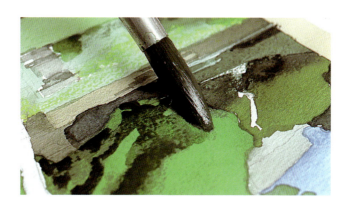

▷ 5 *Finally, the dark tones are painted into the pale tree shapes. Here, the underside of one of the main trees is applied wet on dry.*

▽ 6 *Although green is the dominant colour here, the mixtures are varied enough to make the subject interesting. The wax crayon shows through in certain places, interrupting washes of watercolour with patches of broken texture.*

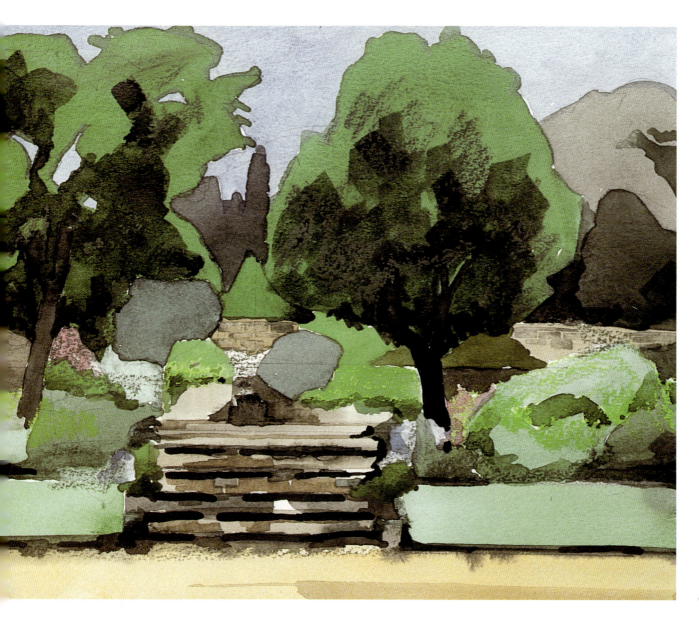

PROJECTS

WATER: REFLECTIONS

Water, of course, is fluid and this means it can generally be painted as such, by allowing the wet colours to flow and merge on the paper. Reflections, however, usually have quite definite shapes. They often have sharp edges, especially in bright sunlight, and these call for a different approach.

Reflected shapes

Water is seldom absolutely calm, so the reflections are constantly moving and changing, and this can make them quite difficult to see. It is much easier to paint water from a photograph because this gives you the opportunity to study and copy the characteristic shapes of light and colour that flicker fleetingly on the surface. However, there is a danger in this, especially if you make a habit of painting

from photographs. The paintings can look rather static and tend to lack the freshness of work done by observation of the actual subject. Use photographs for general guidance, to find out how the surface of moving water looks at any given moment in time. Then put the pictures aside and concentrate on the real thing.

Either leave the highlights on the reflected shapes as patches of white paper or use masking fluid to block out the colour. Reflections often have one hard edge and one blurred edge, depending on the direction of the light, so eventually you will probably want to work back into the shapes with clean water to soften some of the edges.

Colour

Reflected colours are often as bright as the objects they reflect, but because they are broken by the movement on the water surface, they always look softer. The shape and colours of the reflections should correspond exactly to whatever is being reflected – a reflection from a tree, for instance, should be just as tree-like as the tree itself. A good way to test this is to turn your painting upside down – when seen from an unfamilar angle, it is always easier to spot mistakes and discrepancies.

◁1 *The artist starts with a light pencil drawing, sketching in the shape of the boat and indicating the movement of the water. Masking fluid is applied over those shapes which the artist wants to protect – namely, the emblem and side markings on the boat.*

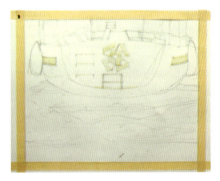

◁2 *The extent of the composition is defined on the paper with strips of masking tape. This not only gives the finished painting a clean edge, but the artist also finds it helps to stop the paper from buckling.*

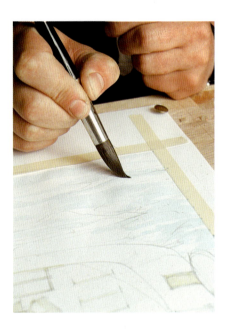

△3 *A very pale wash of cobalt blue is applied to the large reflected shapes on the water surface, and then allowed to dry.*

▽ **4** *Small, dark reflections from the boat are painted with a mixture of Payne's grey, Hooker's green dark and burnt umber. The bottom edge of each shape is very dark; the top half slightly lighter.*

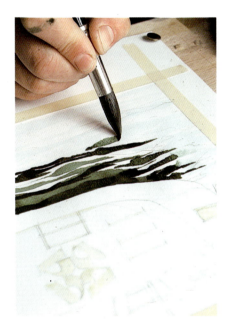

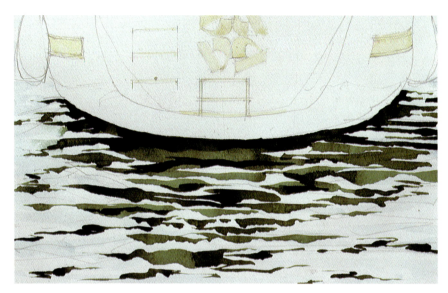

△ **5** *Reflected shapes flicker horizontally across the surface of the water and, characteristically, the closer they are to the object being reflected, the larger and denser the shapes become. Hence, the largest, darkest shape is directly beneath the boat.*

▽ **6** *The boat is painted in diluted Payne's grey, which the artist takes right across the masked areas.*

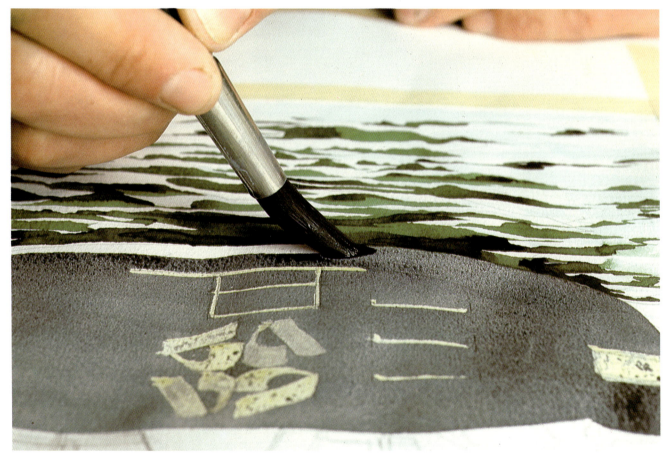

▽7 *Darker shades of grey are used to indicate the shadows underneath the bottom of the boat. Here the artist is removing excess colour.*

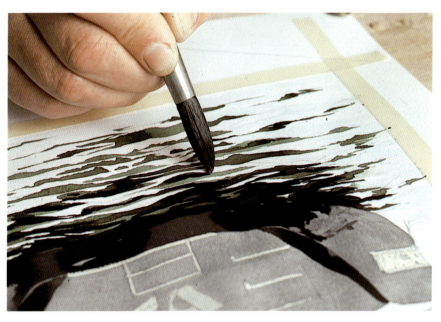

△8 *The darkest shadows on the boat have been added, and the artist repeats these in the reflection using the tip of the brush.*

◁9 *Continuing to develop the water surface, the artist has added tiny grey shapes of reflected sky around the broken outline of the boat reflection.*

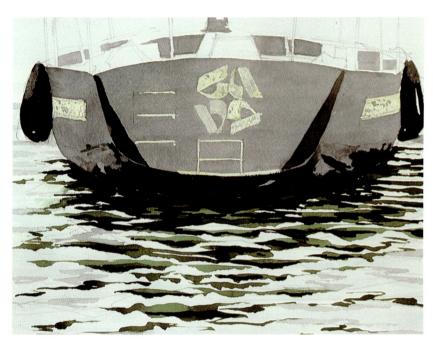

▷10 *When the surrounding paint is completely dry, the masking fluid is removed by rubbing with the finger.*

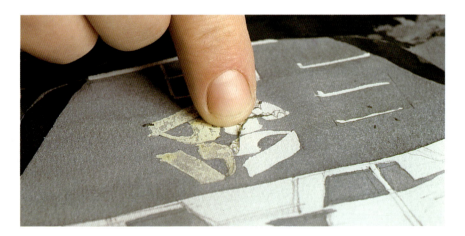

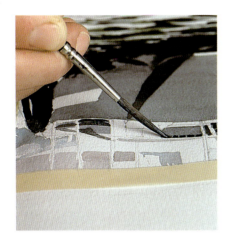

◁**11** *Final touches are made to the boat and background, which is painted in pale washes of grey and other neutrals.*

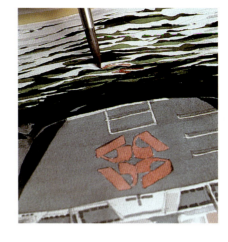

▷**12** *The artist paints the boat's emblem with a diluted mixture of alizarin and a little yellow ochre; the same colour is then introduced into the reflection.*

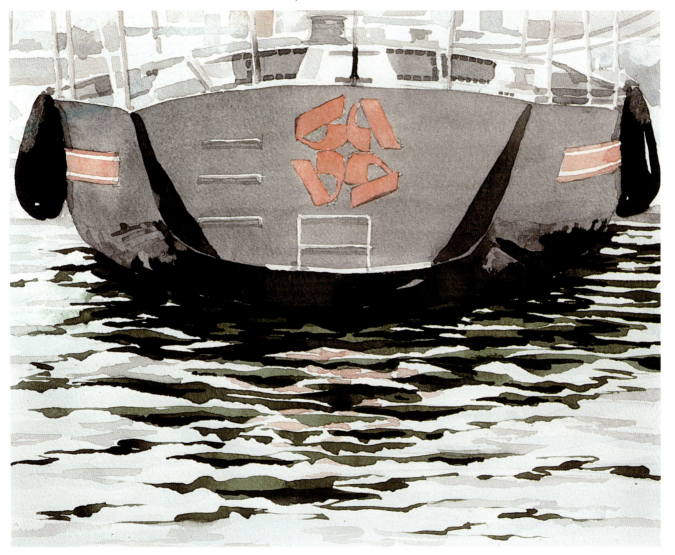

△**13** *In the finished picture, the surface of the water is predominantly white with overlaid areas of pale blue. The reflected shapes are hard and sharp, painted in two tones to indicate the concave and convex forms on the water surface.*

PROJECTS

WATER: WAVES

Waves and other rapidly moving water surfaces are slightly trickier than calm water, but try not to be put off. Spend time studying the surface and look for repeated patterns to help give you a general impression. At first sight a wavy sea might look chaotic, but waves tend to repeat themselves in regular patterns and you may notice that every fourth or fifth wave is more or less the same shape. You may also find it helpful to make a few very rapid colour sketches to help establish the pattern in your mind.

Breaking waves

A breaking wave is formed as water is sucked back into a ridge which then becomes top-heavy and tumbles over. This gives each wave a cylindrical form, and if you can capture this by using light and dark tones, the waves will look much more realistic than if they were treated as flat shapes.

Unlike calm water, a rough sea does not take on the colour of the sky but is usually darker. The water is usually opaque, often muddy green or grey, made this way by the action of disturbed particles of sand and mud. The waves are topped with sprays of white froth as each one tumbles and breaks.

Spattered spray

White spray can be achieved with masking fluid, applied before you start to paint, or with white paint. Use gouache for a dense white or Chinese white for a slightly more transparent effect, spattering it with a toothbrush or small decorating brush.

Of course, no painting of water is going to be entirely accurate because the surface is moving all the time, with constantly changing shapes and tones that appear on the surface. So, unless you are painting from a photograph, which will freeze an instant in time and make all the shapes instantly visible, the shapes and colours will be approximate. But careful observation will help you create the essential characteristics of the types of water.

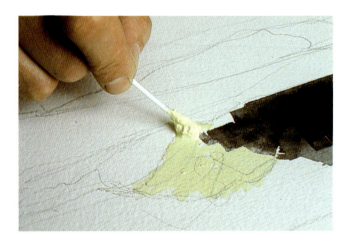

△**1** *The artist begins by blocking in the rocks in a mixture of Payne's grey and black. Next, masking fluid is applied to all areas needing to be protected from the paint – in this case, the frothy tops of the waves, which will eventually be white. Masking fluid is applied with a cotton bud to approximate the chunky shapes of the froth and spray.*

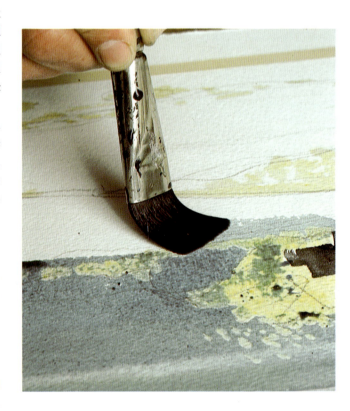

△**2** *The sky is a thin wash of cerulean blue and Payne's grey; the sea is painted with a large, flat brush in a mixture of cerulean blue, Payne's grey and Hooker's green light. Colour is applied in horizontal stripes, some of which are deliberately pale and washy. The light streaks represent reflections on the water.*

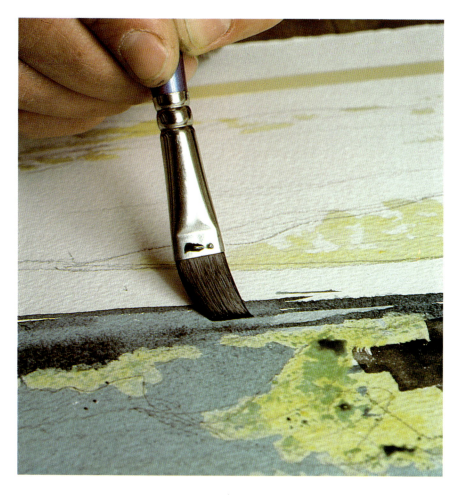

◁ **3** *Dark streaks of horizontal shadow are applied in a mixture of French ultramarine, cerulean blue and Payne's grey.*

▽ **4** *Already, simply by applying strips of dark-blue shadow, the waves are taking shape. At this stage, the artist develops the rocks by adding areas of black shadow.*

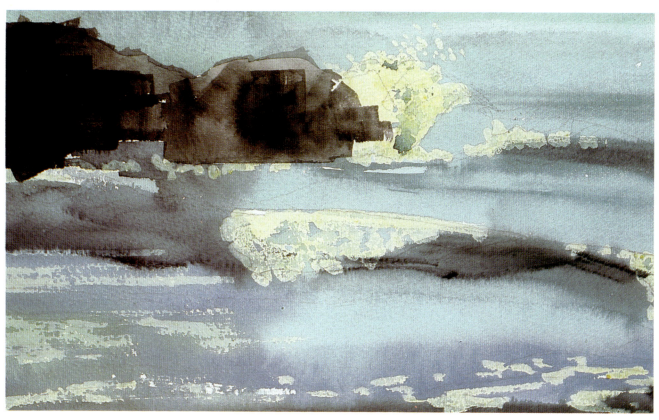

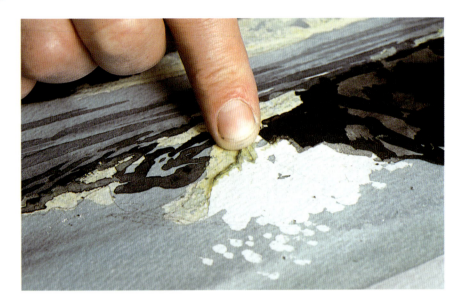

◁**5** *When the paint is completely dry, the masking fluid is removed to reveal the white paper beneath.*

▷**6** *The white shapes revealed by the removal of the masking fluid look flat and bright compared with the tones established elsewhere in the painting, but they are ready for further development.*

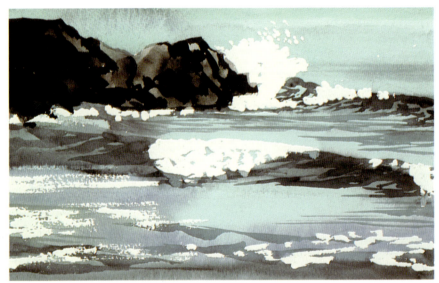

▽**7** *Using a sponge, the artist dabs a little of the sea colour into the white shapes.*

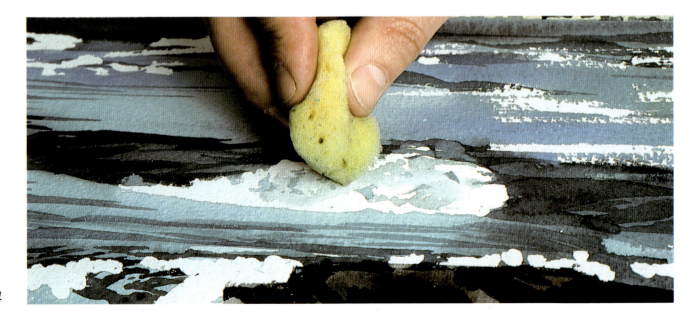

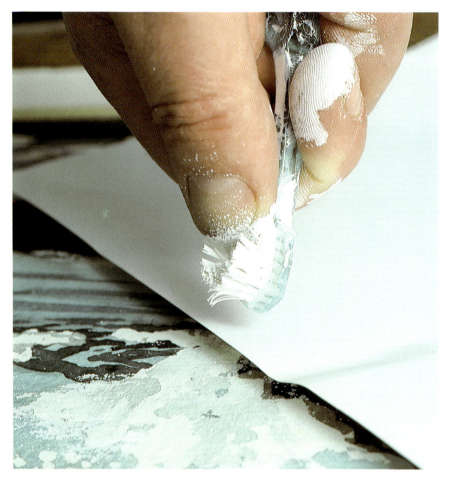

◁8 Froth is spattered with white gouache, flicked with a toothbrush while the rest of the painting is masked with a sheet of paper.

▽9 The final picture is a lively representation of a rough sea, painted in a limited range of colours and in the minimum of stages.

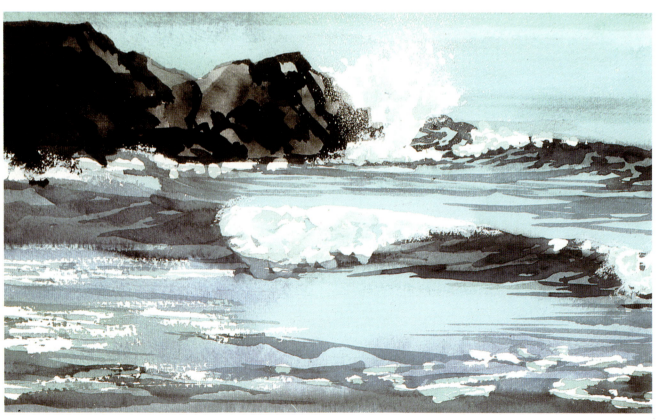

Painting Light
in Watercolour

Patricia Monahan

Light . . . and dark

●

WHEN ASKED BY Boswell, 'Sir, what is poetry?', Dr Johnson replied, 'Why Sir, it is much easier to say what it is not. We all *know* what light is; but it is not easy to *tell* what it is.'

You can't touch it, you can't taste it, you can't hear it, but it is this nebulous, insubstantial and difficult-to-understand 'thing' that allows us to see. It gives us a visual world, allowing us to discern colour and form, and even mood. All visual art depends on the ability to see, and much of it is concerned with expressing aspects of light in some form – a challenge that absorbs, puzzles, exasperates and sometimes confounds the artist.

This book is an attempt to capture this most elusive of phenomena, to find out what it is, what it does and how you can exploit and render it in watercolour. I have concentrated on particular aspects of light and have asked artists to explain in their own words what light means to them.

●

▶ *'Plum Blossom' by Sarah Holliday. By playing with the way light reveals and conceals forms, the artist has created an image that is coolly beautiful and rigorously composed. The twigs and shadows form a zigzag that holds the composition together. 'I was intrigued by the overall geometry of the composition, which had a non-geometric form as its main focus,' she says. A narrow slit of light was falling through the blossom, illuminating parts of it while putting others in shadow.*

▼ *This pencil drawing is Sarah Holliday's first response to the subject and is the basis for the work opposite.*

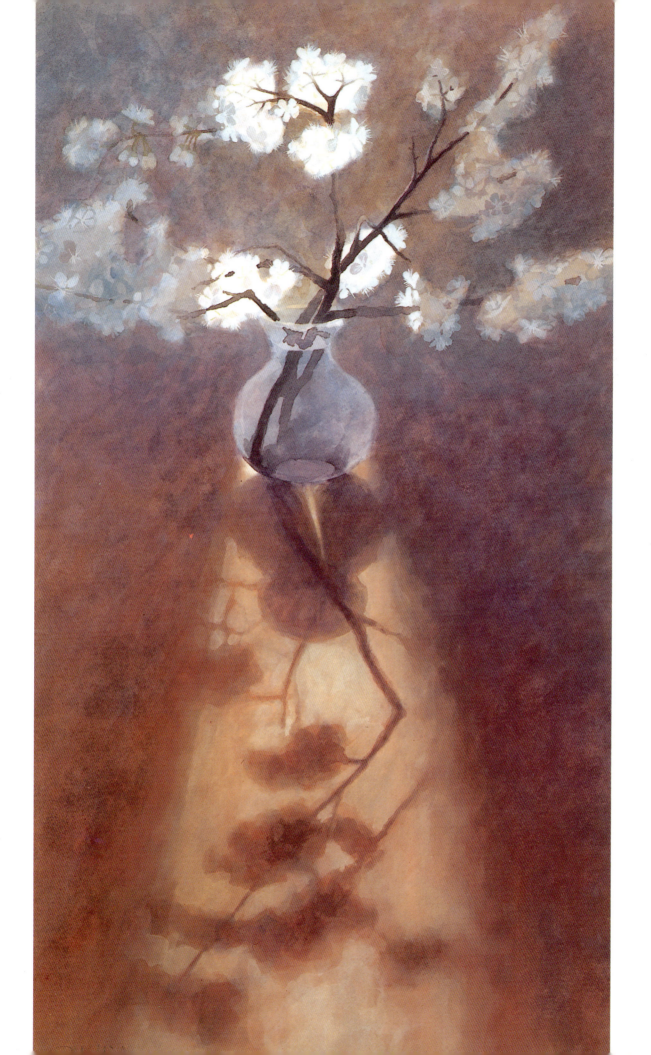

TECHNIQUES

SEEING TONE

Ask anyone to complete the phrase 'light and . . .' and they will invariably supply the word 'dark'. It is really this contradictory relationship that we have in mind when we think of light. Where light isn't, there is dark. The transition between light and dark gives us tone, the gradations of lightness and darkness, which is one of the ways we see and understand forms, and describe them in our paintings and drawings.

Tone is a difficult concept to grasp at first, but if you look at a black-and-white photograph in a newspaper, you will see that you get almost as much information from it as you would from a colour photograph of the same subject. This is because the areas of black, white and grey (dark tones, highlights and half-tones) allow you to understand the depth and space within the picture and the bulk and solidity of objects.

Look around you now, and try and see your surroundings in terms of light and dark areas. Initially, it is very difficult to see tone because colours, patterns, shadows, reflected light and different light sources interfere and cause confusion. If you screw up your eyes, it will be easier. Now make a quick sketch, blocking in patches of light and dark tone, with three shades of grey. It will help if you can forget what you are looking at and try to see the subject purely as an abstract. Remember that the white of the paper gives you your lightest tone, so save that for highlights or very light colours. Work quickly and don't worry about what the result will look like. When you've finished, you'll be surprised to find that a convincing image emerges from the patches of tone.

▼ The tone of colour
In these four spheres tone is used to describe form and colour. The side away from the light is darkest, but if you compare this with the single orange on the left you will see that the lightest area is a pale grey rather than the white of the paper. The grey implies a colour.

▲ Light, tone and shadow
An orange is placed in a strong directional light. It blocks the beam of light so that the light does not illuminate the side away from the light source; this is in shadow. The orange also throws a cast shadow on the horizontal surface of the table. This is darkest at the centre and fades towards the edge. Notice the way the cast shadow helps to establish the ground on which the object is standing.

Surprisingly, you can even get an idea of the colour of objects, because colour has a tonal value. Find a group of coloured objects – children's building bricks or a pile of books perhaps – and put them together on the floor. Now study them through half-closed eyes. You will find that yellow objects are lighter in tone than red ones, but that some shades of different colours are very similar in tone. In some cases it is extremely difficult to decide which colour is lighter and which is darker, and if you set your family the same task they will agree about some relationships and hotly dispute others.

▶ **Light, tone, shadow, colour and texture**
In this image we have a more ambitious use of tone. There are lights, darks and shadows, but there are also cross-shadows cast by light coming from different directions. The dark areas aren't consistently dark because light is reflected back from other surfaces. Notice that the lightest area is the white of the paper.

▼ **Using four tones**
Here four tones have been used to describe the form and local colour of the balls. Try this exercise. Mix up four shades of grey and use these tones to paint a simple subject like a ball or a cup.

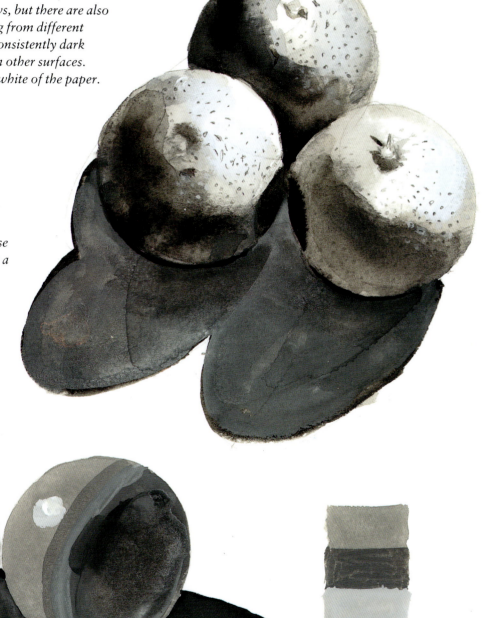

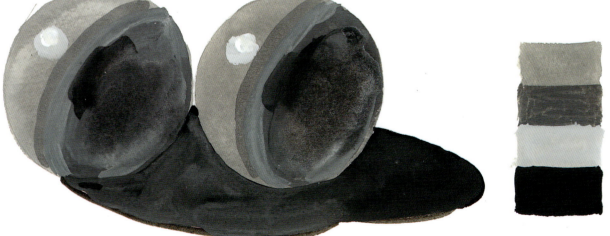

101

▼ *Here we have two studies of the same subject by the artist John Lidzey. On this page an interior is dealt with in terms of light and dark. The artist has used black Conté crayon. The white of the paper stands for the lightest areas, where the light coming through the window falls on the seat of the chair and the top of the table, and the top of the chest of drawers. The darkest tones are created by overlaying layers of hatched Conté. For the mid-tones between the darkest and lightest areas, he has used a web of loosely worked hatching.*

▶ *On the facing page the same subject is now interpreted in watercolour. The artist has captured the sense of an enclosed interior space that is illuminated by warm light filtering through the window. Areas like the wall behind the chest of drawers are warmed by the sunlight, while the areas in shadow have a cool, blue tinge.*

The artist handles watercolour with evident confidence and enjoyment, allowing the paint and the support to do part of the work. In some places washes flow and melt to create ambiguous veils of colour; in others 'accidental' puddles and streaks contribute to a paint surface which acknowledges the special qualities and beauty of watercolour.

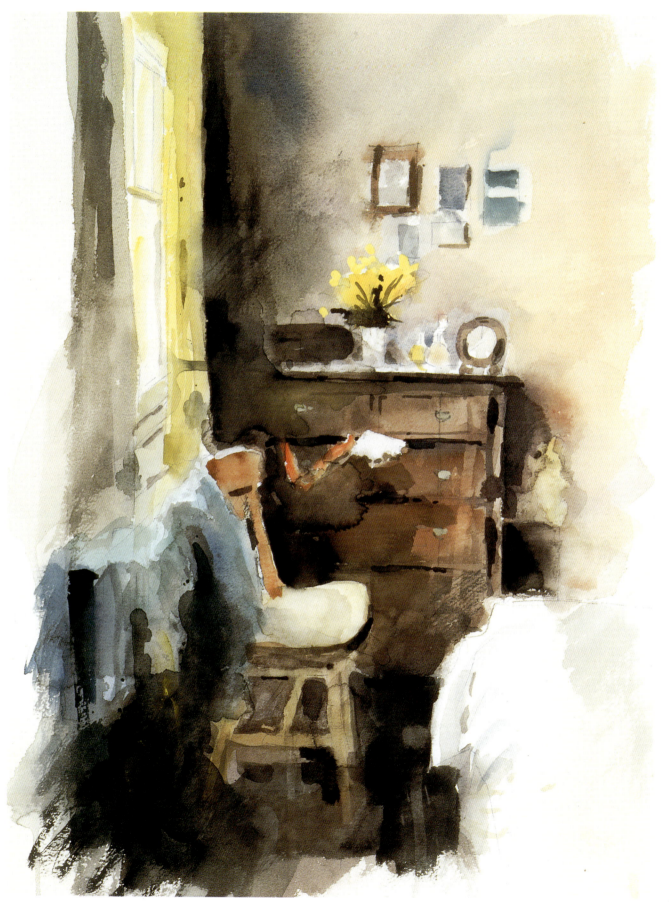

PROJECTS

ROOFSCAPE

One of the traditional concerns of most Western art is the depiction of a three-dimensional world on a two-dimensional surface. Artists are illusionists and use a repertoire of tricks to convince spectators that the rectangle of the picture contains space, relief surfaces and solid forms. Artists need to see and understand light and tone in the real world in order to exploit it convincingly in the 'unreal' illusionist world of their pictures.

Our first project is a subject that will be readily available – a view out of a window. In this case, the jumble of rooftops might seem daunting, but simply draw what you see, using your pencil to assess the relationship between one distance and another. The glazing bars of the window will provide you with a useful drawing grid.

This is not a romantic or sentimental image, but what you have is an abstract arrangement of angles, horizontal and vertical lines and geometric shapes. The contrast of light and dark tones and intense shadows adds another set of graphic forms onto the existing architectural shapes.

The colour range too is limited: closely related brown-reds for the tiles and purplish-blue for the slates, interspersed with patches of complementary greens giving the subject a sense of unity.

Stan Smith started by breaking the picture down into areas of light, tone and shadow, creating an abstract arrangement of shapes and patterns.

He used a limited palette of five colours: Hooker's green, chrome yellow, ultramarine blue, light red and Payne's grey.

You can copy this step-by-step study of rooftops, but it would be much better to find a similar subject. By looking out of the windows or doors of your home, you will find in most cases an equivalent subject; if it's not a roofscape, you may have a view of outbuildings, or the backs of buildings opposite, or even fire escapes, all providing interesting architectural themes that can be studied under different light conditions.

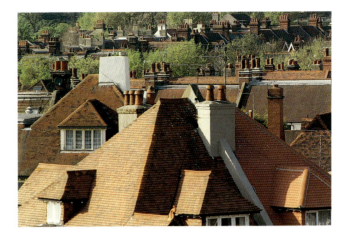

▲ **1** *The subject is superficially daunting – a higgeldy-piggeldy pattern of steeply pitched roofs, dormer windows and tall chimneys topped with a forest of chimney pots. Study the subject and see it as a collection of various abstract geometric shapes. These underlying geometric shapes, together with the overlaid geometry of the patterns of light and dark, and the subtleties of the warm earth reds all provide the hook for the picture.*

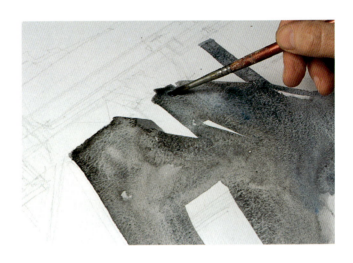

▲ **2** *The artist started with a drawing made with an HB pencil. Spend some time on your drawing, using a pencil to assess the relationships between shapes. By holding your pencil up at arm's length you can measure the angles of the eaves and the slope of the roofs. Look carefully, see how horizontals and verticals relate to each other, measure and judge relationships by eye.*

To simplify this project the artist started by washing in the darkest tones, using a mixture of Payne's grey cooled with ultramarine for a bluish neutral colour. Wash in the colour but don't labour it. Make it a little darker than you intend because watercolour dries lighter.

▶ **3** *The trick is to try not to make the drawing too architectural. Look at the work of people who use architectural details in their work and you'll find that they don't make it look mechanical.*

The drawing must be considered and reconsidered all the way through. Don't simply trace with the paint. Keep on looking to see if the image needs adjustment; here, the artist found that some of the proportions weren't quite right. Realizing that you are not simply 'colouring in' keeps you on your toes. Questioning the decisions you made earlier will ensure that the drawing is a living, evolving thing.

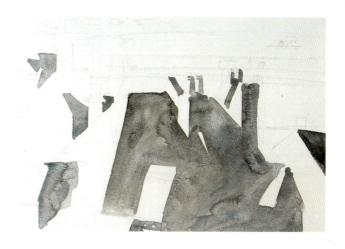

▶ **4** *Now the artist starts to wash in colour, working boldly and broadly with a No. 10 brush. He uses a range of reds mixed from Venetian red and burnt sienna to create variations on the local colour. By using a big brush he stops himself from getting too tight. Try to keep to a general feel of the tones and the colours.*

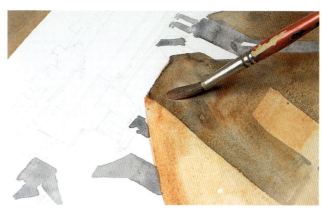

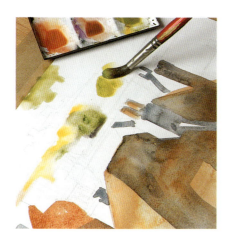

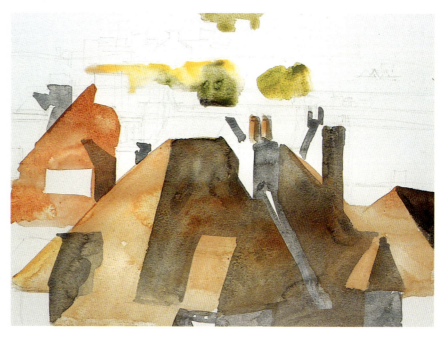

▲ **5** *Don't focus on one part of the painting, try and keep the whole thing going, constantly assessing the tonal arrangements in the subject to see that you get those right in the picture. Screw up your eyes to simplify the subject and exaggerate the tonal contrasts.*

Here, the artist introduced some of the foliage in the background.

▲ **6** *Here you can see how loosely and broadly the colour has been applied. Notice how the crisp contrasts of tone along the ridges of the roofs and on the sides of the chimney, all contribute towards the sense of bright light. The darks make the lights seem brighter.*

105

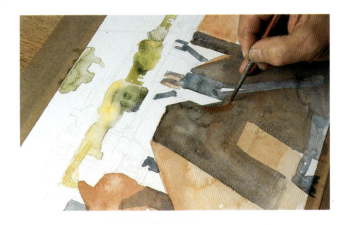

◄ **7** *Using a smaller brush – No. 6 – the artist adds emphasis here and there, adjusting the tones, playing up the contrasts and amending the drawing.*

▼ **8** *Here he develops the background, simplifying and enjoying the way the paint pools and puddles, letting the paint create its own equivalents of reality.*

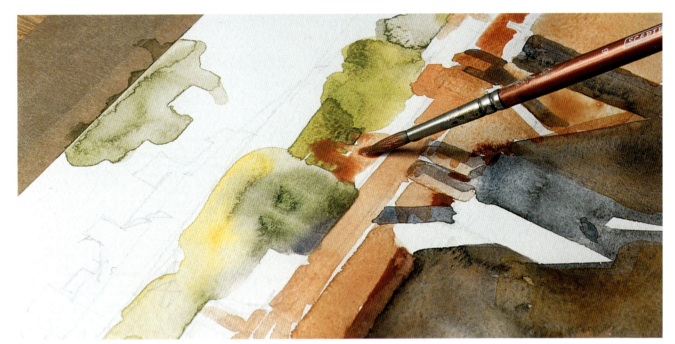

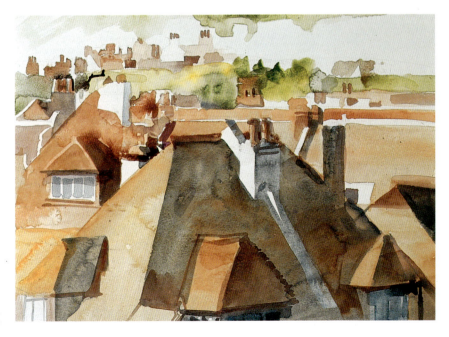

◄ **9** *It is important to stand back and contemplate your work at regular intervals, judging it against the subject and assessing it as an image in its own right. Make any adjustments that will make it a better picture, leaving things out or moving them about if they improve the composition.*

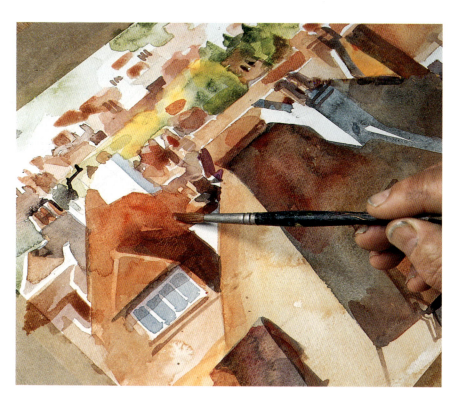

◄ **10** *Some rich red – Venetian red – is washed over a roof, creating an area of bright colour.*

▼ **11** *Avoid the temptation to make the image too architectural; focus instead on pattern and colour. The artist has added some crisp details with the tip of the No. 6 brush. You don't need a lot of brushes. Because a good brush comes to a point, you can get a lot of detail even with quite a large brush. Notice the way the artist has indicated the edge of the ridge tiles and the details on the dormers and within the windows by adding just enough to suggest the forms, but avoiding the temptation to pull them into too sharp a focus.*

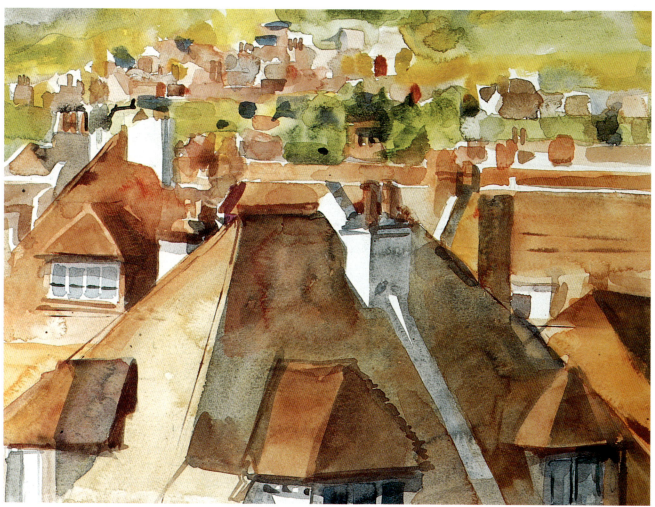

LIGHT AND SHADOW

Shadow should not be confused with tone. Shadow is an area of darkness that is created by an object standing between the light and the surface beneath or adjacent to it. By screwing up your eyes you will see that shadows also have tonal value. Shadows cast on to the subject give you clues about form. For example, if a figure is placed in front of a window in full sunlight, the dark bands of the shadows of the glazing bars will be cast over the figure and will be displaced around the undulations of the form, emphasizing and helping to describe those forms.

Shadow also gives you useful information about the direction and quality of light in a setting. On a bright sunlit day there will be a strong contrast between the areas in full light and those in shadow; on an overcast day there will be less contrast, or possibly no perceptible shadow at all.

So how do you render shadows? The obvious

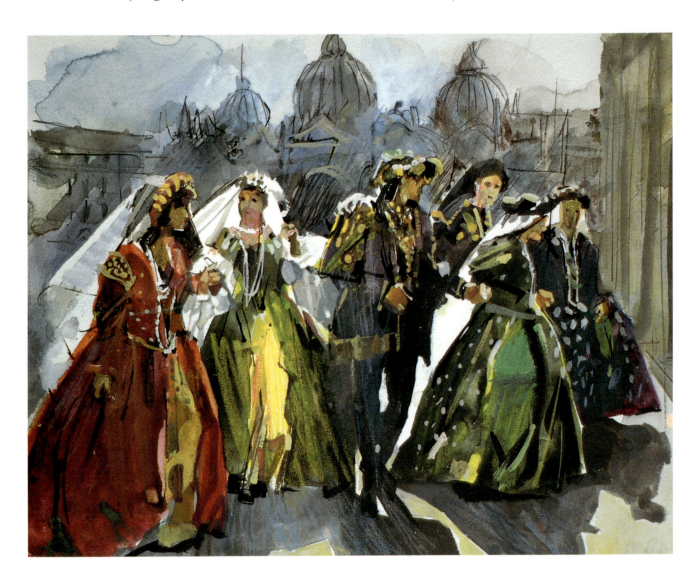

▲ *'Carnival' by Stan Smith. In this study of costumed revellers at Venice's annual carnival, the artist has used backlighting and cast shadows to heighten the drama of the scene. He juxtaposes light and dark, dark and light, so that in some places the forms are negative shapes and in others they are positives. The image was worked up from photographs and sketchbook notes jotted down on the spot. He has used gouache and watercolour, overlaid with crayon, to create a complex web of colour.*

solution might seem to be just to put in a bit of black or a dark colour. In the late nineteenth century, however, it was discovered that the relationship between light and colour is exceedingly complex. Shadows were found to contain a great deal of colour – often the complementary, or opposite, colour of the object casting the shadow (see pages 50–51).

This influenced the work of the Impressionists, and you will find that shadows in their paintings are complex areas of broken and layered colour, containing colour reflected from the surrounding area, plus the complementary. So rather than being areas of flat colour, these shadows have a scintillating luminosity that enlivens the painting and effectively mirrors the complexity of natural light.

Make careful assessments of the degree of contrast between areas in shadow and adjacent areas, whether shaded or illuminated, and study the quality of the edges. These things tell you a lot about the quality of the light, the time of day and the distance of the object casting the shadow from the shadow. Bright light casts crisp shadows, while the shadows cast by diffuse light have softer, less defined edges. Only when the sun is directly overhead do shadows appear directly under horizontal surfaces such as the canopies of trees, the seats of chairs or awnings, and vertical objects such as telegraph poles or standing figures cast almost no shadow at all. But during the short evenings late in the year, when the sun hangs low on the horizon, you get immensely long shadows. And on a clear winter's day, when the sun is glittering and bright, the effect of the long, crisp shadows cast by trees, cattle and figures adds drama to the landscape.

◄ *'Evening Light' by Stan Smith. This image was painted when the sun was low in the sky and threw this tree into dramatic silhouette casting a strong dark shadow. This viewpoint shows the tree and its shadow as a single monolithic form.*

The artist made the image on a blue tinted paper, which captured the coolness of the evening light and provides a foil for the warm summer greens. He interpreted the subject freely, laying colour on then washing and blotting it off to create interesting shapes and textures.

TECHNIQUES

PAINTING SHADOWS

There are two important 'don'ts' when dealing with shadows. First, don't add shadows as an afterthought. You can't grasp them or feel their shape, so it is sometimes tempting to leave them out or add them at the end of the painting. But they are important features of our visual world, even though they don't occupy three-dimensional space or feature in the tactile world. So treat shadows as part of the composition.

Second, don't paint shadows black. If you do, they will look solid and opaque, whereas in reality they should have depth and form just like other areas of the painting. Our environment is full of reflected light that bounces off adjacent objects, modifying local colour, tone and shadows. Nothing is ever what you think it is or what it seems at first glance. Look for the colour in shadow areas and paint what you see. You will find that you create

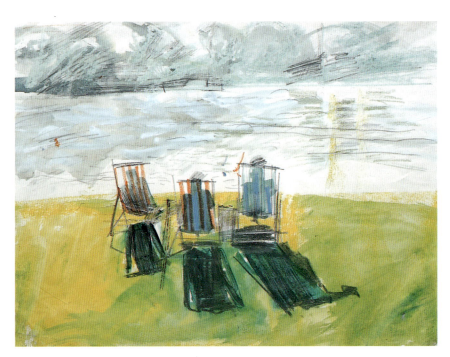

► **1** *This is the original study, made on the spot, of people taking the summer sun. I asked the artist to re-create the chairs and shadows, to see how he achieved the richness and transparency of that area.*

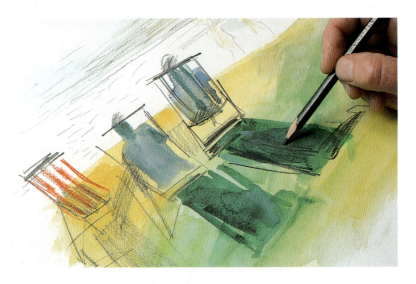

◄ **2** *First the ground is laid in freely with yellows and greens to get a richness throughout. The artist used cadmium medium, lemon yellow and also strong viridian green, overlaying the colours to create an effective grassy ground with a little dappling in it.*

To get transparency into the shadows, he lays them in with Winsor green, a bluish, transparent green. Then he uses a pencil to draw the forms of the deckchairs.

shadows that have luminosity and depth and your paint surface will be varied and interesting.

Here we look at the way Stan Smith has tackled the shadows in a sketch of a riverside scene with the sun shining on figures sitting in deckchairs. It is a pleasing and intriguing theme. The light shines through the fabric, silhouetting the seated forms, and causes the seats to cast shadows. The shadows are treated as important elements in the composition. They are seen as definite shapes and are drawn with the same conviction as the 'real' objects such as chairs and figures.

The brilliance of a hot summer's day is expressed by the brightness of the water, the dark and emphatic shapes of the shadows and the richness of the colour throughout – especially in the shadows.

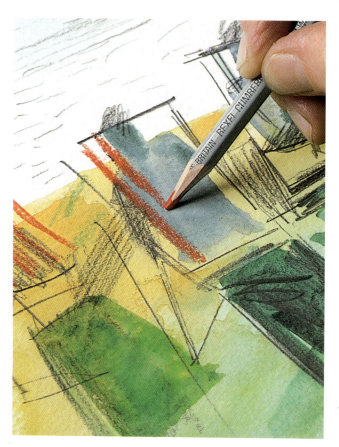

▶ **3** *The stripes of the deckchairs are laid in with a soft coloured pencil.*

▼ **4** *The freshness of the paint and the crispness of the patches of colour, plus the tonal contrasts, capture the qualities of green grass lit by sunlight.*

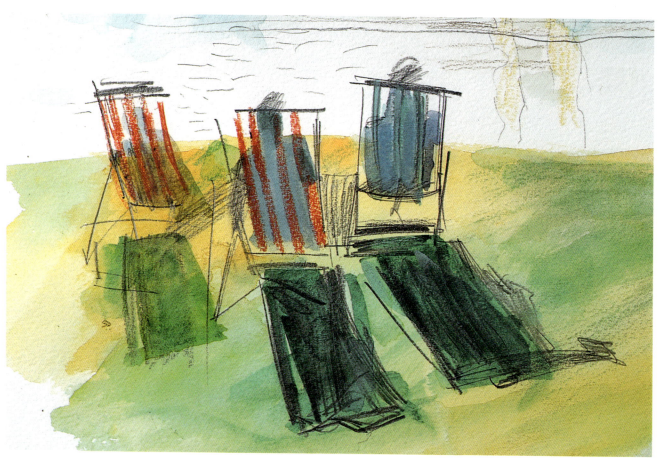

111

TECHNIQUES

COMPOSING WITH LIGHT

Composition is the process by which an designs or constructs a picture. If a picture hold the viewer's attention and communicate, there must be a logical relationship between the pictorial image and the flat area it occupies.

The artist must 'make a picture', using the shapes and colours in the subject, manipulating, selecting, editing and emphasizing to create an image that is effective and unique. All these elements must be juggled and refined so that they work in relation to one another and to the four edges of the image.

Sarah Holliday, whose work is reproduced on this page, is fascinated by light and the ambiguities created by reflected images. She works with still life because the subjects are accessible and easily manipulated, and offer endless variations. She particularly enjoys 'balancing abstract and figurative elements within a composition, adding a sort of dynamic tension to the whole thing'. And, as she points out, still-life subjects often contain very basic abstract shapes, such as the circle of an apple.

In her compositions she usually combines plant forms with geometric shapes, playing the natural and organic qualities of the one against the more formal qualities of the other.

She works entirely from drawings, which allows her to focus on the subject without distraction. She draws the essentials: the precise location of the sunlight, which can change very quickly; the distribution of light and shade; and all the features that excite her. Details like the veining of leaves can be studied later.

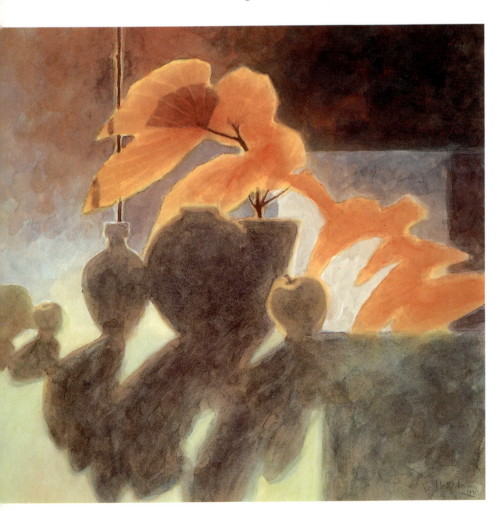

◀ *'Begonia 1' by Sarah Holliday. The stick in the left hand pot and the shadow of the mirror on the right create strong vertical divisions. The mirror and its shadow provide two bold squares: the mirror is a square of light counterpointed by the dark square of its reflection.*

By placing pots and apples in a line across the picture area, the artist actually reduces the sense of space, emphasizing the abstract, pattern-making qualities of the image. The leaves and their reflection form a colourful diagonal. By merging shadows and objects, the artist draws attention to the intervals of light between them. The halo of backlighting adds atmosphere.

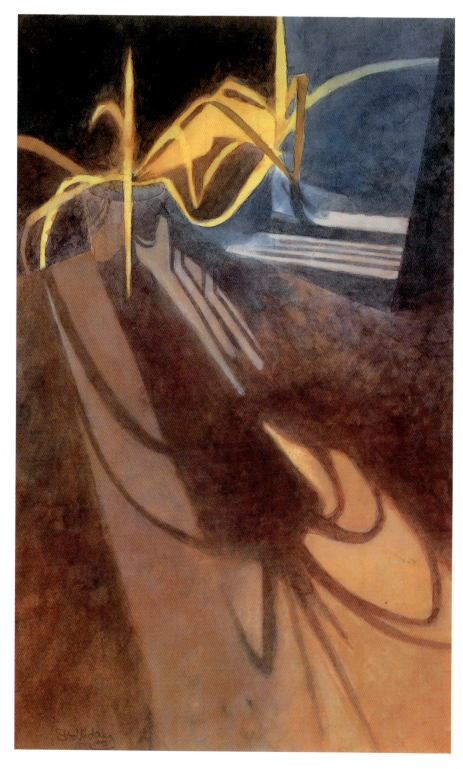

◄ *'Spider Plant' by Sarah Holliday. In this study the artist has created an image from a spider plant and a dramatically lit mirror. To produce this striking image the artist has made some slight modifications to the arrangement, moving things slightly, refining something here, leaving some elements out there, to maximize impact.*

For example, there was a little metal dog in the group; she left the ornament out of the image, but retained the shadows thrown by its legs because they contributed a useful shape to the composition. The pot has been played down because it was not an interesting shape, though the reflections are. The dark wedge shape behind the mirror balances a similar shape on the left-hand side, anchoring the whole picture and at the same time giving a clue to the presence of the mirror.

The initial stimulus and drawings are just the start; next comes 'the really exciting stage – working out the composition'. She makes a working drawing, again tonal, to establish the composition, refine the shapes, looking for repeats and relationships, and wrestles with the tonal values.

She thinks that the main problem people have is failing to consider the picture as a whole. You should try to think of your picture as a rectangle covered with different shapes and patches of colour that can be manipulated to suit your needs. The picture plane can be divided up in pleasing ways, and shapes can be refined so that they have a relationship with each other.

Light reveals form

ONE OF THE enthralling and confusing aspects of light is the way it both reveals the world to us but at the same time plays tricks, concealing, confusing and always beguiling us.

In the search for 'reality', which has consumed much of Western art since the Renaissance, the artist has been concerned with using the distribution of light and dark around an object to reveal and describe its volume and form, to create an illusion of three dimensions on a two-dimensional surface. But we don't see the world as a series of snapshots. Our field of vision is precisely focused at the centre and blurred at the periphery. Our eyes dart about, taking in bits of information here and there, processing and extrapolating to make sense of what we see. So a painting in which everything is rendered with equal clarity will appear less 'real' than one which is apparently more ambiguous.

The constant shifts of natural light complicate the process further. Distant hills that seem solid, monumental and almost close to at one moment can appear diffuse and insubstantial, mere wisps of things, at another.

'Figure in Light' by Stan Smith. Light streaming through a window here illuminates and defines the figure and at the same time dissolves it into abstract shapes. The artist has exploited these ambiguities: in some places the figure is seen as light flesh set against a dark background; in others it is seen as dark against light.

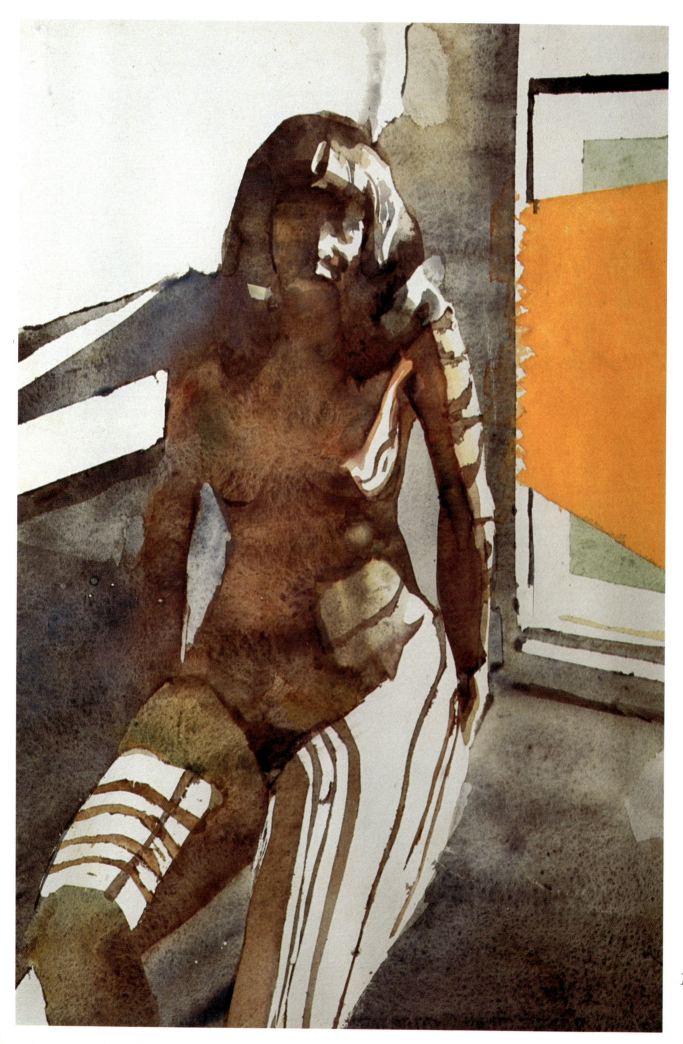

PROJECTS

EGGS IN A CONTAINER

Why waste time looking for 'exciting' subjects when there are marvellous things in the fridge or larder. The artist, Stan Smith had been given a gift of assorted ducks', guinea fowls' and hens' eggs. The simplicity of the forms, the delicacy of the colours and the brittleness of the shells cried out to be painted.

Light from a nearby window washed across the forms, creating patterns of light and dark, emphasizing the contrast between the smooth, fragile surfaces of the eggs and the dimpled texture of the cardboard carton.

A box of hens' eggs will do just as well, but try to find a cardboard container as the polystyrene versions have a less interesting texture and colour. Several eggs in a china dish or a wicker basket would also make a pleasing study.

Simplicity is the key to this project so spend time contemplating the group before you start. If a natural light source is not conveniently available, use a table lamp or a candle to create a strong directional light, which will emphasize the pleasing shapes and textures.

Start by making a quick tonal study of the subject in pencil. This will help you to analyse the subject and fix it in your mind. Think carefully about the way you intend to proceed; use only a few colours and keep the washes to a minimum. Having planned the painting, work as quickly as you can. Don't rework it. If you aren't satisfied with your first efforts, do it again . . . and again. The great advantage of a still-life group is that you can come back to it.

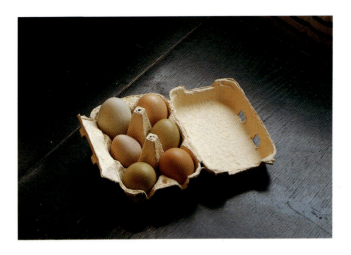

▲ 1 *The subject is eggs in a carton. We happened to have ducks', guinea fowls' and hens' eggs, but hens' eggs alone will do just as well. The artist was captivated by their wonderfully subtle colours, their compact forms and the contrast between their smooth shells and the soft, pitted paper surface of their container. The group provides a subtly coloured subject in primarily neutral shades. Notice the way the light falls around the forms, creating interesting patterns, as well as giving us clues about their shapes and volume.*

▲ 2 *The artist worked on a smoothish paper – Cotman with a Not surface. He started by toning the paper with a wash of raw sienna to give the paper a warm, virtually transparent glow. To do this he mixed the wash and then laid it on briskly with a sponge.*

▶ 3 *When the paper was dry he started to lay in the broad outlines of the form, working directly with a No. 6 brush. Don't hesitate. Study the subject and then draw what you see, allowing the brush to 'feel' its way about the forms. Look at the subject rather than the image; really concentrate and be bold. If you find your drawing is inaccurate, you can make adjustments as you paint, and the overpainted marks will become part of the final image. Don't forget that watercolour dries much lighter than it looks when wet, so these apparently bold marks will be much less bold when dry.*

The artist laid in areas of tone at an early stage using thin washes – here of cadmium yellow pale.

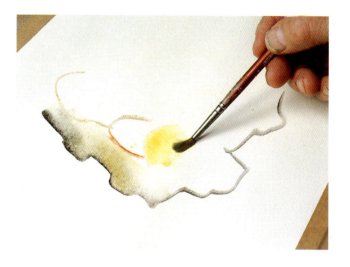

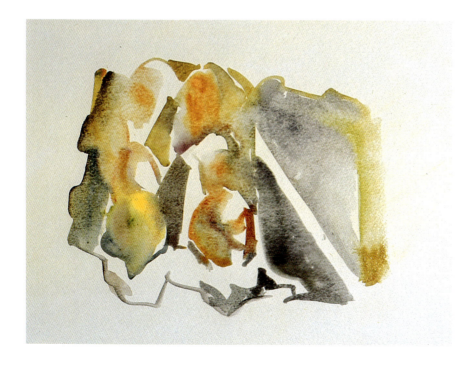

◀ 4 *The artist is working with washes of chrome, cadmium yellow, burnt sienna and Payne's grey. He applies the washes wet-in-wet, allowing one colour to melt into another to achieve subtle gradations that cannot be achieved in any other way. Notice how he has painted the spaces between the eggs – the negatives rather than the positives. This is an excellent way of achieving an accurate drawing and also allows him to minimize the painting of the eggs; he wants to keep the paint in these areas as fresh and transparent as possible. Too much overworking to get the drawing right would detract from the delicacy of the surface, which is the main characteristic of the subject.*

◀ 5 *The image is emerging from the washes of subtle colour. Notice the way crisp edges define the junction between light and dark on the angular forms of the container and the more gradual and blurred transitions on the curving surface of the eggs.*

117

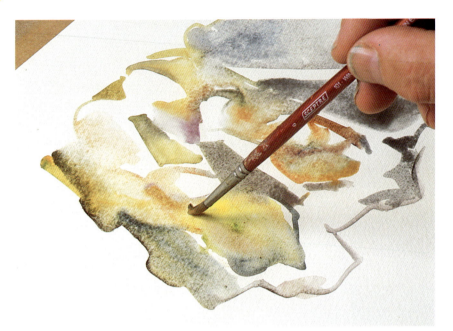

◀ **6** *Working wet-in-wet, the artist touches in warm yellow highlights.*

▼ **7** *The brightest tones and the mid-tones have been established. Now the artist lays in the darkest tones in the recesses of the container. He uses Payne's grey, loading a No. 6 brush and touching in the colour with the very tip. It bleeds into the surrounding still-wet paint to create precise yet soft-edged dark tones.*

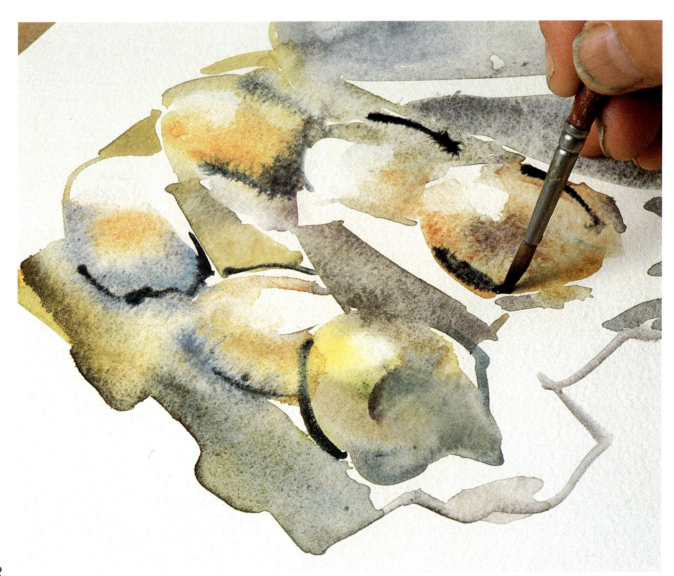

118

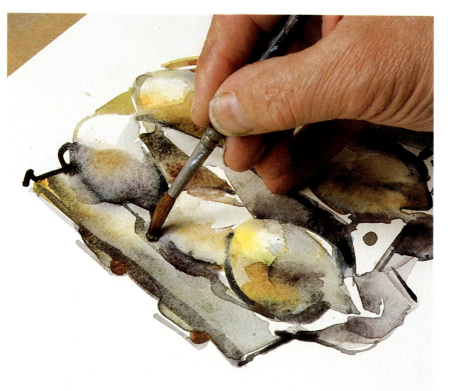

◄ 8 *The artist continues to work into the image, adding more dark and mid-tones, but keeping the washes fresh and clear. He doesn't scrub the paint. He constantly refers back to the subject, making adjustments as the light changes.*

▼ 9 *The final image combines careful observation, respect for the special qualities of the subject and a controlled use of the medium. Much of the work was done working wet-in-wet, but further fresh layers have then been applied. The paint surface is clear and lucid. The artist used a limited palette.*

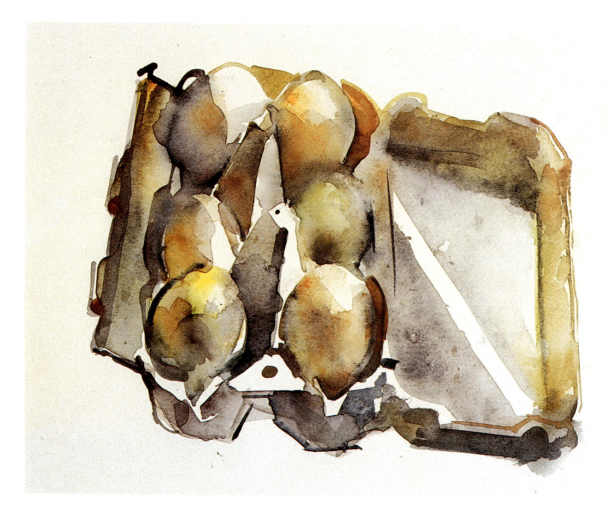

LIGHT ON THE FIGURE

When we talk of the figure in art we are dealing with a big subject that includes portraits, single-figure studies, groups, draped figures and nudes, figures in action and figures in an interior. There are two important ways of studying what light can do to the human form. You can look at the work of other artists, both contemporary and from the past, in galleries and in reproduction. These will give you clues and ideas for your own work.

By far the most important way of finding out about the figure in light, however, is direct observation and sketching. If you have friends or family who are interested, you may be able to persuade them to sit for you, but in the end you will undoubtedly be your own most amenable sitter. This, together with the cost of hiring models, explains why self-portraits feature so regularly in artists' work. Life classes at local colleges offer excellent opportunities to work from the nude at very little cost. If you have a group of friends interested in painting, you could even hire a model of your own, sharing the cost among you. A local school or art college would be able to give you a list of life models.

▼ *Here two figures are caught in light streaming in from a window. This composition flouts the traditional rules in that the two figures are, in fact, more or less symmetrically placed and because both gaze out of the composition. Notice the way the eye tends to dance from one pool of light to another, so that the two figures seem to be trapped in light.*

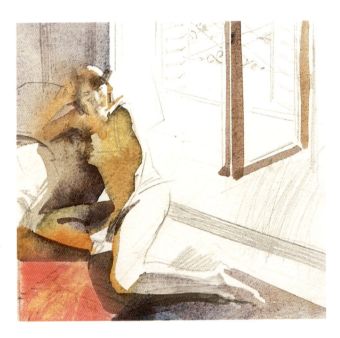

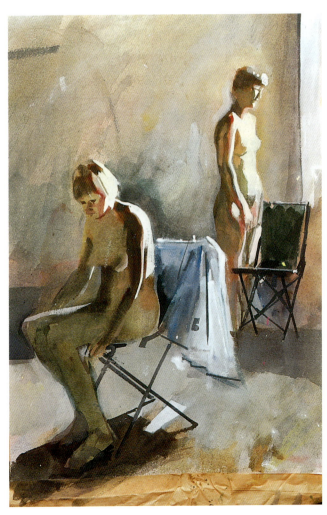

▲ *The light from the open windows falls across the reclining figure, illuminating the back and upper thigh, catching the side of the left hand and parts of the face. This is a perfect demonstration of the shadows being used to explain the solids; sometimes the shadows become almost solid things in their own right. In some places you read dark lines on the light, in others you read the light out of the dark. The front of the figure is in its own shadow, the dark tones visually linking it with the interior space. Notice the almost abstract shapes defined by the highlighted areas.*

On these pages I have shown several studies by Stan Smith, an artist who works primarily with the figure. His large oils are very often concerned with the way light dissolves and resolves forms, but these direct studies are the raw material from which he works up his ideas.

Get into the habit of keeping a sketchbook and in just the same way as you note forms and colours, also focus on the way that light affects the subject – not just its structural appearance but also its mood. Jot down special light effects, noting the source, direction, intensity and colour of the light. Supplement your drawing and colour notes with annotations – anything that will help recall the details to mind.

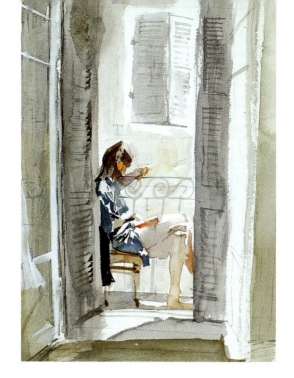

▲ *Here we have an example of the inside/outside theme – a subject full of ambiguity and one to which many artists constantly return. A figure is framed in a doorway. The brilliance of the sunlight outside is contrasted with the cool, grey light indoors. The figure is cropped by the doorway, so that we have a sense of someone glimpsed and caught unawares, giving the painting a sense of intimacy.*

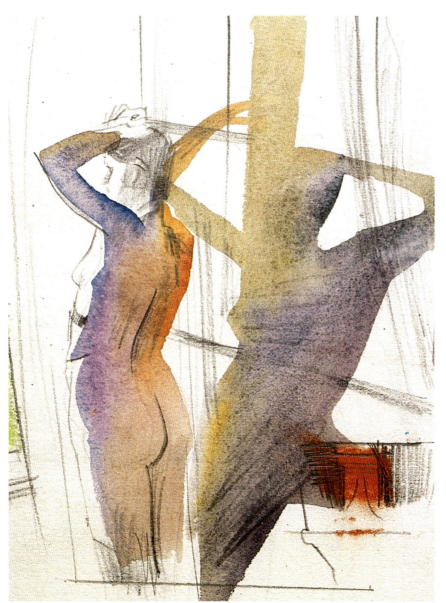

◀ *In this study a single figure is seen against the light and casts a shadow on the wall. Notice the way the artist has seen the back of the figure and the cast shadow as a single complex shape; in fact the shadow has more significance than the subject. Notice also the interesting shapes trapped between the figure and its shadow.*

TECHNIQUES

LIGHT ON FLESH

In sympathetic hands watercolour has a transparency, delicacy and lightness of touch that is unmatched by any other medium. It can also be used in a direct, punchy way to produce gloriously bold and colourful images. To get the best from it you must match your approach to the subject.

Figure painting requires a feeling for the bulk and solidity of forms, as well as an understanding of the subtleties of the skin which covers those forms. Poor drawing and heavily handled paint result in figures that are flabby and unconvincing, with flesh that is dull and dead.

The white of the paper under transparent washes gives watercolour its special liveliness and translucency. But the white of the paper can also contribute to the image in other ways. In this study of a nude in a sunlit room, the white of the paper stands for the colour of the flesh in light, the fine muslin curtain and the sunlight dappling the patterned wall behind the figure. In many ways the white of the paper can be seen as light.

You can give a watercolour painting a definite mood by toning the white paper with a very pale wash. The early watercolourists did this in their topographical work, using Naples yellow in summer to give the painting warmth and Payne's grey in winter to give it a cool cast. If you look back at the painting of 'Eggs' on pages 116–119, you'll find that by toning the paper with Naples yellow the artist gave the painting a delicate, sunny feeling.

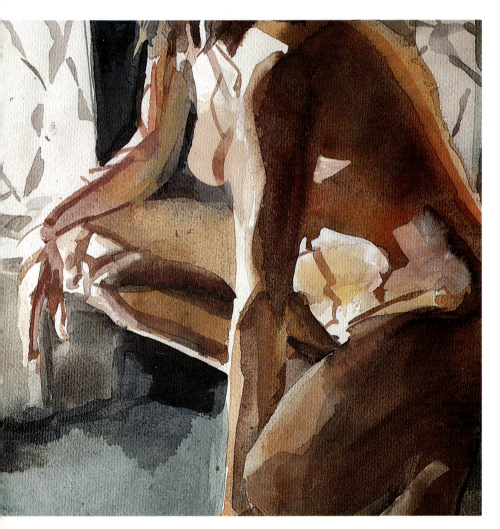

◀ **1** *In this detail you can see how the white of the paper has been allowed to stand for the brightest flesh tones – all the light areas of the flesh are either white or a conditioned white. Elsewhere transparent washes of earth reds and browns applied wet-in-wet describe the warm flesh mid-tones. Over this the artist has applied transparent watercolour and body colour wet-on-dry, creating crisply defined patterns of colour which capture the patterns of the shadows cast by the tracery of the balcony. It is the crispness of these edges and the sharp contrast of tone that give us a clue to the quality of the light.*

▶ **2** *This study was made from life. The artist, Stan Smith, wanted to capture the quality of the light shining through a typically ornate Parisian balcony and being filtered by fine muslin curtains. We will look at the way in which the sense of brilliant but modified light has been achieved.*

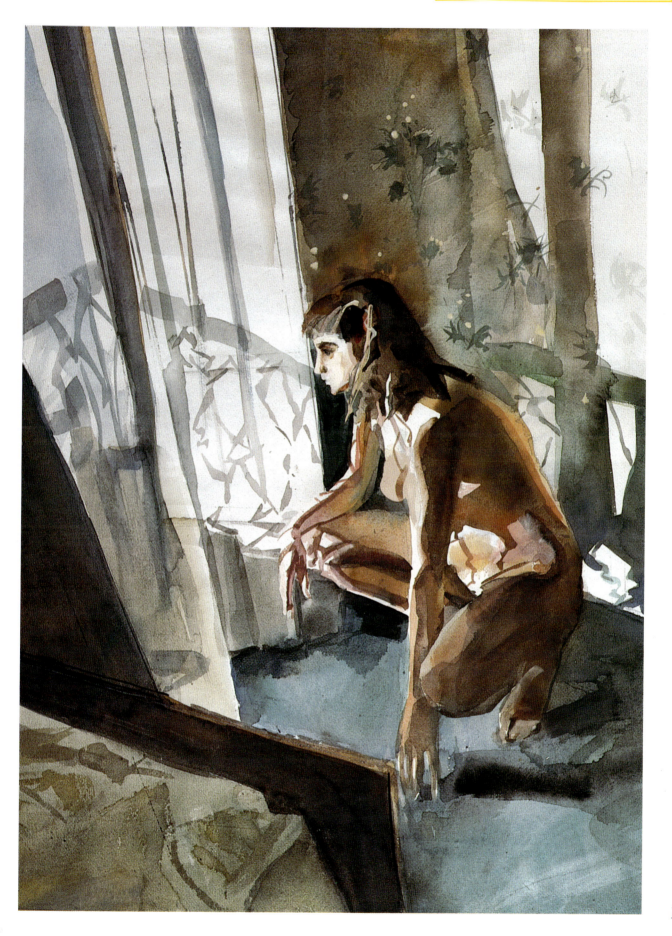

TECHNIQUES

LIGHT ON WALLPAPER

The room was furnished with a rather lush wallpaper with a repeat floral pattern. The artist was interested in the way light fell on the wallpaper, bleaching it, so that it contrasted with the rich colours in the shadow areas. Painting patterns, fabrics and furnishings often presents the beginner with a problem. There is a tendency to render the pattern precisely, but if you do this the pattern will become too important and will leap out of the picture, drawing attention away from other important elements. Here the artist has summarized the paper so that it appears rich but not overwhelming.

▲ 1 *A wash of very dilute terre vert and burnt sienna is used to wash in the wallpaper colour where it is away from the direct light. A crisp edge defines the edge of the shadowed area. A cool mixed blue-grey is added wet-in-wet to re-create the dappling of the surface.*

▼ 2 *With the tip of a No. 6 brush and the same blue-grey mix, the artist touches in a summary of the floral pattern. He is creating an 'impression' of the motif, as it would be experienced by someone in the room, not a detailed record for a student of wallpaper design.*

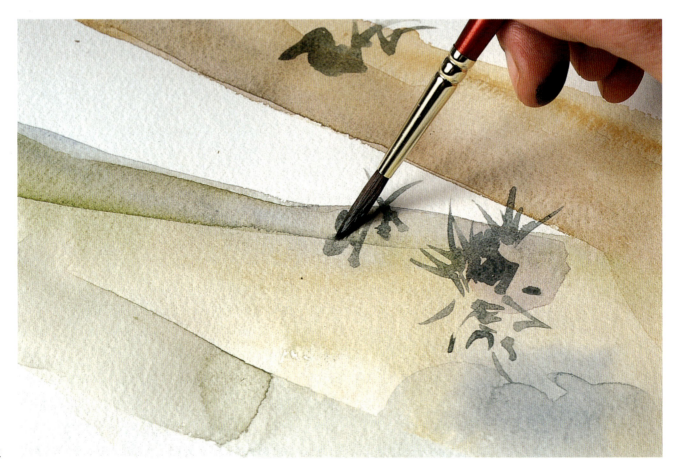

► **3** *While the motifs are still wet, he blots those that are in full sunlight, to blur and bleach them.*

▼ **4** *The artist has created the illusion of light falling on a single surface which is seen in both light and shadow. In the shadow areas the richness and texture of the wallpaper is apparent; in the sunlit areas it is bleached out.*

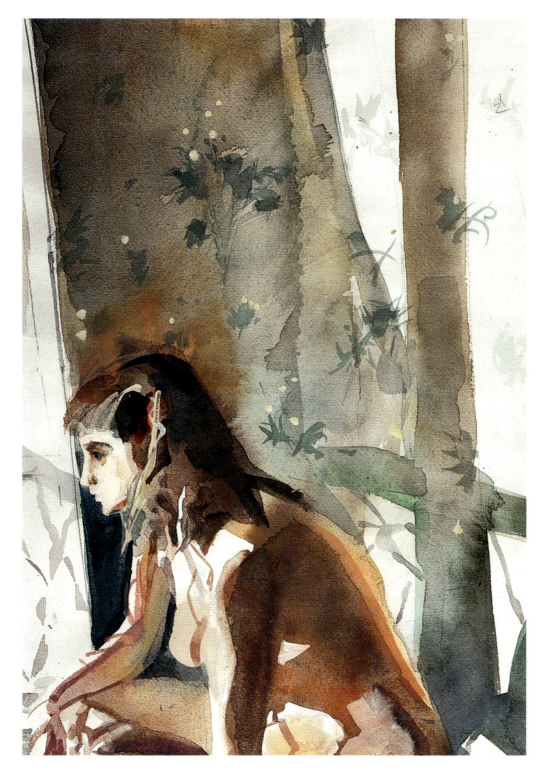

125

TECHNIQUES

LIGHT THROUGH MUSLIN

The way Stan Smith approaches these descriptions of light is very simple indeed, though it takes practice, confidence and skill to know just how much or how little to do. In places he uses very little paint; calligraphic marks describe and follow forms, a splash of light is hinted at by the contrasts or shadows that define it, and what is left out is as important as what he chooses to put in.

Watercolour allows you to say a great deal with very little, but you do have to plan to get it right. Here he has used the white of the paper and the transparency of the paint to create the illusion of a diaphanous fabric fluttering in the breeze from an open window. For the beginner it takes an enormous leap of faith to believe that you can do so little and imply so much.

▼ 2 *A flowing line captures the character of the main border decoration. There is no single correct way of painting any subject; artists are always searching for a means of describing what they see, an approximation that will work in the context.*

▲ 1 *Use a thin mix of Payne's grey to paint the pattern on the muslin curtains. Work freely, to achieve the broken and irregular quality of the pattern as it is modified by the folds of the fabric. Here the artist uses a twisting movement with the flat of the brush to create a continuous line that changes in width.*

▶ 3 *From the patches of white paper on the girl's face, and the way the white paper in the area of the window opening is broken up, we deduce that we are seeing light coming through a muslin curtain. When you study the picture in detail you will see that there are very few clues, but those that are given are very effective indeed. The artist has exploited the transparency of the watercolour, the crispness of edges and the white of the paper with a deftness of touch that comes from a lifetime of looking and exploring.*

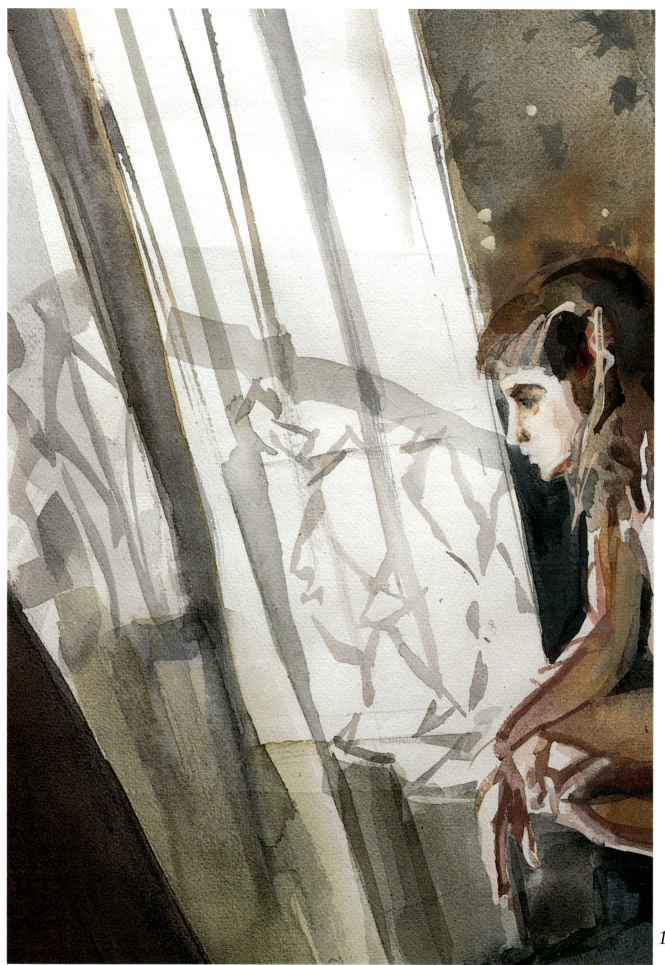

TECHNIQUES

DRAMATIC LIGHT

In this dramatic image light is very much the subject of the painting. It is a heightened, theatrical light, splashing down like a spot from above. Stan Smith is interested in the paradox of light as a transitory phenomenon and light as a constant. 'We tend to think of light as constantly changing, but although the light might be in this position at least ten times a year, the figure won't be there again,' he says.

The composition is based on a strong diagonal occupying the lower half of the picture plane.

The sitter was captured in the light cast through a Venetian blind. All the forms are picked out very simply by light overlaid on the flesh colour. The figure is loosely described in warm earth tones – burnt sienna, raw umber and yellow ochre – with Naples yellow for the light. Notice the way the bands of light are seen as a warm buttery colour as they illuminate the flesh tones, and a cool blue as they fall across the blue carpet. The insubstantial background focuses attention on the figure, rendered in a neutral mix of Payne's grey and cobalt blue. 'The background mustn't be dead,' Stan says. 'It must have tonal value. But it must also have colour value. Something with a little bit of the complementary will give it zest. Here the orangy flesh tones are enlivened by the complementary blues in the background.'

The artist used a combination of gouache and body colour (opaque forms of watercolour) on a warm neutral paper.

▶ **1** *In this dramatic study of a figure, light is the real subject of the painting. The artist has simplified the bands of light to create a dramatic effect. I was interested in the way the bands of paint had been applied, as the precision of the mark didn't look like the mark of a brush. I asked the artist, Stan Smith, to re-create the process for me.*

▼ **2** *The flesh tones were laid in simply in warm earth colours. The artist then cut narrow strips of paper, the width of the required mark, and loaded them with paint.*

▼ **3** *The paint-covered strip was then touched on to the figure to create a band of colour.*

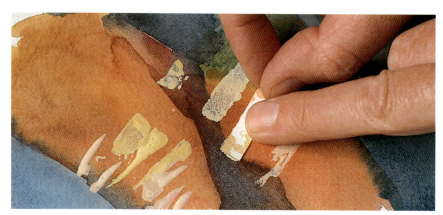

▼ **4** *The mark left has an interesting quality: crisp edges and an uneven paint application that combines the qualities of controlled and accidental marks.*

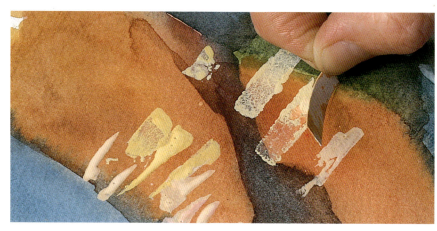

Light in interiors

MOST OF US spend much of our time indoors, in our home or office, or in public spaces like shops, banks or museums, so the interior provides an obvious and available theme for the artist.

The interior space is an enclosed composition. The space is defined and contained, so the artist can ensure that the viewer's eye is held within the picture area. The subject has an inherent completeness.

Studies of interiors generally have a revealing and intimate quality, providing an evocative glimpse of domestic spaces and everyday objects, of someone else's life. Still-life or figure groups are often included, sometimes providing an important focus, often as an incidental part of a complex whole.

Your own home will provide you with a rich source of subjects – the cluttered corner of a living room, a hallway with discarded coats and boots, or a bedroom glimpsed through a half-opened door. Subjects such as these recur time and time again in the work of artists like Pierre Bonnard (1867–1947), Gwen John (1876–1939) and Edouard Vuillard (1868–1940).

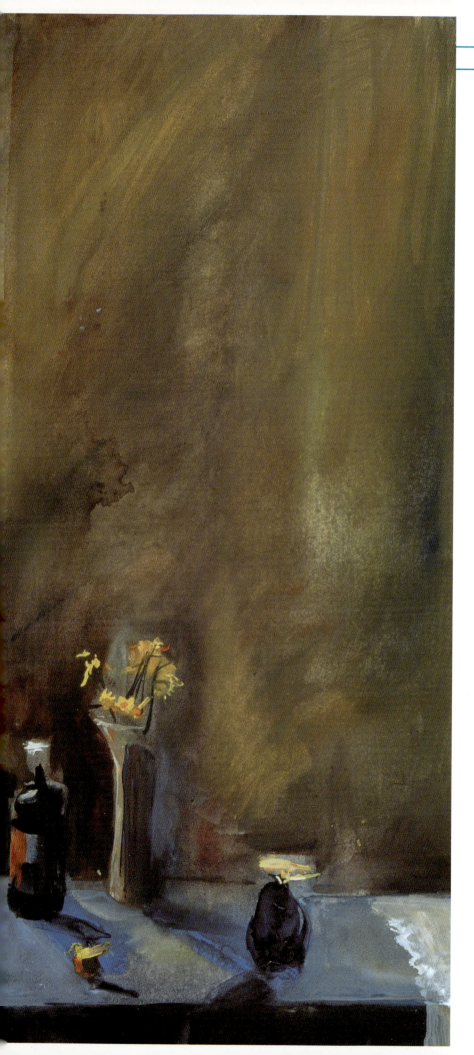

'Interior with Bottle and Flowers' by Sophie Knight. There is a marvellous sense of filtered light in an enclosed, interior space in this luminous and atmospheric painting. The artist used a combination of watercolour and body colour, building up layers of transparent and semitransparent colour for the golden background. These insubstantial paint layers are contrasted with the touches of bright opaque colour – on the flowers and on the objects on the table. The brilliant blue of the tablecloth is complemented by the touch of bright orange on the label on the bottle.

NATURAL OR ARTIFICIAL LIGHT?

Light is often the real subject of an interior study, establishing a mood, holding disparate elements together, emphasizing forms here, rendering them ambiguous there.

Natural light streaming in through a window or an open door introduces a sense of 'outside' and the open spaces beyond the enclosed interior. Sometimes the light source is seen and a view through a window or a door gives us a glimpse of landscape or garden – another world. Traditionally the light source was often placed beyond the picture area, so that observed light and shadow are the only clues to its existence.

Artificial light sources emphasize the contained or even claustrophobic nature of the interior and can be used to spotlight some areas, creating mysterious pools of darkness elsewhere. It is more intimate and concealing, and because it belongs in that space it has a more self-contained quality.

There are many different artificial light sources, each with a different mood and colour. A single incandescent light bulb casts a bleak, pitiless light with harsh, often strange shadows. A gleaming brass candelabrum suggests magnificence, while table lamps and standard lamps create pools of intimate light throughout the space, with mysterious shadows between. In our homes light is used quite consciously to create mood. We have direct light to work by, but wall lights and table lamps are used to create atmospheric background lighting. Romantic dinners are candlelit, and firelight has such an evocative appeal that fake fires fuelled by gas are common in homes in smoke-free zones.

Artists prefer natural light because all artificial light distorts colour to a greater or lesser degree. Natural light can be modified by blocking it with drapes or filtering it through gauzy fabrics or Venetian blinds. Stan Smith's paintings on pages 115, 123 and 128 all deal with the human figure seen in

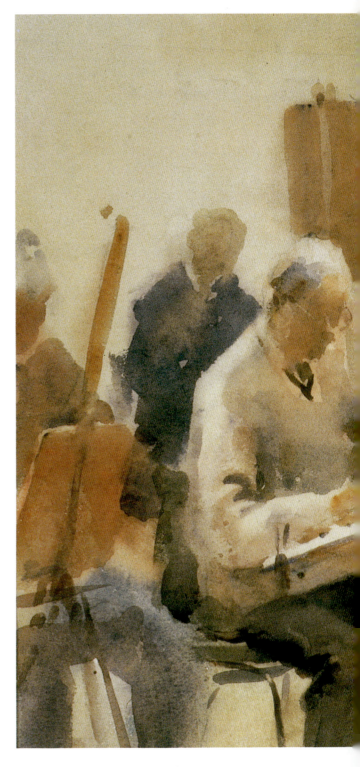

an interior illuminated by modified natural light.

Artificial light is controlled light. It can be turned on or off, raised or lowered, directed on to the subject or bounced off an adjacent surface. A shaded light creates an area of direct, bright illumination, but a more diffuse light generally percolates through the shade, bathing adjacent

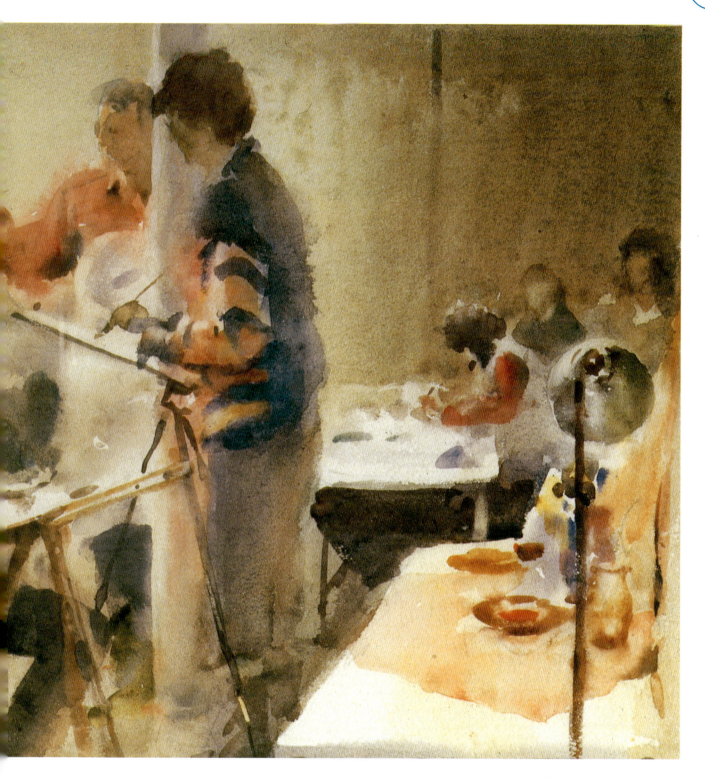

objects in a soft and often coloured glow that gives the group a harmonious unity. An Anglepoise or a spotlight can be used to create a dynamic directional light. Light can be used to distort forms so that they become strange. For example, as a child you may have put a torch under your chin so that your face was lit from below; the effect is quite disturbing.

▲ *'Still Life Session at the Seed Warehouse' by Trevor Chamberlain. Still life groups can generally be arranged so you can 'compose' the subject itself as well as on the support. Light is a very important element – here the painters have a desk lamp directed onto the subject. The light is being thrown from the side to give a variety of interesting shadows.*

133

PROJECTS

ARTICHOKE FLOWER

A single flower in a bottle provides the motif for this painting. It is a simple subject, but with a little thought Stan Smith has made something beautiful and intriguing of it.

In a very shallow picture plane the painting establishes an inside/outside theme, with light passing through the window and picking out the flower head. This is enhanced by the contrast between the dimly lit and muted interior space and the brightly lit exterior. Notice the way the strip of the window reveal takes the full force of the light, providing a particularly sharp contrast between one area and another.

Out of the window we can see a chimney, which appears almost the same size as the plant, though in fact it is much larger. This introduces an element of ambiguity and tension. The rich warm oranges of the chimneypots pick up the golden ochre of the flower head, providing a visual link, on a diagonal that runs from corner to corner of the image.

To capture the crisp transitions between light and dark the artist masked the areas, using masking tape and masking fluid. Masking is an extremely useful technique that allows you to flood colour on, keeping it loose and free, overlaying and letting one colour melt into another. If the colour looks as though it is going to run away from you, it can be arrested by drying it with a hair-dryer. Then at the very end you can remove the mask to reveal crisp white paper. The white paper can be left as high-light or local colour (daisies, for example), or it can be washed with bright, pure colour to create a brilliant focal point, as the artist did with the golden flower head. Because masking is so effective, there is a temptation to overdo it, so that it becomes a cliché. In the project on page 150 the artist has reserved many areas of crisp white or pale tones without using any masking technique.

▲ **1** *A deceptively simple subject – an artichoke flower in a bottle, on a windowsill – provides the artist with a stimulating subject.*

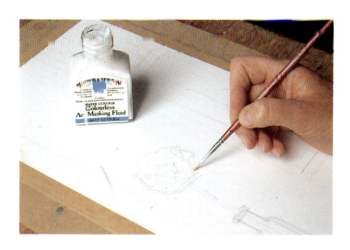

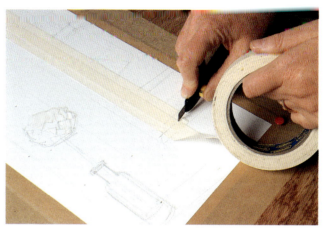

▲ 2 *The artist worked on a sheet of Saunders Waterford watercolour paper with a rough surface. He drew in the broad outlines of the subject with an HB pencil. He wanted to capture the way the flower catches the light. To reserve the paper so that he could judge the correct tone at the last minute, he masked it with colourless masking fluid.*

▲ 3 *The other bright area in the subject was the inside of the window reveal. He could have masked this with fluid, but it was a large area and he wanted a neat 'architectural' edge. Masking tape was used here and is an ideal solution. This is a low-tack tape, available from art and graphics shops. He laid it down and trimmed it off with a craft knife.*

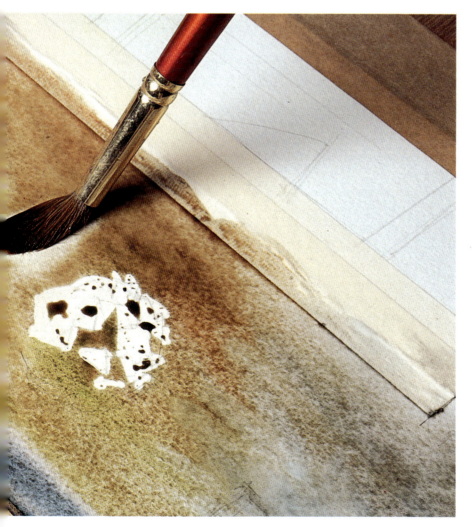

◀ 4 *Colour is washed on – Prussian blue with a touch of alizarin, crimson and raw umber – applied wet-in-wet. You can wash the colour right over the masked areas.*

▼ 5 *The chimney is laid in with Indian red.*

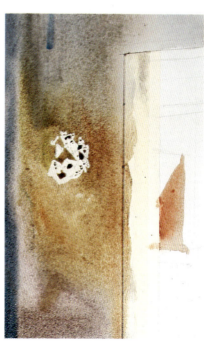

135

▶ 6 *The area beyond the window was washed in with ultramarine. Then the artist drew the bottle in thinned black with just a little ultramarine. Using the same mix, he then drew in the linear details around the window. He used a ruler to guide him. To do this, hold the ruler on its side and use it as a guide for your hand. If you rule against the ruler itself, you risk paint getting under it.*

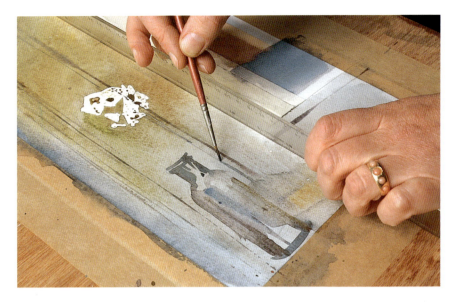

▶ 7 *Masking fluid can be removed by rubbing it gently with your finger; it comes away as a rubbery film. This must be done when the paint is dry.*

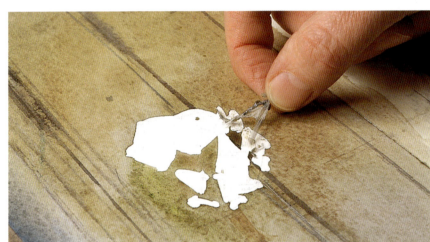

▼ 8 *Next the masking tape is removed.*

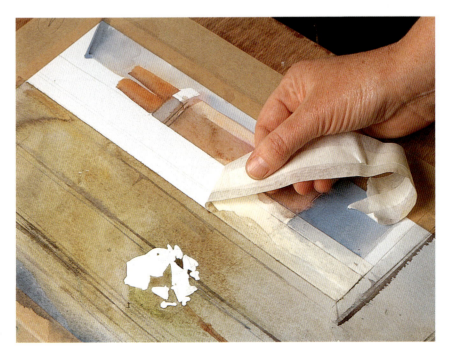

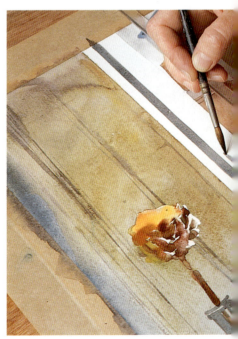

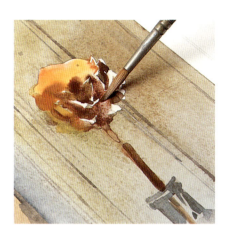

▲ **9** *The colours of the flower head can now be washed in on the fresh white paper. The artist used cadmium yellow deep for the top side and Indian red with a touch of ultramarine for the lower petals.*

▼ **10** *A few more lines are drawn in using the ruler, in ultramarine with a touch of black.*

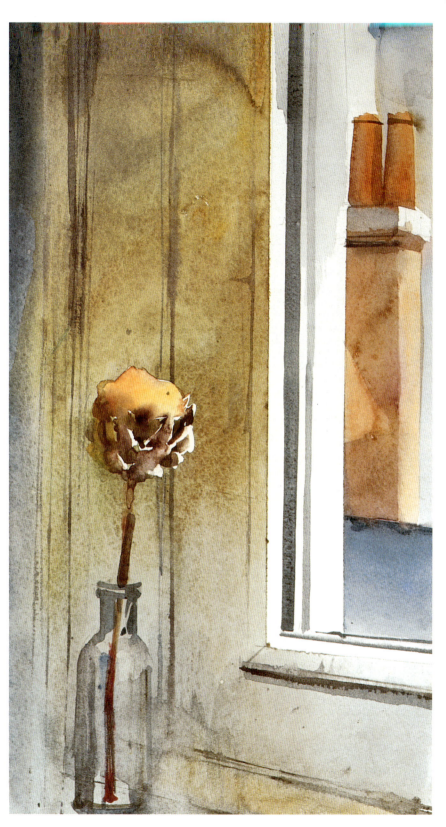

▲ **11** *In the final image there is a harmony of warm and cool colours. The vertical support mirrors the vertical nature of the flower and the chimney.*

CHILD CONTRE-JOUR

The figure *contre-jour*, or against the light, has long been popular with artists. By placing the figure in partial silhouette, the image is bathed with a diffuse, mysterious light. The viewer is given some information, but much of the image is implied and ambiguous. If the figure is placed against a very bright light, the result will be harsher and more dramatic – with more contrast between the light and dark areas. To achieve a true *contre-jour* effect, you may need to filter the light by draping muslin or some other fine fabric over the window.

The figure in an interior has been a common theme throughout art history. As soon as a figure is introduced, it tends to become the focal point, no matter how small or sketchily defined. The child was caught in profile just as she got up from the table. The moment is transitory, the movement out of the picture space implicit in her stance. She is trapped in light and rendered timeless on the picture surface.

Francis Bowyer treats the figure and her surroundings as a pattern of light and dark, with diffuse light defining forms, echoing tones and colour, and melding the whole into a single coherent entity.

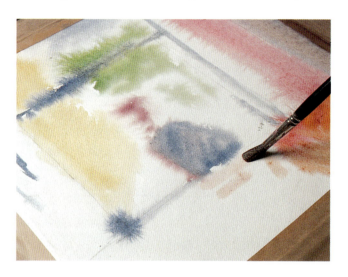

▲ **2** *The artist has flooded the paper with water and lays in the broad forms of the subject using sap green, ultramarine, yellow ochre and alizarin crimson.*

▼ **3** *You can see the way in which the wet-in-wet application causes the forms to dissolve, creating ghostly images. It takes great confidence to work in this way. By applying the paint boldly with a loaded brush or by allowing it to bleed off the brush, the artist keeps the paint fresh. Avoid the temptation to overwork the surface or scrub one colour into another.*

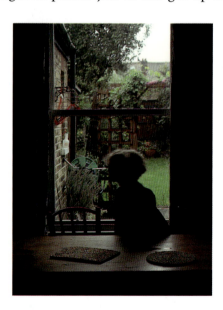

▲ **1** *The child was captured as she rose to leave the table – a movement caught in time. The artist made a sketch on the spot and then worked the image up in his studio. We have re-created the event to give you an idea of what he was working with and what he made of it.*

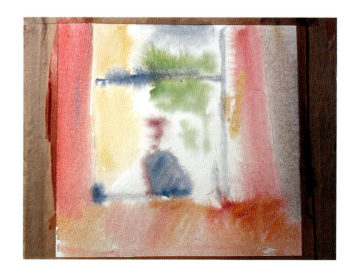

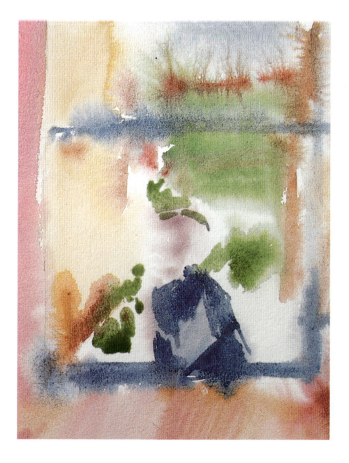

�*4 The subject is very broadly established, but it has been carefully observed. The artist works fast and with great intensity, then breaks off to spend some time contemplating the image.*

▼ *5 More washes of pure colour are added – cool blues for the figure, which is cast into shadow, and warm, rich colours for the drapery about the window, where it catches the light.*

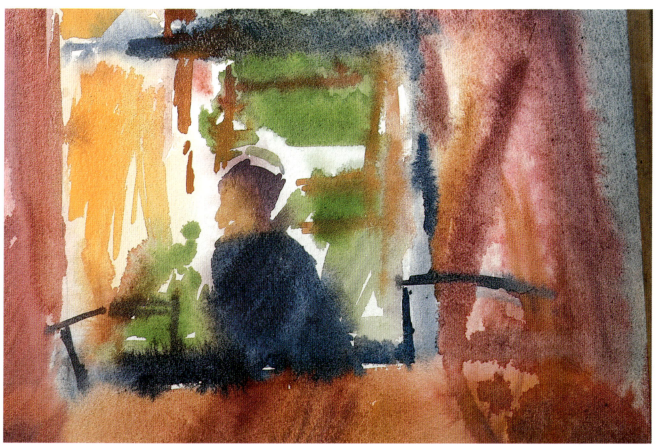

◄ 6 *The artist drops a pair of L-shaped masks around the image. This helps him 'see' how the composition is working. He also experiments with cropping the image, to see if it might look more effective as as a square rather than a rectangle, for example.*

▼ 7 *Here he saturates the paper with water so that he can apply more colour wet-in-wet.*

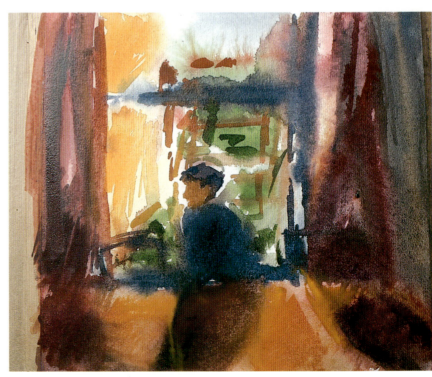

► 8 *The image is clearly established – it is figurative, with abstract qualities. These are evident in the way the artist interprets light as patches of pure colour.*

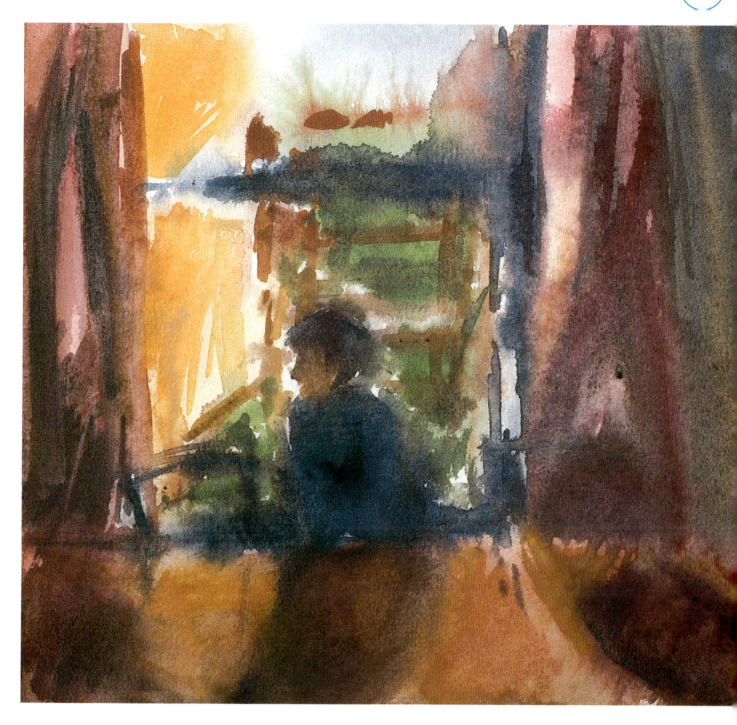

▲ 9 *The artist wanted to achieve a particular mood in the picture and having contemplated it, he added more paint layers, some opaque, some transparent. The final image is descriptive and entertaining, a symphony of light and dark and patches of colour.*

PROJECTS

CANDLELIGHT 1

Candles produce a soft, flickering light that gives the most mundane setting an aura of mystery and romance. The flame has a brilliant, pulsating intensity, while a halo of illumination spreads out from the centre, creating an envelope of hazy, shifting light. Candlelight has a luminous quality, with subtle gradations of tone rather than the harsh contrasts of incandescent light. To show luminosity you need a fairly limited palette and muted colours.

In our studies the candle is placed within the picture area. The flame is the lightest area in the picture; everything else is darker in tone. Colours are subtly shaded and graded from the flame out to the concluding darkness. Find a way to soften the edges of each gradation so that it blends into the adjacent area.

Adrian Smith tried two different approaches to the image. In the first he worked up the tones in charcoal, fixing them and then washing colour over the tonal study. The combination of charcoal and fixative gave the paper an absorbent quality, with the watercolour tending to seep and bleed, creating a softly blurred effect that suited the subject.

▲ **2** *The artist started by blocking in the dark areas using a charcoal stick. In some areas he used it on its side to block in broad areas of tone. Here he uses a soft putty eraser to pull out areas of highlight.*

▼ **3** *When the artist has established the lights and darks to his satisfaction he fixes the drawing. This prevents the charcoal powder from contaminating the watercolour.*

▲ **1** *This is the subject, but not precisely as the artist saw it. He worked without any background light at all; the photographer, on the other hand, used a flash.*

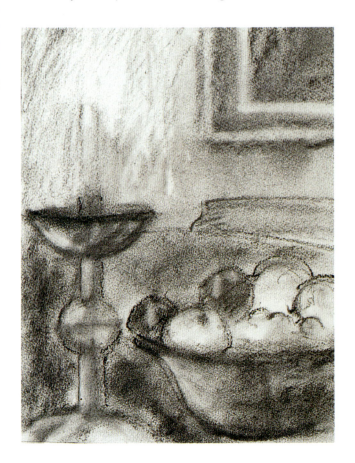

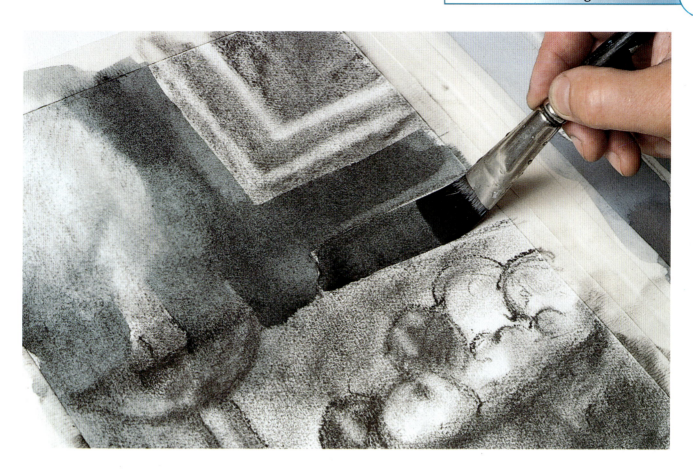

▲ **4** *Using a mix of ultramarine, cobalt and Payne's grey, he washes in the background. The paper has become very absorbent – a bit like blotting paper.*

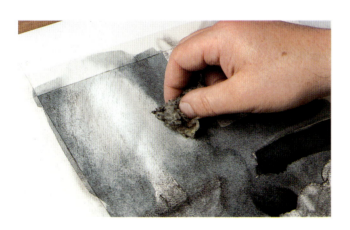

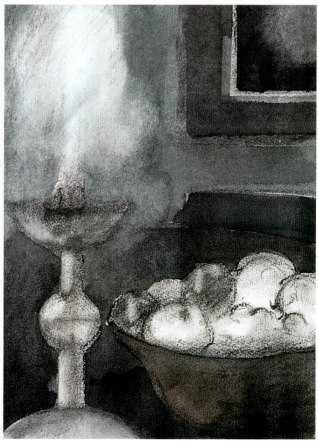

▲ **5** *He uses a mix of indigo and raw sienna for the darker tones, letting the colours run and blend. Here he uses a wet sponge to lift off colour around the halo of the flame to heighten the effect.*

▶ **6** *He uses the indigo–raw sienna mix to lay in the dark side of the fruit dish. The light and dark tones have now been established.*

143

▶ 7 *He next touches in local colour, primarily in the illuminated areas, where the light allows the colour to be seen.*

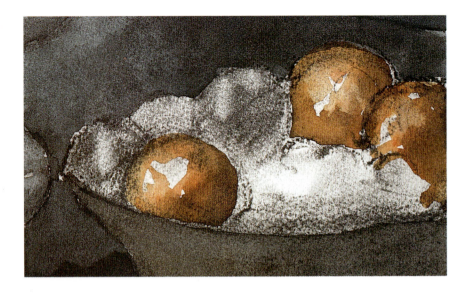

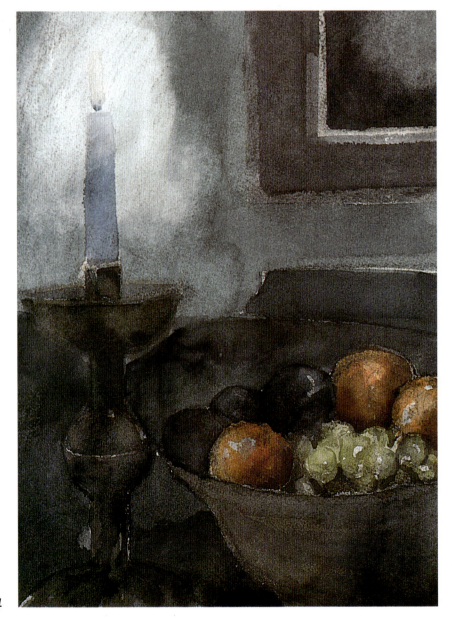

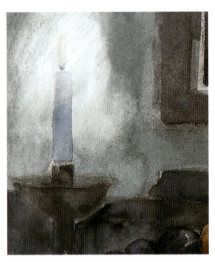

▲ 8 *The rough texture of the paper combines with the grainy quality of the charcoal underdrawing to create a diffuse aura which captures perfectly the flickering quality of the candle flame.*

◀ 9 *The final image captures the drama of the subject. Now look at the next study of the subject, for which the artist used a different technique.*

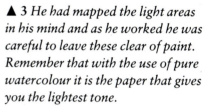

PROJECTS

CANDLELIGHT 2

You can learn a lot by returning to the same subject again and again. In this second study of candlelight the artist worked with pure watercolour, building on the experience gained in the first study. Don't think that when you have painted a subject you have finished with it. Each time you will see different aspects of the subject and new solutions will occur to you.

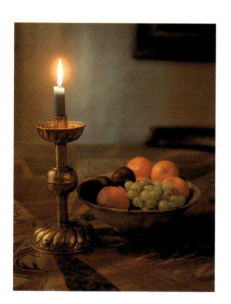

◄ 1 *The artist is painting the same setting as for the previous project.*

▼ 2 *The artist started by first establishing the main elements of the subject in pencil. The drawing should be accurate, but remember that you can make adjustments as you paint. He studied the subject carefully, deciding where exactly the mid-tones lay. He mixed a wash of ultramarine, cobalt and Payne's grey. He used a large wash brush loaded with colour and, working quickly, laid in the first wash.*

▲ 3 *He had mapped the light areas in his mind and as he worked he was careful to leave these clear of paint. Remember that with the use of pure watercolour it is the paper that gives you the lightest tone.*

▼ 4 *He then made a darker colour by adding indigo to his blue-grey mix and laid in the darkest tones in the shadow areas.*

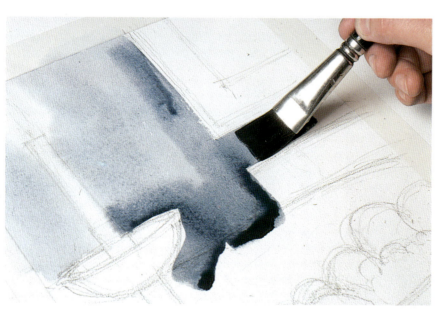

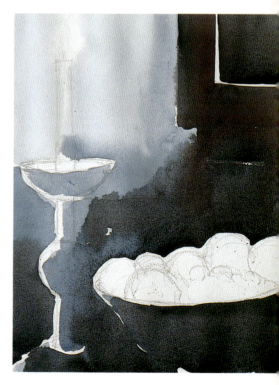

▶ 5 *He uses a broad 'one-stroke' brush to paint the candle stick. He wanted to give the candle a crisp outline to emphasize the strong tonal contrasts. Here the candle is seen against the soft light being bounced against the wall behind.*

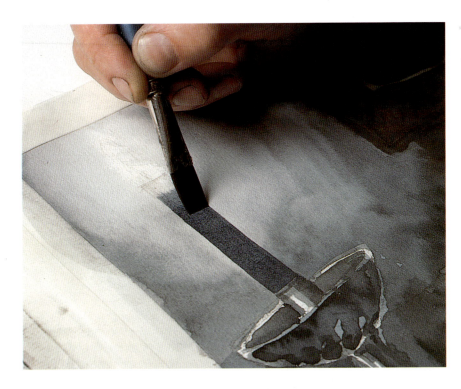

▼ 6 *He intensifies the aura of the candle flame by sponging out colour with a damp sponge. Although watercolour has a reputation for being difficult, it is actually quite forgiving. You can lift out colour and make adjustments to a remarkable degree, especially if you use good-quality paper.*

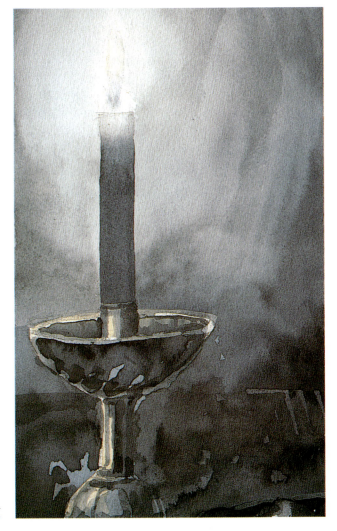

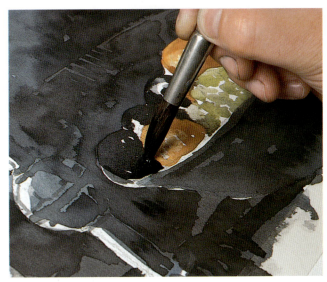

▲ 7 *Here he has laid in the local colours in the fruit dish – orange and green. He then adds darker tones to give the fruits form.*

▶ 8 *In the final image the paint surface is fresh and exciting and the artist has captured the mysterious, shifting quality of the candlelight.*

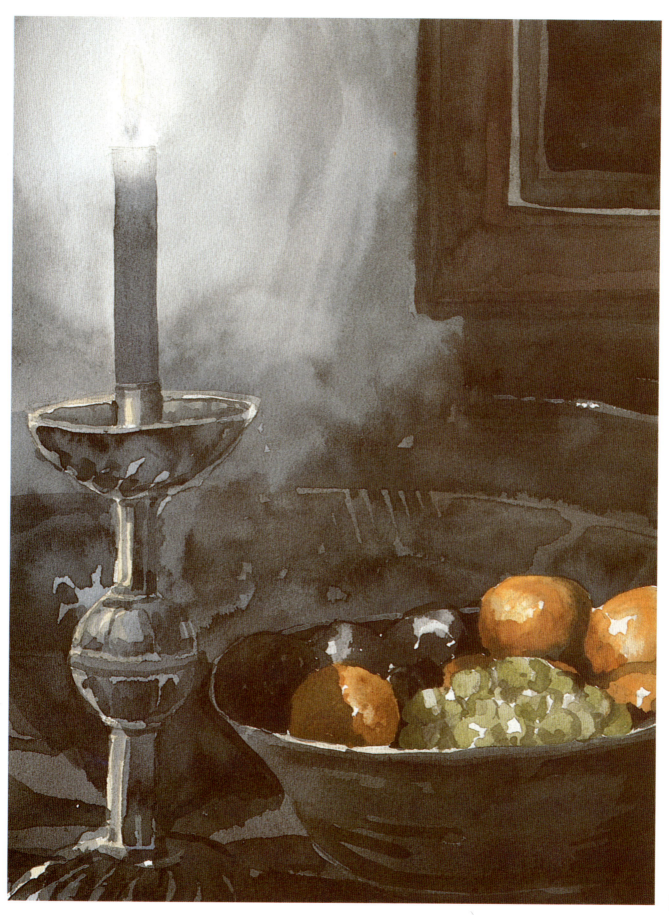

CHAPTER 4 CHAPTER

Outdoor light

T HE APPEARANCE OF the landscape is affected by the quality of the light. This in turn is affected by factors like weather, time of day and even geographical location. The appearance of a landscape can change dramatically from one day to the next, even from minute to minute.

Rain, snow, fog and mist can transform the landscape, and each has its own magic. On a foggy autumnal day only a little weak light manages to struggle through the veil of swirling mist. Water droplets in the air scatter and filter the light, draining colours of their intensity and giving them a bluish cast. Spatial arrangements become confused as tonal contrasts are evened out, forms are flattened and the details of objects appear blurred and indistinct. In such conditions the artist searches for subtle nuances of colour and tone, mixing a range of warm and cool neutrals to create a subdued but atmospheric image.

The same stretch of the countryside will look entirely different on a sunny summer's day. Brilliant sunshine creates contrasts of light and dark, throwing some areas into harsh relief and plunging others into impenetrable shadow. Colours will be seen at their most intense, though on a really dazzlingly bright day they can appear bleached and washed-out.

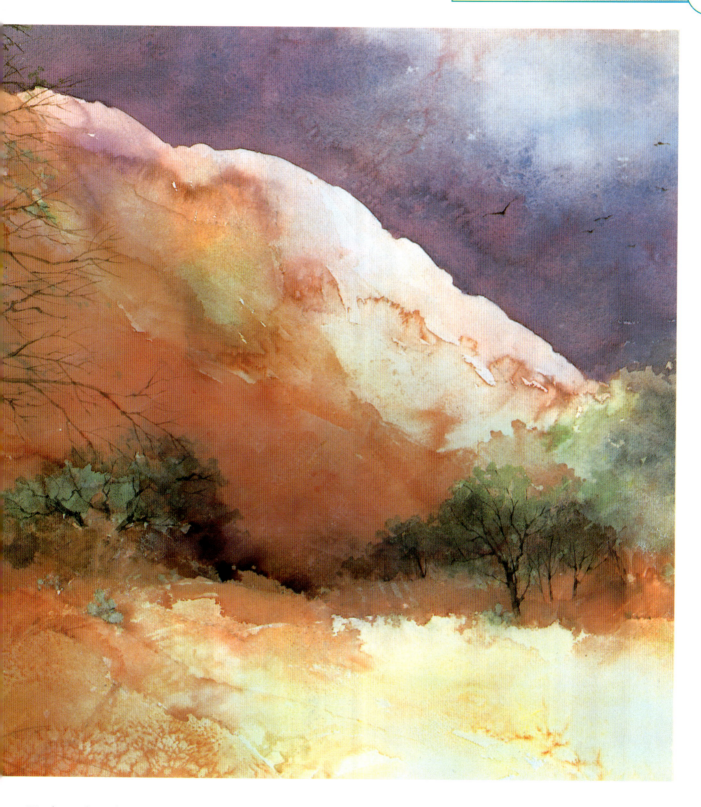

'Enchanted Rock, Texas', by Shirley Felts. This is an area she returns to time and time again. The heightened colour produced by the threatening storm gives the picture a magical quality.

PROJECTS

TREE ON THE DOWNS

No other medium serves light as well as water-colour. Light is transitory and ambiguous, and in watercolour the white of the paper has some of the same qualities. Just as dark tones and shadows define the bright areas in the subject, so it is only when washes of paint are applied that the paper begins to read as highlight. Stan Smith's treatment of shadow in this study illustrates the point very well.

The stand of trees in its sunny downland location provided an excellent motif for the study of light and shadow. The dark foliage was broken up by a pattern of white branches, boughs and twigs, counterpointed by the tracery of their shadows on the silvery tree trunk. This is a perfect demonstration of how light strikes objects and creates shadows suggesting the dimensions, shape and character of the object on to which they are cast. The highly contrasted lights and darks help to emphasize the brilliance of the day.

All the shadows have a colour value, so don't be tempted to render them in black and white. Create dark tones that have richness by experimenting with mixes – raw umber (a yellowish brown) and Prussian blue (an icy blue) will give you a deep olive, for example. Don't cheat by adding colour to black, because the mixes will be leaden.

The artist used a box of sixteen pan colours with two places to mix colour – the lid and a fold-out palette. He used one brush – a No. 10.

Working quickly, he laid in broad washes of colour, allowing the colours to blend. He left the painting to dry then applied more washes, keeping the image simple and fresh.

You will learn a lot by trying to replicate this painting, but do find opportunities to work directly from nature. Even in a city, there should be a garden or park where you can practise and hone your powers of observation.

▲ **1** *The subject was a tree on a vegetation-covered bank, with summer sun slanting through it. The artist was fascinated by the complex tracery of branches, seen as shadow on the silvery trunk of the tree.*

▼ **2** *Working conditions are not always ideal out of doors, but the artist made do, squatting on the ground to work and replenishing his water jar every now and then from a nearby stream.*

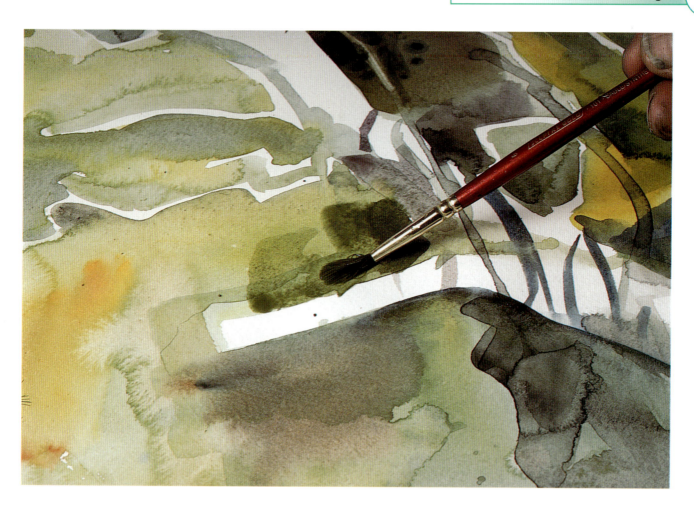

▲ 3 *The artist laid in a wash of greens – sap green, a green mixed from cobalt and cadmium yellow, and a dark green mixed from viridian with raw umber for the dark tones. He didn't have masking fluid so he worked carefully to reserve the white of the paper for the highlighted areas. Crisp edges and sharp contrasts of tone create the effect of maximum brightness.*

Simplify the forms that you see and work boldly. Don't move the paint around too much, otherwise it will soon lose its freshness and look overworked.

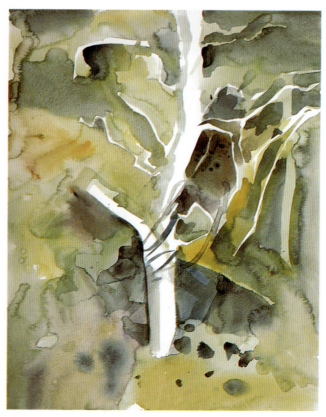

▶ 4 *Here you can see the structure of the painting. It is comprised of initial washes and colour added wet-in-wet. More colour was added as the paint surface dried, causing the colours to 'flare' – a happy accident that helps describe the clumpy foliage of trees. Over this he has laid more washes, constantly adjusting his mixes to match the observed colour, but always simplifying, trying to find a direct way of expressing what he sees.*

▶ **5** *Darker tones are laid in with ultramarine and darkened green mixes. Cadmium yellow is laid on over the previous washes, now dried in the sun. This warms the areas in the foreground, where the sun warms grass and foliage.*

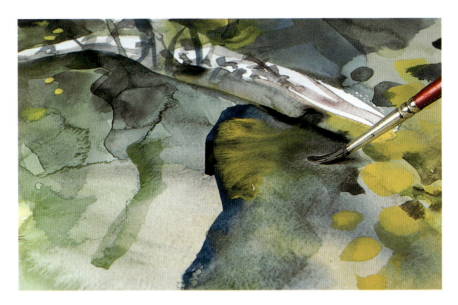

▼ **6** *To capture the intensity and depth of the dark areas in the dense summer foliage, the artist is building up successive layers of transparent colour. This creates dark and mid-tones of great luminosity.*

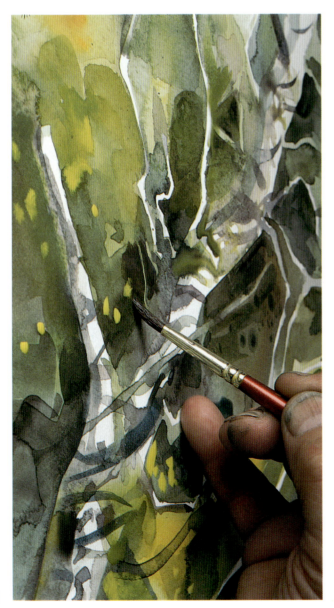

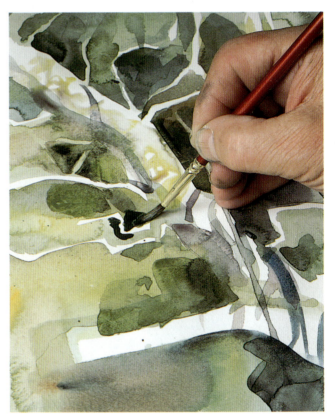

▲ **7** *Here the artist is using the tip of his brush to define some of the branches. He is painting the foliage between, leaving the branches as lighter areas – the negatives rather than the positives.*

▶ **8** *The final image captures the warmth and brightness of the sunny day with great economy. It was painted entirely on location and the artist has successfully captured the mood of the scene.*

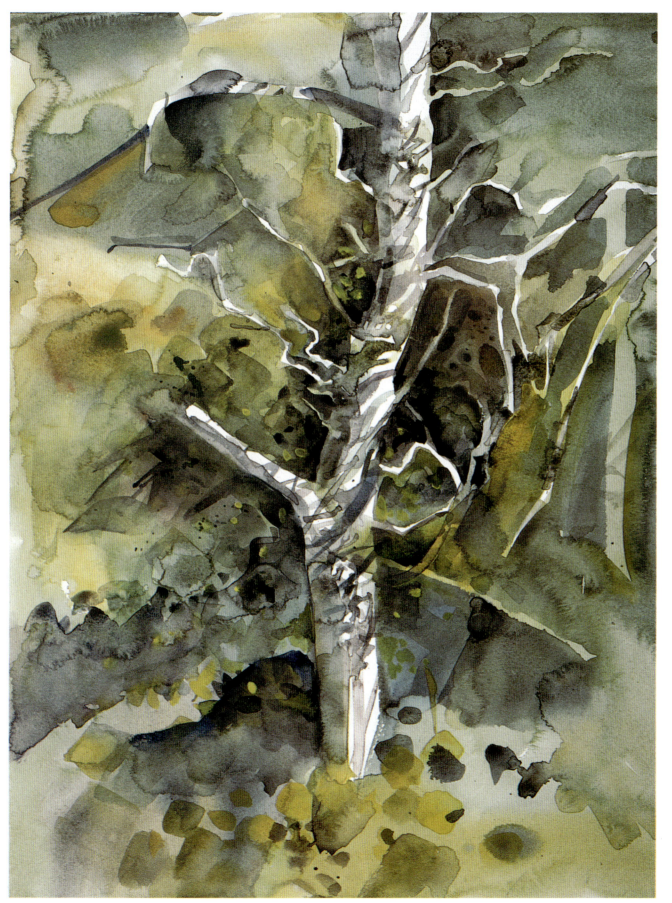

PROJECTS

VENICE

This painting was developed from a sketch made on location. Albany Wiseman visited Venice quite early in the year. His main concern was to capture the luminous quality of Venetian light, which results from the city's unique combination of big skies over expanses of water. The city often appears insubstantial, a mirage floating on a shimmering surface of water, seen through a gauzy veil of dancing light. Since its foundation, painters have been drawn there, keen to experience its strangely theatrical qualities, impelled to capture an impression of them in paint. So often has the city featured in paintings, drawings, photographs and films that even the first-time visitor has a sense of *déjà vu*.

In this painting the artist depicts that time of day when the city is reduced to a silhouette by the setting sun. The 'cut-out' profiles of rooftops overlap like stage flats, the effects of atmospheric perspective making them appear paler and bluer as they recede into the distance. The artist has focused on this effect, using a limited palette of colours and a series of overlapping washes to describe clusters of buildings. The water, too, is handled with a simple but sure touch. If it were laboured and overworked, it would lack the sparkle inherent in the theme of light on water.

By rigorously editing, selecting and organizing the elements of the composition, the artist has created an image which has a pared-down beauty. And if you study the step-by-step stages, you'll find that he has managed to make the process of painting the picture look deceptively simple too. In fact, the process describes a few easy-to-master techniques which the amateur painter can put to good use in his or her own work. The painting is a fine example of the way that practice and the ability to observe and analyse give an artist the confidence to temper boldness with restraint when appropriate to the subject. You might find it difficult to get started, but it takes years to know just when to leave well alone.

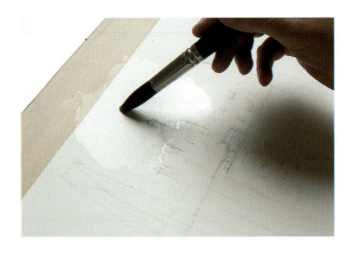

▲ 1 *The painting shows a mist-shrouded sun shining on to the water. The artist used masking fluid to reserve the white paper in those areas where the sun illuminated a path across the water, glancing across the top of the ripples in the water. To create the indistinct image of the sun just behind the church, he wet the paper in that general area. He then laid in the rest of the sky wet-on-dry, using a wash of Naples yellow.*

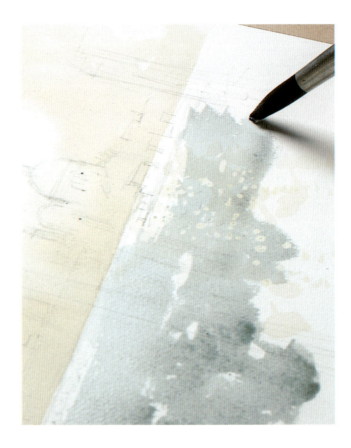

▲ 2 *He mixed up a colour for water from Prussian green – a dark bluish green – and Winsor blue with a touch of Van Dyke brown.*

▶ **3** *He used tissue to lift out some of the colour from the path of the sun – the sun on the water was so bright it was very light.*

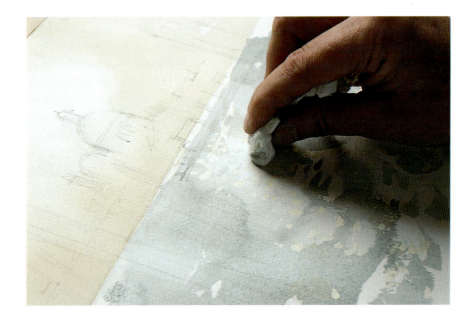

▼ **4** *For the buildings he used Winsor blue with a bit of alizarin crimson and Van Dyke brown, keeping the edges crisp, so that they showed dark against the light sky.*

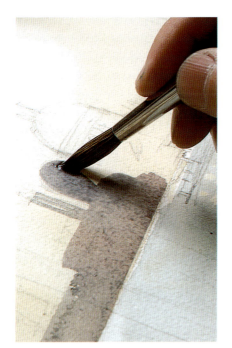

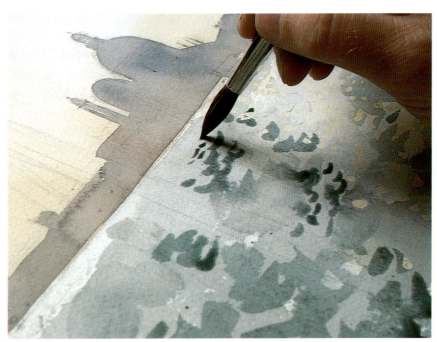

▲ **5** *He applied a darker tone in the water for contrast.*

◀ **6** *The artist's approach is deceptively simple, but it takes a great deal of practice and a lot of planning to produce such an effective image.*

155

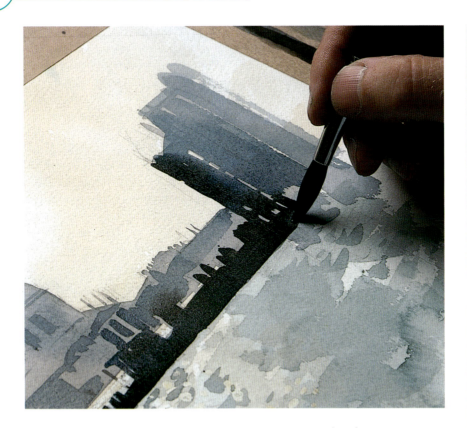

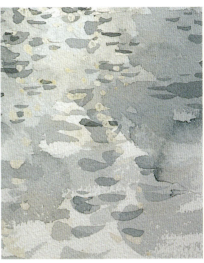

▲ 7 *A slightly darker tone is applied in the middle distance.*

▼ 8 *Using a dark wash of Payne's grey mixed with Van Dyke brown, the artist starts to put in the poles that emerge from the water. He uses a big brush loaded with paint to give the mark a textural quality.*

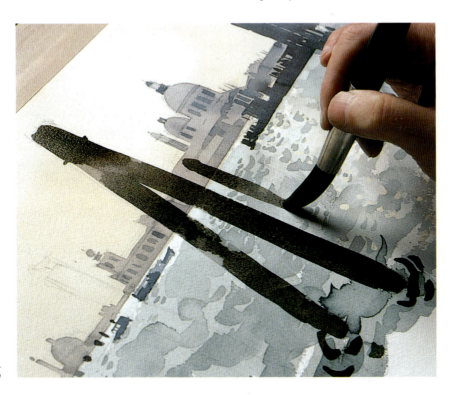

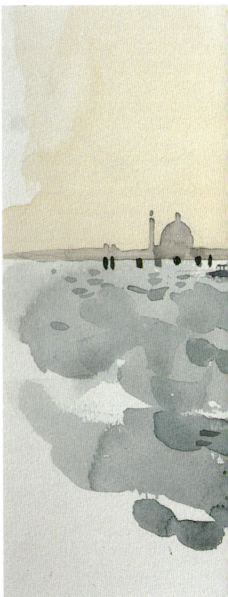

◄ **9** *In this detail we see the water before the masking fluid is removed.*

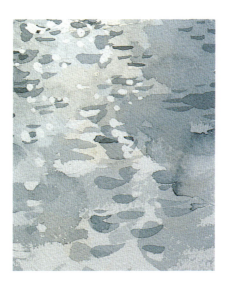

► **10** *Here we can see the way the water sparkles when the masking fluid is removed.*

▼ **11** *The final image captures the mood of the place, the luminous quality of the mist-filtered light and the sparkling, light-scattering quality of the water.*

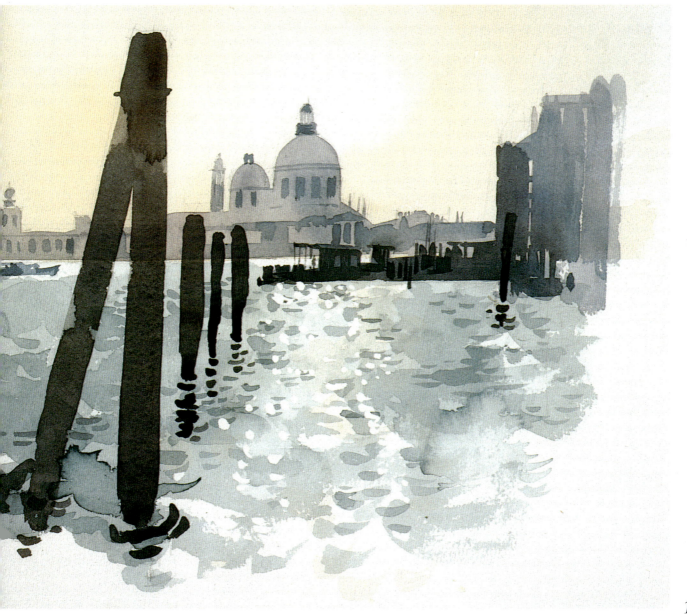

157

TECHNIQUES

TIME OF DAY

The character of natural light changes throughout the day, so that bright, early morning light has a very different quality from the glimmering, silvery light of evening. Both colour and the direction and intensity of light and shadows change as the sun rises, passes overhead and then sinks in the west. This means that the same scene can reveal many different appearances, characters and moods in a single day. Weather conditions and seasonal changes increase these potential differences, so that the artist can paint the same scene time and time again and constantly find new themes and motifs.

The Impressionist Claude Monet (1840–1926) explored these changes in his series paintings. The first of these was the 'Haystacks' or 'Grain Stacks' series, painted in the autumn of 1890. He would go out to paint in the early morning or in the hours before sunset, taking paints, easels and several partially completed canvases, often conveying his equipment in a wheelbarrow. He would then work first on one canvas, then on another as the light changed, finding the canvas that most closely resembled the scene in front of him. In this way he was able to record precise shifts of light and tone, and subtle nuances of colour. He was trying 'to convey the weather, the atmosphere and the general mood'. In the 'Grain Stacks' series he also recorded the seasonal changes, capturing the golden colours of autumn, the cold bluish tones of a snowy winter landscape and the fresh pinks and greens of springtime.

Try painting one scene – the view through your window perhaps – in morning, afternoon and evening light, or on a sunny day and in overcast or rainy conditions. Concentrate on the broad forms, the groupings of light and dark, and the colour balances. Watercolour is ideal for making quick notes. Make as many as you can and don't review them until you have several that you can compare and contrast. You will be surprised how very different the results are.

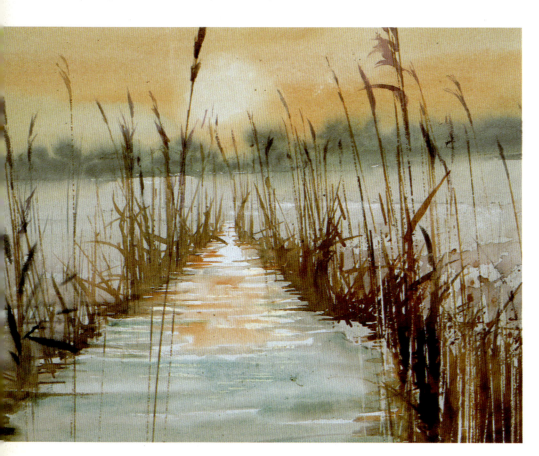

On these pages we show two studies of early morning by different artists. In 'Dawn Mist' by Charles Bartlett, the artist has captured that moment when the rising sun begins to warm and burn up the chilly mists hanging over the marshland. In the second painting John Lidzey describes the same time of day as seen from the window of a north London house. He uses watercolour and Conté pencil, contrasting the orange sky with the complementary blues of the gardens that are still in deep shadow.

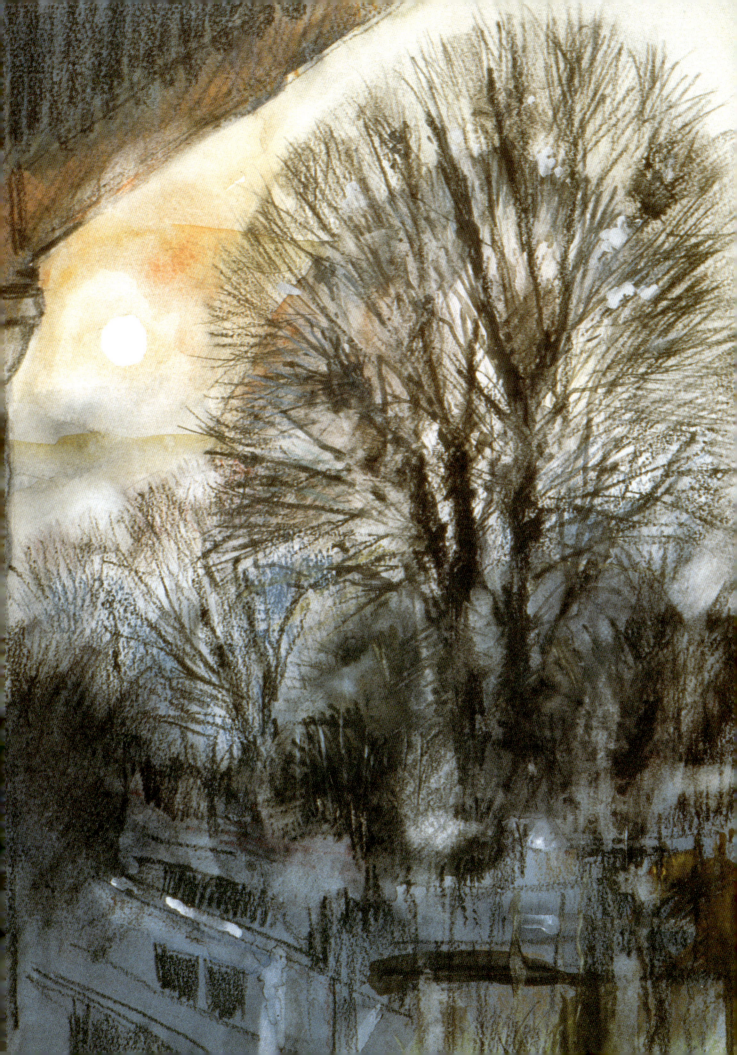

PROJECTS

GATEWAY IN TRASIERRA 1

In the following pages Albany Wiseman shows just what a difference a few hours can make to the way a scene is lit, and to the appearance and atmosphere. He has painted two versions of the same scene, one with bright light falling directly on the gateway and the other when the sun has moved, so that the gate is almost backlit. The first was painted in the morning at about ten o'clock; the other was painted a little later.

He worked under a tree that gave a lot of shadow and contrast in the foreground. He drew the wall and the trailing ivy on the left of the picture in some detail, so that the eye is led up and into the painting, and ultimately through the arch that frames the courtyard beyond. This is the focal point of the painting.

He edited out the tree on the right and included a palm tree. Notice also that he cropped the picture. He felt that the weight on the left and right of the composition was too similar. By cropping one side, he gave emphasis to the other and energy to the painting.

Notice that the painting doesn't go right to the edge of the support. This gives the artist the choice of squaring it up at a later date if he wants to, and in many ways this also represents your field of vision more accurately – you don't see a rectangle in precise focus.

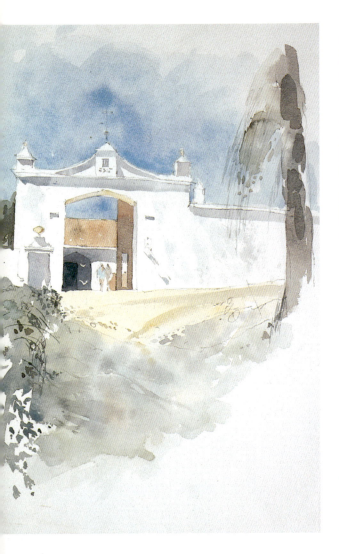

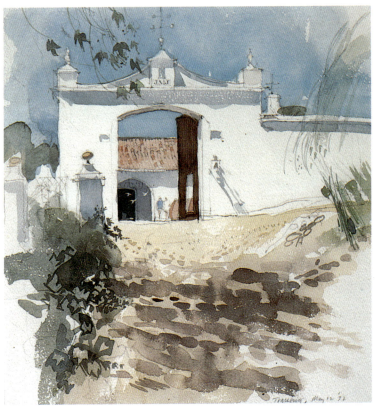

◄ ▲ **1** *Two studies of the same scene made on location at Trasierra in Spain. The artist was teaching there and often sat down to paint with his students. The sun was overhead, to the left and slightly behind him, so the sun fell directly on the gateway.*

▶ **2** *The artist worked on an 140lb (300 gsm) Arches Rough surface. He started by laying in the sky, wetting the paper first, then flooding in Winsor blue and dropping in some cerulean blue to create a subtly variegated effect. The sky is critical in a painting and needs to be handled deftly to keep the colour fresh if it is to be convincing. Avoid the temptation to move the colour about once you have put it on. Leave it to dry and you'll be surprised how effective it is.*

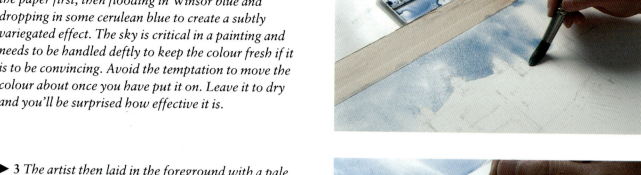

▶ **3** *The artist then laid in the foreground with a pale wash of Naples yellow. This is rather a chalky, slightly opaque colour, more like gouache in its characteristics than typical transparent watercolour. Nevertheless, it is a lovely warm yellow, which the artist finds ideal for painting in southern European and Mediterranean locations. He doesn't mix Naples yellow with other colours, because it does render them a bit opaque. Interestingly, when he goes abroad, he sometimes buys colours locally, because the palette he uses in the English climate needs supplementing.*

He was sitting under a tree. The dappled shadows in the foreground were laid in with a mix of Van Dyke brown and a bit of blue. The 'flare' is a bit of accidental mixing that the artist didn't intend but decided to leave.

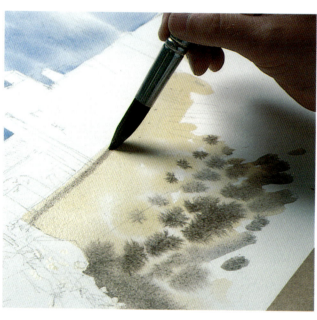

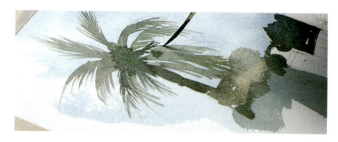

◀ **4** *He masked the forms of some of the ivy leaves with masking fluid. Do keep an old brush for this purpose and wash it carefully afterwards. When the masking fluid was quite dry, he laid in a loose wash of Hooker's green, which forms the basis of the foliage. He uses Hooker's green with raw sienna for the palm tree, laying in the fronds with a rigger – a brush with long fibres, ideal for linear detail, so-named because it was originally used for laying in the rigging in nautical paintings.*

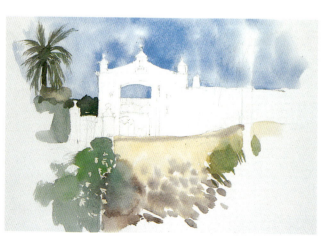

◀ **5** *For the darker foliage by the gateway the artist used a mix of Hooker's green and Payne's grey. The white of the paper shimmers through the washes of colour and stands for the colour of the sunlit whitewashed wall.*

161

▼ **6** *The shadows were laid in using a big brush – a No.10. The colour is applied wet-on-dry because the artist wanted a hard line to maximize the contrast between light and dark areas, which enhances the sense of brilliant sunlight. He uses Payne's grey with a little blue. Crisp lines and cool shadow evoke the sense of sunlight.*

▼ **7** *The artist lays in some darker tones for the vegetation, using Hooker's green and Payne's grey. When that is dry he removes the masking fluid by rubbing it gently with a gum eraser (this is made fom Cow Gum adhesive); you can also use your fingertips. Notice how the crisp, masked forms give this area a sparkle and impact.*

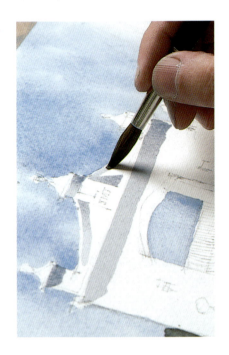

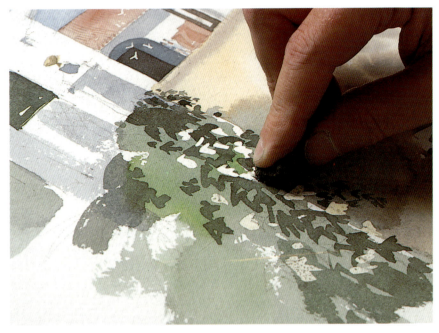

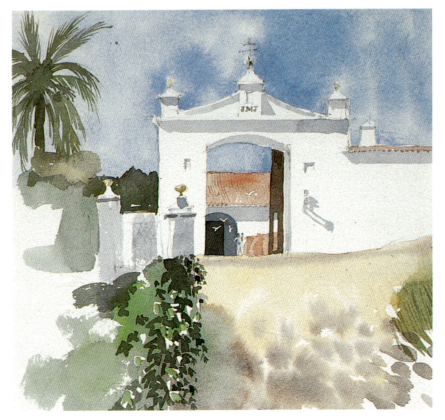

◀ **8** *To complete the picture he adds the details within the arch. He used light red for the pantiled roof. This is another colour that is useful in Mediterranean countries. He left the pencil in to convey the detail of the pantiles. When it is dry he adds a little darker tone. He uses the same mix for the terracotta urns: these were old olive-oil vats and are 1.2 metres high. The bright mustard ceramic finials are touched in with a bit of raw sienna. This isn't a particularly bright colour but looks bright against the blue sky.*

PROJECTS

GATEWAY IN TRASIERRA 2

This second demonstration is based on a painting made a little later; only an hour or so had passed but the light had changed dramatically. The sun is still on the left but it has moved to eleven o'clock in relation to the artist, so that this side of the gateway is in shadow. Compare the two studies and see how dramatically the passage of the sun has changed the colour and tonal relationships within the subject. You'll also notice that the artist has opted for different compositions, cropping the image to include a tree on the right here, while in the previous picture there is a date palm on the left of the picture.

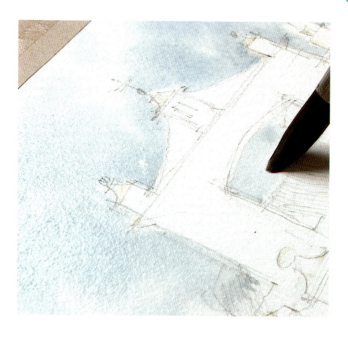

▲ 2 *The artist used an HB pencil for the drawing. He then masked various areas – some of the foliage, the white doves in the yard and the geese – but only the highlight, where they are backlit by the sun. The artist used cerulean blue for the sky in this case. Again it was laid on to wet paper.*

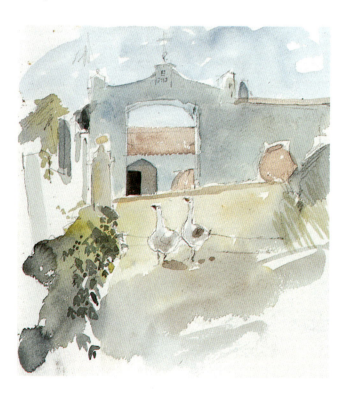

▲ 1 *This is the artist's sketch on which the second demonstration is based. It was painted on location, only an hour or two after the first one, but the light has changed dramatically.*

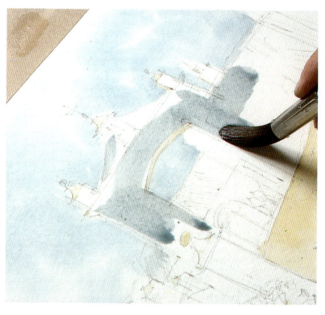

▲ 3 *The foreground was washed in with Naples yellow, which gives the earth a warm glow. Notice that the artist has used Naples yellow for the underside of the arch. You might expect this area to be dark, but in fact light was reflecting up from the earth below. The wall and gate are painted in cerulean blue with just a touch of Payne's grey.*

163

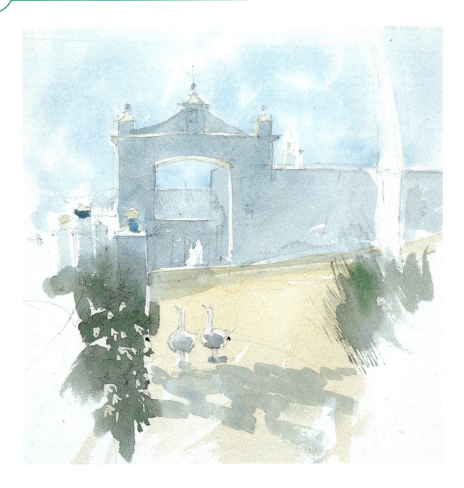

◄ **4** *The artist then laid in the foliage with a Hooker's green– Payne's grey mix, using the same colour for the shadows. For the dark tones on the geese he uses the Payne's grey-blue mix.*

▼ **5** *He darkened the wall and gate with another wash of colour and, while it was still wet, dropped in a bit of Naples yellow, which gives the wall a warm glow and suggests the effect of light reflecting up from the light-coloured earth.*

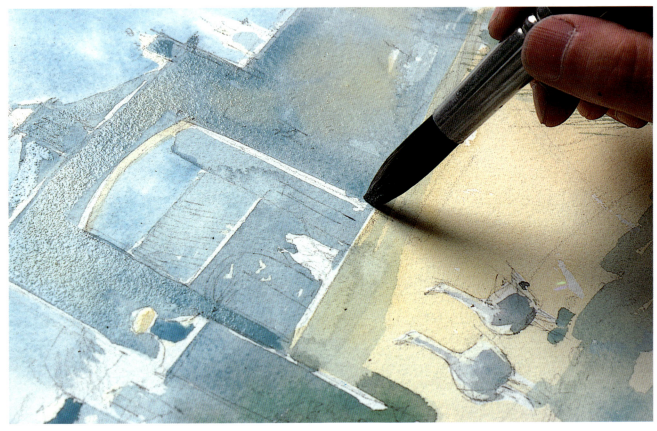

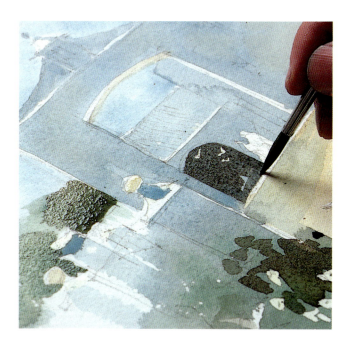

◄ **6** *He added more detail to the foliage with the Hooker's green–Payne's grey mix. Payne's grey and Van Dyke brown were used for the dark tones of the gates.*

▼ **7** *The red roof of the yard was washed in with light red, which is qualified by the cool tone beneath. The artist has removed the masking fluid from the ivy-clad wall and washed in sap green, which gives a light but not white highlight to this area. For the tree on the left he uses sap green with a touch of Van Dyke brown to knock it back. He spattered some colour on to the base of the tree to describe the weeds and growth in this area. If you do this, do mask other areas with a sheet of paper to prevent spattered colour from going where it shouldn't.*

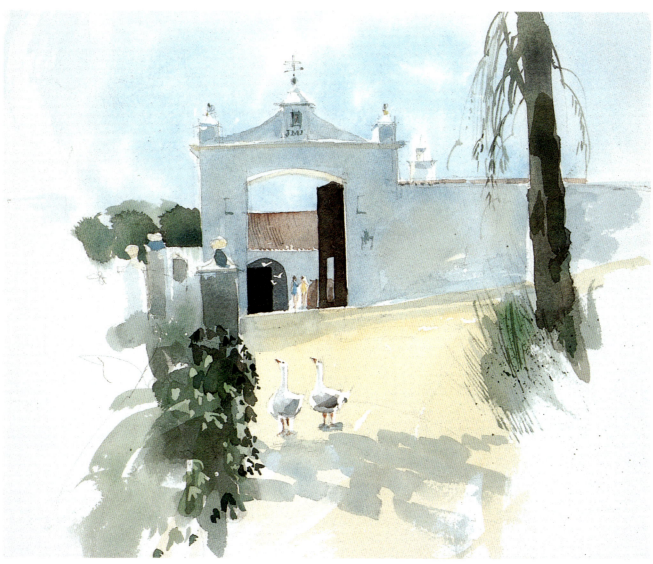

TECHNIQUES

MISTS USING 'BLOTESQUE'

'Blotesque' is a technique in which Chinese white is applied under transparent watercolour and then blotted or rubbed back to achieve areas of hazy, softly modulated colour. The technique was devised and used by two painters, Joseph Crawhall (1861–1913) and Arthur Melville (1855–1904). Both were 'Glasgow Boys', members of a loose association of painters based in Glasgow at the end of the nineteenth century. Like the New English Art Club,

founded in 1886, and the Impressionists, the Glasgow school favoured lyrical naturalism and working '*en plein air*'.

Crawhall painted in watercolour and body colour on a fine linen fabric called holland, washing on colour and then blotting it off.

Melville travelled in the Middle East and North Africa, painting in Tangiers and in the desert. In his paintings, highly contrasted light and shadow evince the heat and exoticism of the location.

Melville would often saturate the paper with Chinese white, rinsing off much of the colour so that the paper was impregnated with a thin film of white. He would then make a drawing before applying washes of colour with vigorous brushstrokes, sponging out any superfluous detail. Finally, touches of intense colour would be applied to give the composition life and vibrancy when the paper was nearly dry.

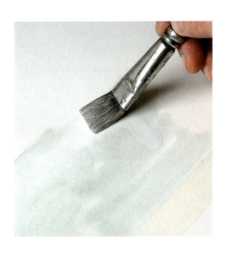

▲ 1 *For this demonstration the artist used Chinese white, cerulean blue, raw umber, Winsor & Newton Payne's grey, which is quite blue, and aureolin, giving a particularly clear, fine yellow. The horizon is masked with low-tack tape.*

He started by laying down Chinese white and a touch of cerulean blue and aureolin, rubbing some pure Chinese white in the wet colour. He was careful to take the colour right down to the horizon line, then evened it out a little with a dry brush.

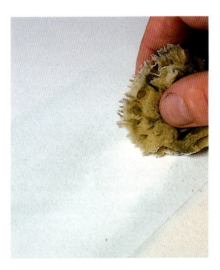

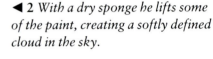

◀ 2 *With a dry sponge he lifts some of the paint, creating a softly defined cloud in the sky.*

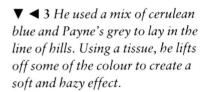

▼ ◀ 3 *He used a mix of cerulean blue and Payne's grey to lay in the line of hills. Using a tissue, he lifts off some of the colour to create a soft and hazy effect.*

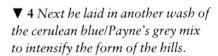

▼ 4 *Next he laid in another wash of the cerulean blue/Payne's grey mix to intensify the form of the hills.*

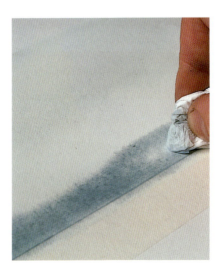

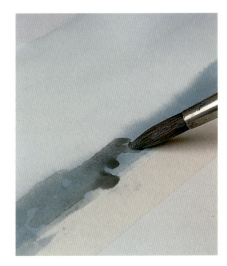

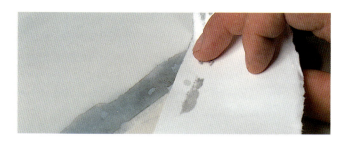

◄ 5 *When the paint has begun to go off but is still damp in places, he used blotting paper to take off some of the colour. This creates areas of misty, diffuse colour.*

◄ 6 *He laid in another loose wash of colour, this time a slightly warmer mix of raw umber and cerulean blue, blotting it as he did with the previous washes.*

Finally he draws in the shoreline with a mix of Payne's grey and raw umber. The line is drawn freehand; notice how he uses his little finger as a support to keep his hand perfectly steady.

◄ 7 *The masking tape is removed, revealing the crisp edge of the shoreline.*

▼ 8 *In this study of a lake in Donegal, Ireland, by Adrian Smith, you can see the way the blurring of the paint captures the effect of hazy, rain-laden clouds.*

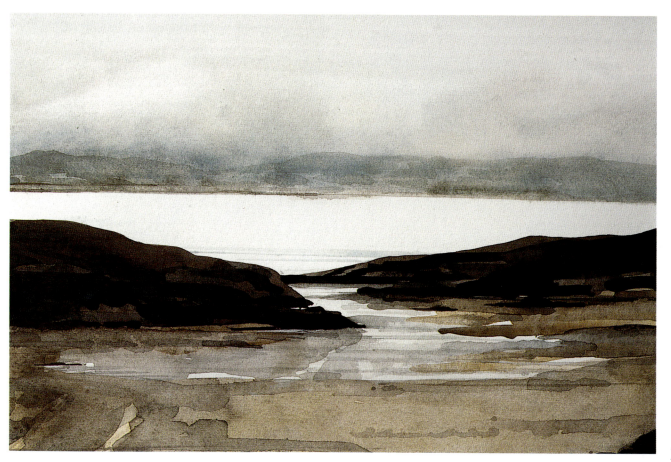

TECHNIQUES

SUNNY DAYS

Working out of doors on a bright sunny day is a delightful experience. Brilliant sunlight casts emphatic shadows which can shift quite rapidly as the sun moves across the sky. The focus of your painting may suddenly be engulfed in shade, completely changing the composition. If you work quickly, you may complete the painting before the light changes. You will be forced to simplify the forms and tonal arrangements, to include only the essentials and edit out anything that is superfluous to the impact of the final image. Working directly from the subject in this concentrated way is an invaluable experience.

If time or your confidence doesn't permit you to complete a painting, you can make sketches and colour notes. These can be supplemented with reference photographs and all this material can be used in the studio later.

Bright light can be so dazzling that you can't see the subject clearly. And changing light on your working support can make it difficult to accurately assess tonal and colour relationships. Ideally, you should try to find a shaded spot – under a tree or a café awning, or in the shadow of a building, for example. Failing that, a large-brimmed hat or a parasol will protect your eyes from the glare and give you a neutral light to work in. The artist in a panama isn't posing; he or she is adopting a sensible working practice.

The strength and direction of sunlight affect the appearance of things. If the sun is in front of you, buildings and objects are thrown into shadow and colours will have a coolish cast. Light from behind the observer is generally warmer in colour and objects bathed in sunlight appear warmer and nearer. Side-lighting creates the most striking shadows and throws forms and textures into high relief. When the sun is overhead the opposite happens: shadows are reduced to a minimum, while forms and textures appear flatter. Dawn and sunset provide some wonderfully dramatic backlit effects.

You can see this in John Lidzey's picture on page 159. The demonstrations by Albany Wiseman, on pages 160 and 163, show how dramatically sunlight can change in a short time and what a difference this makes to the appearance of things.

▶ *'Harbour, Mount Deya' by David Curtis. The artist has captured the unique sun-drenched warmth of a Mediterranean village. He has used a palette of pale ochry yellows, which are contrasted with blues and blue-greens of sea and sky. The sun is high in the sky, casting intense but limited shadows such as those directly under the boat and under the awning of the taverna. Again, the brilliance of the white watercolour paper creates the luminosity of light and also unifies the entire image.*

▼ *The artist Bill Taylor has created a different kind of bright light. This time it is the cool bright light of winter. Cool blue shadows are contrasted with warmer areas of sunlight. Long crisp shadows thrown on to the rooftops and the ground tell you that the sun is low in the sky.*

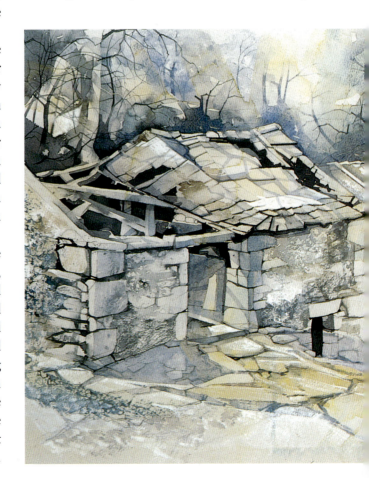

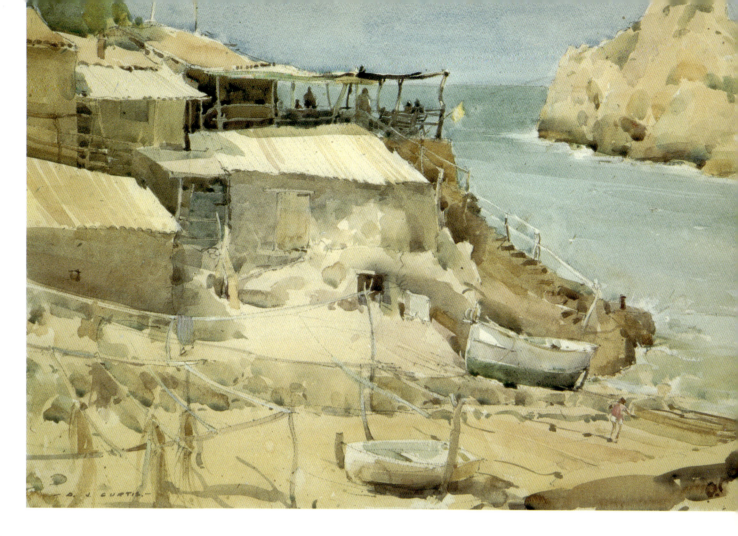

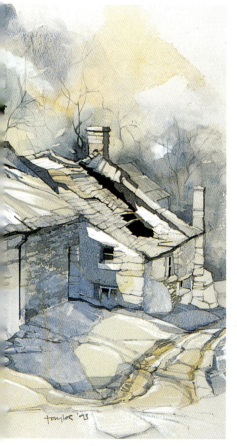

▼ In 'Sunlight Façade' by Ian Sidaway, strong bright sunlight from the side casts intense dark shadows. These, together with the dark interiors seen through the window and doorway, provide an important compositional motif.

The crisp forms and the contrast between the light and dark areas heighten the sense of sun and light. The dark shadows and the spattered texturing on the façade allow us to read white paper as light on a white surface.

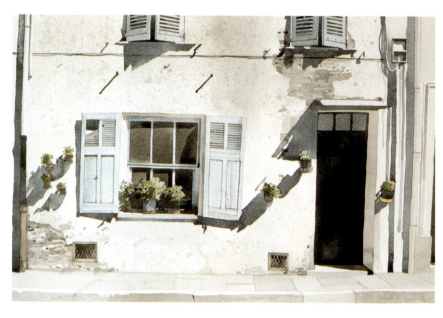

169

TECHNIQUES

ARCHITECTURE AND LIGHT

I asked the artist Tig Sutton to find a subject that expressed an aspect of light. He chose this enchanting pig, which can be found on a buttress on the south side of Lincoln Cathedral. It was a brilliantly sunny day in August and the sun was quite high in the sky. Deep shadows threw the architectural details into sharp relief. On a more overcast day they would not be seen with the same clarity.

The jostle of faces and forms that break up the solidity of the architectural mass provides an engaging subject. The artist particularly liked the mellow rosy colours of the weathered stone and the fact that, in places, the stonework is crumbling and grimy with soot. He wanted to capture the character of the stonework in his painting.

He had to look directly upwards to see the details of the subject, creating a dizzying perspective, emphasized by the way the two main figures loom over the ledge.

The artist likes to work on a large scale, so that he can stand back from the picture and view it from a distance. The painting measures 54 × 36 cm (22 × 14 in). He started by making a series of pencil sketches, which familiarized him with the subject and allowed him to investigate different compositional possibilities.

◀ *He started by making sketches of the subject. He did a drawing of the subject face-on for his own benefit, so that he could better understand what he was seeing in steep perspective. A roof and a spire were visible in the distance, but he removed these in order to create a more dramatic image.*

▶ *If you look closely you can see that the artist has captured the particular quality of the crumbling stone. He used a series of warm neutral washes to depict the rosy weathered stone. It is the contrast between the light and dark areas and the sharp edges of the shadows that conveys the brightness of the light.*

The tall format emphasizes the verticality of the architecture and makes for a bold composition. The bright blue sky provides a cool balance to the warm neutrals of the stone. The composition is carefully conceived. The eye is led from the base of the painting to the figure at the top. From there the angle of the ledge directs our attention to the sculpted form of the pig. The way the bright blue sky throws it into silhouette also arrests our attention.

Painting Landscape
in Watercolour

Patricia Monahan

Introduction

LANDSCAPE IS A glorious subject for the painter – endlessly fascinating, absorbing and constantly changing. You can return to the same location time and time again and always find something different, something new to enchant, tantalize and stimulate you.

Consider the changes that can occur on a single summer's day. Shortly after daybreak a haze hangs in valley bottoms and dewdrops glitter on cobwebs. Later, with the midday sun high overhead, shadows shorten, forms flatten and the horizon seems pale and distant. A brisk breeze blows up. Clouds scudding across the sun threaten rain. In the moisture-laden atmosphere, far-away hills become intensely blue. Crisply outlined against the lowering sky, they seem much closer to the viewer than before. Suddenly the heavens open and a squally shower veils the landscape, muting colours and reducing contrasts of tone. As evening approaches, the setting sun suffuses the western sky with a spreading blush of rose pinks and fiery reds streaked with orange.

Rich material indeed . . . and then there are the seasonal changes to take into consideration too.

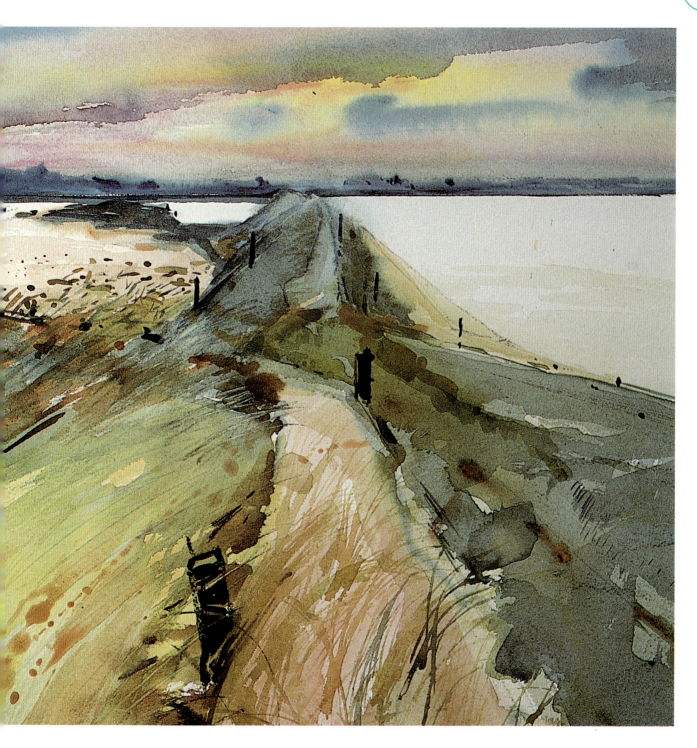

'Upper Reaches, River Blyth', 17 ×
23½ inches (42.5 × 58.8 cm), by
Charles Bartlett. The painting is not
simply a description of the Suffolk
landscape, but captures the
atmosphere of the area: the
emptiness, the wide open skies, the
special quality of the light and the
sheer poetry of the place.

WHY LANDSCAPE?

I would be lying if I said landscape painting was easy. But the rewards and pleasures are so great that any difficulties really don't matter.

Professional painters and Sunday dabblers return to the subject again and again. Undaunted, they struggle with the vagaries of the weather and the inconveniences of working away from home. In winter they cocoon themselves in seemingly endless layers of protective clothing, crouching beneath enormous golfing umbrellas, their easels staked to the ground or weighted down with rocks.

In summertime they don straw hats and sandals, and, laden with canvases, easels, flasks of tea and hip-flasks of something stronger, they tramp down country paths, over stiles, through herds of inquisitive cattle, up hill and down dale.

There are days when everything goes wrong. Paint dries either too quickly or too slowly, rain speckles an almost complete watercolour, a painting falls 'butter-side' down on to grass or gravel. But still they persevere.

Why do they do it? Well, *I* do it because I find landscape painting challenging, stimulating and capable of so many interpretations. There is always some discovery to make, some new path to explore. I'm never at a loss for something to paint and I'm never, ever bored when painting out of doors. I love the sights, sounds and smells of the countryside – the soothing murmur of a small stream, the hum of insects and the sound of a combine harvester working several fields away. I like the sense that I am part of a long tradition, and the way landscape painting heightens both my awareness of the world in which I live and my appreciation of the work of those who have recorded it.

I like the richness of the subject matter, which encompasses everything from the absorbing detail and textures of a rotting, moss- and lichen-covered tree stump to the grandeur of a steep-sided, glacier-gouged and rain-sodden valley in Ireland, or the romance of the rolling, manicured downlands of southern England.

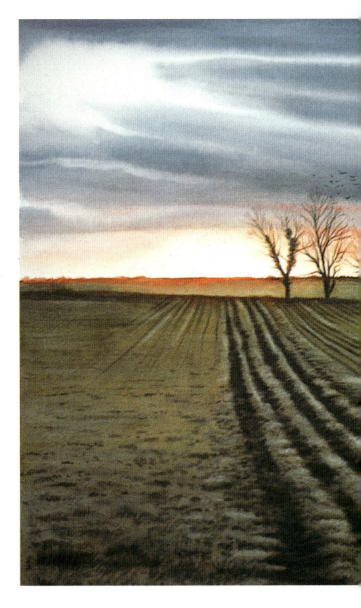

And don't think you have to journey to remote locations to find 'landscapes'. I open my back door and see a small flint-walled garden with houses beyond – a symphony of subtle greys in winter, full of bright colour and strong shadows in summer. From the upper storeys I'm presented with a patchwork of tile and slate roofs, a church spire poking through in the distance. The front of the house provides me with yet more vistas and this wealth of material is available without even stepping out of doors.

There are 'landscapes' all around you if you just open your eyes – in parks and cemeteries, on the seafront, on suburban streets, along inner-city canals, and in the industrial wastelands which girdle our towns and cities.

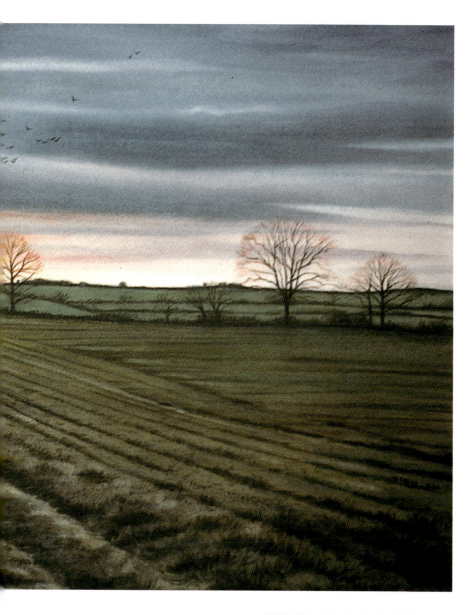

△ *The artist Anne Cherry is particularly concerned with the effects of light on the landscape. In 'Sudden Flight' she describes tilled farmland near her home, illuminated by a weak, wintry sun. She rarely finishes a painting on location, but works from sketches made on the spot with lots of colour notes.*

▷ *'Property for Sale' is a wonderfully moody painting by Martin Caulkin. Many of his works are concerned with derelict buildings and abandoned machinery within a landscape setting.*

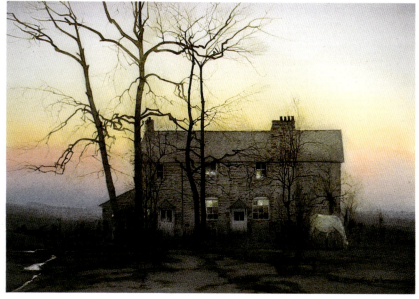

WHY WATERCOLOUR?

Watercolour has many qualities which make it an almost perfect medium for the landscape painter. It is beautiful, exciting, expressive, unpredictable and immensely flexible. It can be used for quick sketches, as washes of colour on line work, or for large finished paintings.

There is a huge repertoire of watercolour techniques and, if you are prepared to experiment and take risks, you can find all sorts of short cuts and tricks which will surprise and please you, while also giving your work liveliness and personality.

Watercolour can be used to create works in a wide variety of styles. Wildlife painters and illustrators, for example, often favour a precise, tightly wrought style in which the paint is applied in a series of carefully controlled washes, with the detail added wet on dry, using small, controlled brushstrokes. But watercolour can also be used to create big, bold studies in which the paint is applied as wet washes, with broad gestural brushstrokes. The colour can be dripped, dribbled, splattered and spattered. You can tip the board to make the paint run, or use a hairdrier to send the colour swirling across the surface of the paper. Used in this way, you can create paintings which are expressionist, impressionist or move towards abstraction.

So what exactly is watercolour? For those who are unfamiliar with the medium, the term watercolour – or, more accurately, 'pure' watercolour or 'transparent' watercolour – is used to describe a water-soluble medium bound with gum arabic. It is available in two forms – as semi-moist pans and as creamy tube colour.

In both forms the paint is diluted with water to create thin washes of colour, and applied to white or creamy paper. The white of the paper shows through the thin films of colour, giving the best watercolours a special translucency and shimmering brilliance which lend themselves to the subtle and shifting tones and colours of landscape.

With watercolour it is important to remember that the only white and the brightest highlights you

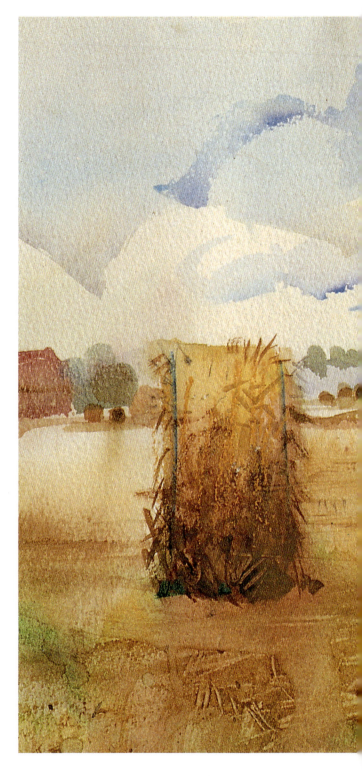

can have are formed by the white of the paper. To succeed with watercolour you must grasp the notion of working from light to dark. You have to reserve white and pale areas, gradually building up the darker tones with overlapping layers of colour or darker washes. It takes a bit of practice to get this right, but it's not as difficult as it sounds.

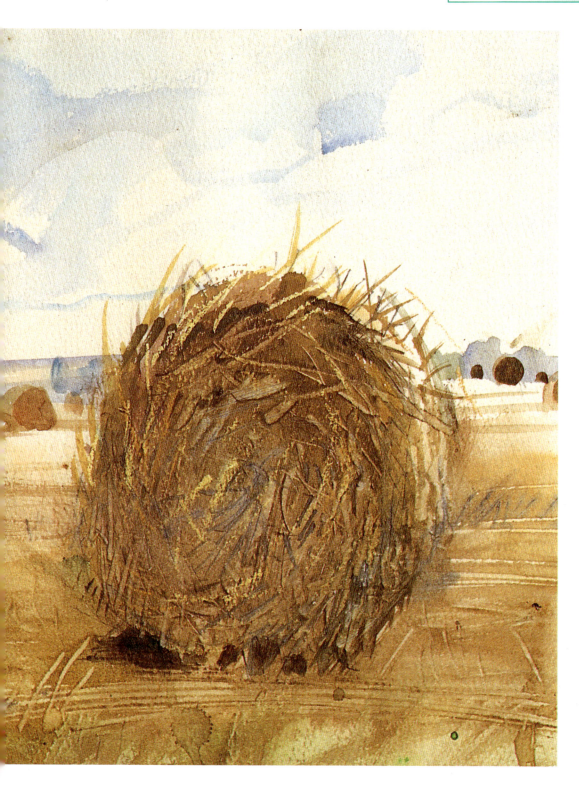

There is another form of watercolour, which is opaque. Called body colour, or gouache, it is available in tubes and sometimes in hard pans. Because gouache is opaque, you can overpaint dark colours with pale, laying, for example, light highlights on to dark areas. It also allows you to make corrections.

Stan Smith was entranced by the monumental quality of these 'Big Bales'. Gum arabic was used to create texture.

In this book we deal primarily with pure watercolour, but in places the artists have created body colour by adding white paint to watercolour, thus rendering it opaque.

BASIC KIT

One of the advantages of watercolour is the relative simplicity of the materials required. This is particularly evident and useful when you paint away from home.

A kit for out of doors

The watercolour painter can travel light. All you really need are paints, brushes, water and paper. Semi-moist pans of solid colour come into their own when you work away from home. Tube colours are great for large-scale work, but you need lots of mixing saucers and palettes. With solid pans, all the colours can be seen at a glance, and you can mix washes quickly, without having to fumble with caps and squeeze out paint.

The ideal box of colours would consist of a maximum of twelve pans or half-pans in a box with a lid and a flap which fold out to provide mixing spaces. The lids of watercolour boxes are recessed for this purpose.

You can find tiny boxes of watercolour – small enough to fit into a shirt pocket – which contain quarter-pans. Winsor & Newton call their sketching boxes 'Bijou' and offer two – one with twelve colours and one with eighteen. Some people find quarter-pans difficult to work with, because they are so small. If you use a large brush, stick to half-pans or pans.

Then, of course, you will need brushes. This is a difficult area to advise on, because there are so many brushes to choose from and in the end the decision depends on you and your style. If you are setting up from scratch, choose three round brushes in pure sable, if you can afford it, or in a mixture of synthetic and sable. Buy the best you can afford. Winsor & Newton's Sceptre Gold range is a good example of the mixed-fibre brushes. Start with numbers 1, 6, 10 and 14.

Pads of paper are easy to carry, especially the blocks which are gummed on four sides and don't need to be stretched. Many artists stretch paper on lightweight boards for outdoor work, but the advisability of this depends on what you are going to do, how far you have to carry your stuff and whether you have transport.

Whether you need an easel or not will depend on the scale at which you work. If your work is small, you can usually manage by balancing a pad on your knee, a wall or a convenient tree stump. For large-scale work, you will need an easel. Easels for watercolour need to be used in a horizontal

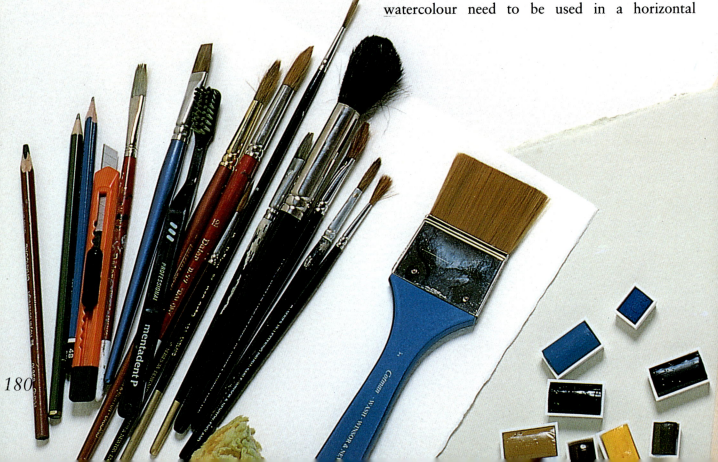

position for washes, so check this when making a purchase. Wood sketching easels are quite cheap and light. Aluminium easels are also light, and are much easier to set up and adjust, but they are quite a lot more expensive.

You will also need containers for water, a bottle to carry it in and two jars – one for mixing washes, one for cleaning brushes. Plastic bottles are lighter than glass – save mineral-water bottles. Glass jars, though heavier than plastic, are more stable. You will need some rag, kitchen paper, a pencil, an eraser, a craft knife and a bag to carry everything in.

A kit for working in the studio

The equipment you use in the field may well suffice for working at home, but generally you will want to work on a larger scale indoors. You will need sheets of paper, boards, palettes and a collection of tube colours for mixing big washes. Gummed tape is used for stretching paper; masking tape is useful for masking and for taping heavy paper to boards. Gum water and gum arabic are media which can be

added to the paint to give it a sheen. They also allow you to develop textured effects, and to wet the paint once it is dry – to lift it off to create highlights or textures, for example. Masking fluid is useful for covering and thus saving areas that are to remain light or white while you continue working around them. A white candle, crayon or oil pastel can be used for resist techniques, and pencil, ink and coloured pencil can be combined with water-colour very successfully. Collect and experiment with dip pens, quills, reeds and any other drawing implements you come across.

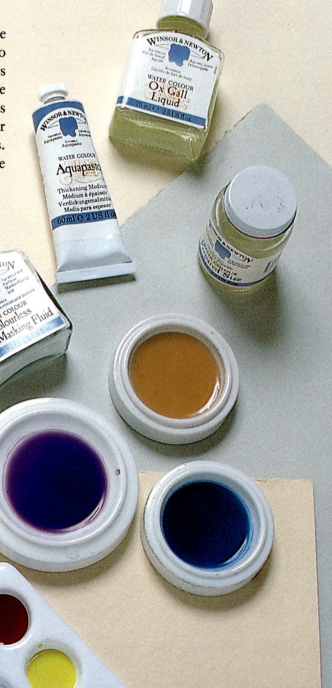

COLOURS FOR LANDSCAPE

There is a lot to be said for working with only a few colours – artists call this a 'limited palette'. Paints are expensive, and cost is an important factor for many people, but there are other reasons for restraint.

The more you know about the materials you use, the more you will be able to get from them. If you start with just a few colours, you can really get to know how they dilute, overpaint and mix. You will be forced to experiment with mixes to get the range of colours and tones you need from your limited selection. If you have a large selection, with four or five yellows, for example, you will never need to explore the full potential of each one. You may get lazy and, rather than forcing yourself to find just the right colour, make do with an approximation because it is there in the tube or pan.

If you use a limited range, you will become so familiar with your colours that you can use them without having to think about it – and at that point you will be able to focus on the really important thing, which is the subject in front of you and your interpretation of, and response to, it.

In Chapter 4 I talk to three artists about their approaches to landscape and watercolour. You'll find that they all work with a limited range of colours.

One of the delights of watercolour is its incredible brilliance and clarity, and anything which detracts from that should be avoided. The best colour mixtures are made from two main colours, with perhaps a touch of a third and fourth for more complex, muted shades, like greys and neutrals.

▷ **A starter palette**
The following colours will allow you to mix all the colours you need for a landscape, including a wide range of greens. The colours are: ivory black, cobalt blue, cerulean blue, Prussian blue, raw umber, yellow ochre, cadmium yellow pale, alizarin crimson.

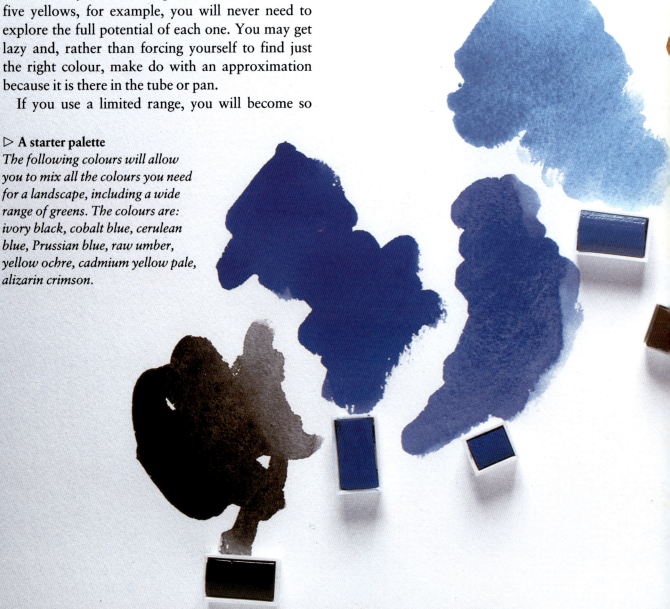

Mixing greens

Green is the most important colour in the landscape-painter's palette, and causes the most problems. Proprietary greens are useful but don't give you the range you need to capture the colours of nature.

To explore the possibilities of one pair of colours, see how many shades of green you can get from ultramarine and cadmium yellow pale, for example. Then add a touch of raw sienna to each of the mixtures to produce a more muted tone.

An effective way of creating lively greens in a painting is to underpaint them with another colour. Because watercolour is transparent, the underlying colour will modify the top colour, adding interest and acting as a visual link between different areas.

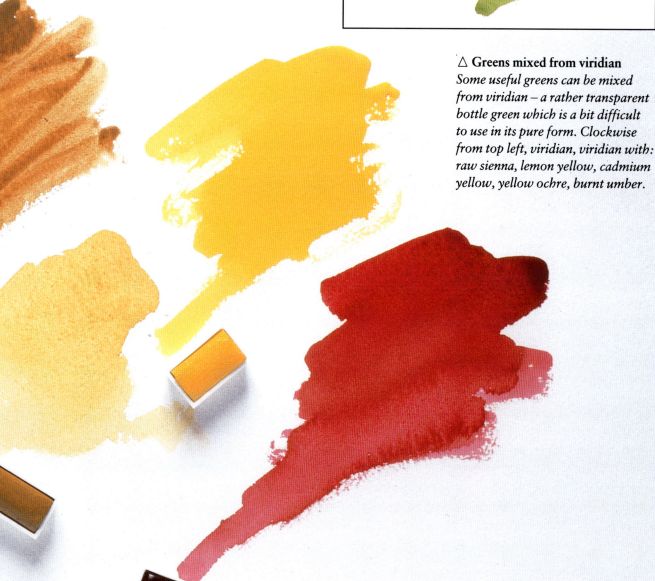

△ **Greens mixed from viridian**
Some useful greens can be mixed from viridian – a rather transparent bottle green which is a bit difficult to use in its pure form. Clockwise from top left, viridian, viridian with: raw sienna, lemon yellow, cadmium yellow, yellow ochre, burnt umber.

COMPOSITION

A successful painting is both complex and many-layered. It must inform, entertain and communicate. A good painting grabs your attention and, having done so, holds it.

There are several ways in which artists will achieve these ends, including the skill with which they render the image, describe the form and imply space. The painterly qualities of the work are also important – a meticulously rendered surface or luscious layers and swirls of colour can give real pleasure. These qualities are obvious to even a fairly uninformed viewer. But there is another area which is often overlooked, even though it is more powerful than all the others.

'Composition' concerns the way the elements of a painting are organized within the picture area. It is the underlying geometry of a painting; an abstract quality which gives it tension and harmony, and is present in other areas of the arts – in great music and architecture, for example.

Why is composition so important? There are many reasons. A well-composed painting has an internal harmony – the individual elements hang together to create a convincing and pleasing whole. Composition provides the framework upon which the painting is constructed and gives it solidity and coherence. Get this right and you are well on the way to success. Compositional devices can be used to give a painting impact, to create rhythms and stresses, to draw attention to important passages and to lead the eye around the painting. A badly designed painting has a flabby, unstructured quality – the eye doesn't know where to start, and either wanders aimlessly over the picture surface or ricochets from one area to another.

So how can you exploit this powerful device and use it to your advantage? The shape of the picture is the first compositional decision you make. Most paintings are based on a rectangle, but there are different sorts of rectangle, each of which has a different impact on the viewer and suggests different moods and emotions. A square, for example, is compact, contained and stable. It invites the eye into the centre and focuses it there.

A single image placed in the centre of the picture (above) rarely makes an interesting composition. Above and below right, the trees lead the eye in.

An upright or 'portrait' format, on the other hand, has an incipient instability – because it is tall, it might just tip over. There again, it encourages the eye to roam up and down, and has a soaring, inspiring and imposing quality that has been exploited by great religious painters throughout the ages, and by portrait painters. The broad, expansive 'landscape' shape, which is wider than it is tall, is inherently stable. It invites you in and allows the eye to wander from side to side and go deep into the painting. It lends itself particularly well to landscape painting, though there is absolutely no reason why you shouldn't paint a landscape within a square or a portrait shape – and indeed some images cry out for those shapes.

A successful composition forces you to look at it, so you must provide viewers with a way into the painting (this is usually at the bottom, but not

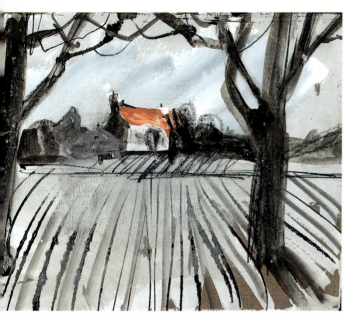

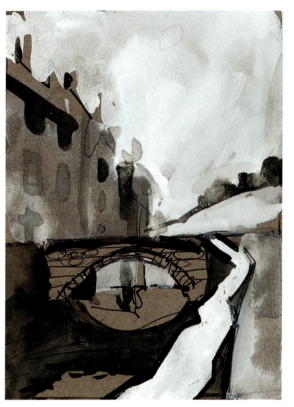

Avoid a rigorously symmetrical composition. A pathway and bridge (above) are used as compositional devices, drawing you into the picture. Horizontal divisions are important in this 'portrait' format, and particularly so in the picture below.

necessarily so). Once you have got them there, you must hold their interest. A painting should also have a focus, a single important point to which the eye returns again and again. In the painting of the bridge on pages 194–5, for example, the eye is drawn to the area contained by the circle created by the bridge.

A good way of analysing composition is to lay a piece of tracing paper over a painting and trace off the main stresses and rhythms, looking for repeated angles and shapes, and for the points at which one line connects with another. A painting can also be analysed in terms of its tonal structures, which provide a hidden compositional theme. To 'see' this, lay a piece of tracing paper over a picture and block in the dark areas with pencil. You will end up with a complex of interlocking abstract shapes.

Try these tracing exercises with reproductions of Old Masters. You will learn a lot.

185

Working out of doors

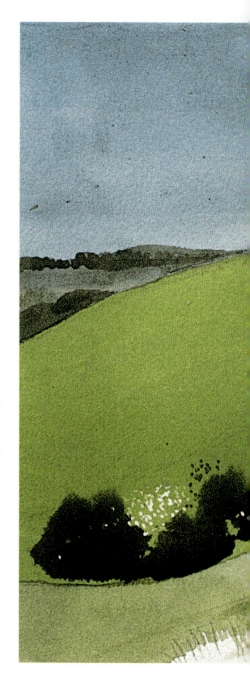

*I*N CHAPTERS 2 AND 3 there are seven step-by-step projects photographed on location and in the studio. These give you the opportunity to look over the artists' shoulders and to share some of their thoughts as they work. The best way to use these projects is to study the text, captions and pictures, and then find a similar subject. You will learn more by doing your own painting and not simply copying.

If you do make a copy, don't be too literal. Personalize the picture by changing the composition, leaving things out and adding bits from another picture, from your own sketchbooks or from photographs. Use the original as a jumping-off point.

Be aware of the paint, the support and the feel of the brush, and allow them to lead you in new directions. Be prepared for the 'happy accident' – the unplanned bleeding of one colour into another, the unintentional blotting or splashing of paint. Leave it, blot it or blow it with the hairdrier. Don't be afraid to take risks, maybe to make mistakes. It is the only way you will learn. And if the picture really is a disaster, simply abandon it and start again.

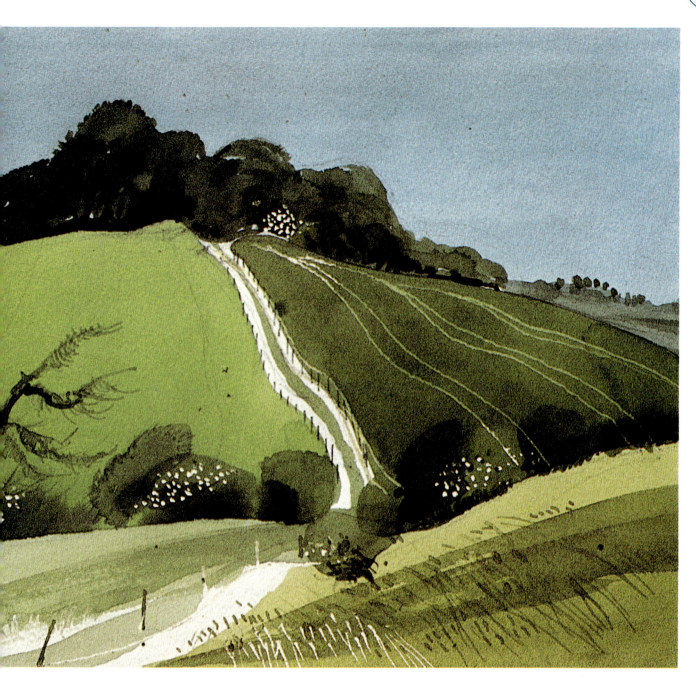

△ 'Chalk Track, King Down,
Dorset' by Ronald Maddox. In this
painting the artist explores a
favourite theme: pattern and shape
within the landscape. He simplifies
and edits to create a satisfying
composition which has drama.

◁ Don't encumber yourself with
too much equipment: here an artist
sets out for a day's work with a bag
of equipment, an easel and a
drawing board.

187

TECHNIQUES

FINDING THE SUBJECT

One of the daunting things about landscape painting is the sheer size of the subject. You have to choose a view, decide where your picture will begin and where it will end, and what you will include and what you will leave out. There are, though, a few tricks of the trade to make this process easier.

The viewfinder
This is a small rectangular frame cut from stiff card. It doesn't have to be very big – mine is 7½ × 9 in (19 × 23 cm), with an aperture 4¼ × 6 in (11 × 15 cm). By viewing the landscape through this frame, you can isolate sections of it to assess their picture-making possibilities. By moving the viewfinder further away from your eye, you will frame a smaller section of the vista.

Exploratory sketches
Quick sketches made on the spot allow you to explore the compositional possibilities of the landscape. Use pencil, coloured pencil, felt pen, ballpoint or whatever you have to hand. Find a focal point – in the examples shown here it is the bridge – and see what happens when you move it around the picture

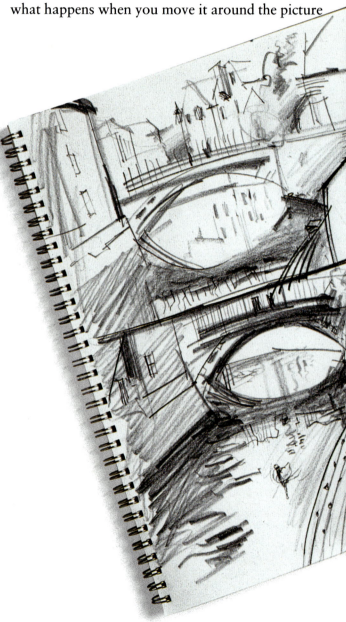

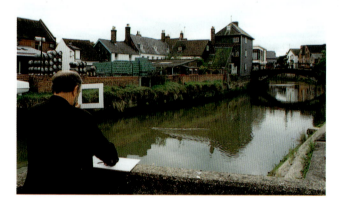

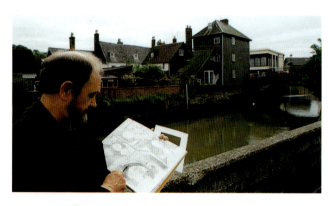

△ *Use a viewfinder and sketches to explore the compositional possibilities.*

area. Look for rhythms and stresses within the subject, and see how these can be contained within the rectangle of the picture area.

Screw up your eyes to see the way light and dark tones are distributed, blocking in the dark areas loosely. You can annotate the sketch with infor-mation about colour, weather conditions and the direction of the light. All this will be useful when you start work on the picture.

Using L-shaped masks
Card masks allow you to isolate a section of a sketch or drawing so that you can see how it works as a picture. For example, if you make a large drawing, you might decide to crop in to a small section of it and use that as the basis of a painting.

The most flexible sort of mask is made out of two L-shapes cut from card. These are laid over a sketch to form a rectangular frame. You can adjust the size and shape of the area masked.

◁ *The first drawing (top left) is a fairly conventional portait of the bridge, putting it and its reflection firmly in the middle of the picture. The sweep of the wall on the right leads the eye into the focal point.*

The image below pushes the bridge to the top of the picture area, creating a strong diagonal sweep with the riverside steps.

In the sketch next to it the artist has cropped in to the bridge to create a more intimate study – a good starting point for a more architectural approach.

The final sketch (top right) is more abstract in feel, stressing the curves, angles and shapes.

▷ *A set of L-shaped frames allows you to isolate different parts of the sketch and to explore different formats.*

189

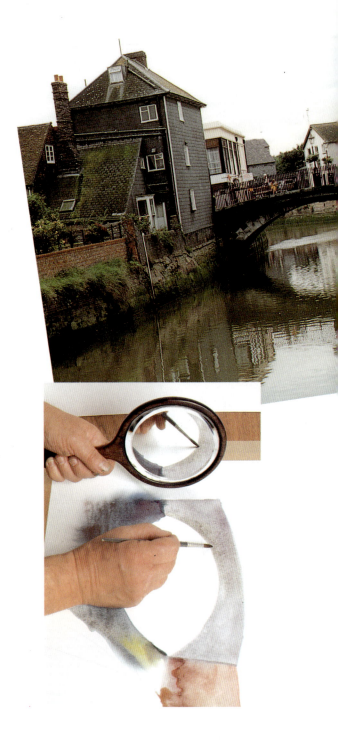

PROJECTS

BRIDGE AT LEWES

A bridge, water and some picturesque old buildings provide the artist with an inspiring subject for a painting. I have described on pages 188–9 some useful techniques for deciding which aspects of the subject to include in your painting.

The artist decided to make the bridge and its reflection the focal point of the composition. Having explored the composition in the sketches on pages 188–9 he found that the dramatic rhythms leading in from the right-hand edge drew the eye up and into the picture, over the bridge and around the reflection. The focal point is the watery area beneath the bridge, and here he has used a variety of marks, washes, lines, and scraped and scratched textures invented from the dappled water. The picture has a strong feeling of drama and movement. It opens its arms and embraces you, inviting you in.

The artist made a light drawing in pencil, then started to lay in blocks of colour, keeping the paint fresh and loose, constantly assessing the tones and colours. To create a good watercolour you must make accurate judgements, studying the subject intently, mixing washes of colour and comparing them with what you see before you and what is on the support, and you must achieve all this without losing the freshness of the surface and a sense of your original vision.

The drawing need not be very detailed, but it should be accurate. The important thing is to make sure that the buildings take up their correct position in space. Do this by drawing the spaces between objects – measuring one angle against another, one line against another, comparing, contrasting, measuring and redrawing until it is right. Check the drawing in a mirror. Because the reversed image is unfamiliar, any errors will jump out at you.

△ **2** *The artist started by laying in a few construction lines in pencil. Get these lines right and you have a sound foundation for your drawing. He drew the vertical of the building on the left and used this as a key against which to judge the other critical lines – the height and angles of the buildings above the bridge, for example, and the curves and angles of the river and wall on the right. The circle formed by the bridge and its reflection is the focal point of the painting. Here a hand-mirror is used to check the accuracy of the curve. Because a reflected image is reversed, it is unfamiliar and the eye is more critical.*

△ **1** *We found this picturesque scene in the car park of a small country town. You don't have to go way into the wilds to find suitable subjects; they are often just outside your back door, even if you live in an urban area.*

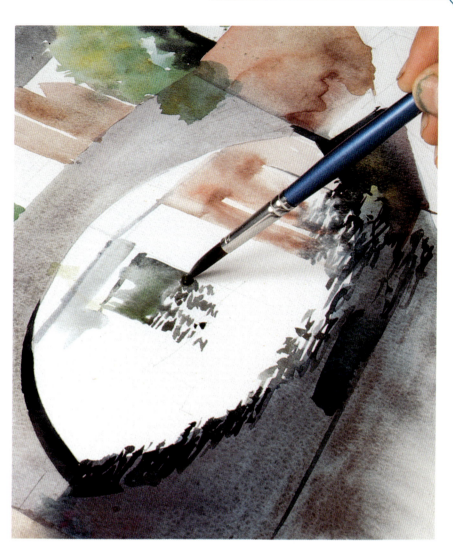

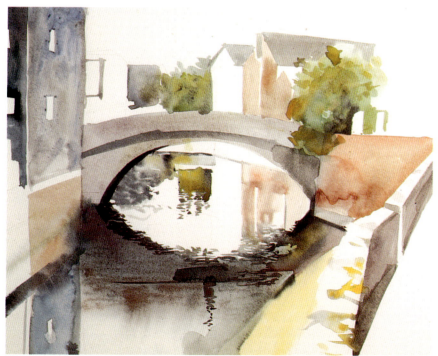

△ **3** *The artist worked quickly to get as much of the painting down as possible before the light changed. He used Prussian blue, black, Indian red and yellow ochre to lay in the water, the bridge and surrounding buildings, mixing greens for the foliage. At this stage try and keep the painting simple. Half-closing your eyes will help you to concentrate on the broad areas of light and dark, and colour, eliminating confusing detail.*

◁ **4** *Working broadly with a number 10 brush, the artist has established the main structures of the painting. Using the very tip of the brush, he then added details such as the ripples in the water.*

191

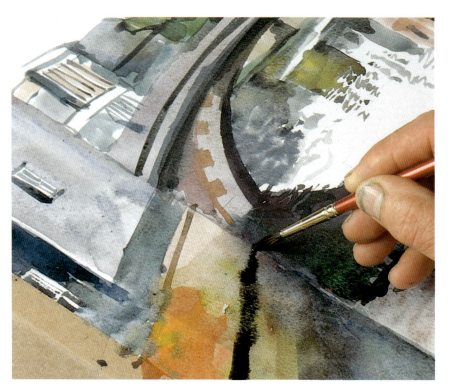

▽ *6 The artist continued to develop the painting, working quickly to keep it fresh. Here he uses a quill to draw in crisp architectural details such as the railings. He uses dilute black ink. The quill gives the line a pleasing calligraphic quality. Don't be afraid to experiment with new materials and equipment, and learn to enjoy them.*

▷ *7 The area of water framed by the bridge and the reflection below it draw the eye and form the focal point of the painting. Here the tip of a craft knife is used to scratch into the paper, breaking the surface to add texture.*

△ *5 The painting was set aside for about ten minutes to allow it to dry. Watercolour behaves differently when it is used wet in wet and wet on dry. Flooding paint on to a wet support, or allowing one colour to flow into another, is exciting, but be careful not to overdo it. Allowing the painting to dry at intervals will let you retain the integrity of the areas of colour. You can modify the initial painting with washes of colour, or add detail wet on dry.*

Here the artist is developing an area to the left of the bridge. Notice the way the orange and green applied wet in wet have melded together, and the way the black line is opening out. Compare this with the crisp brown line above, applied wet on dry.

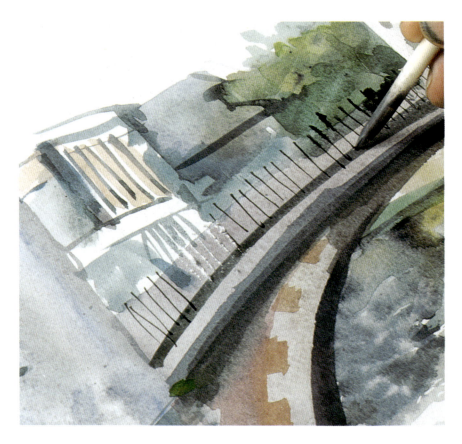

▷ *8 This detail is important because it leads the eye into the composition. The artist has scratched with the blade, creating a symmetrical pattern. It has a mechanical feel, contrasting with the more fluid area behind it.*

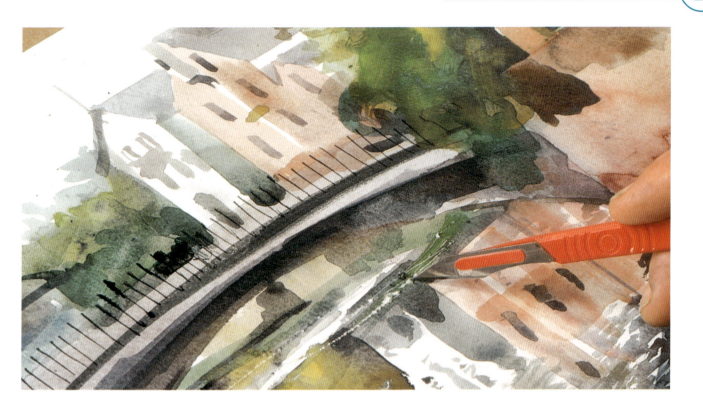

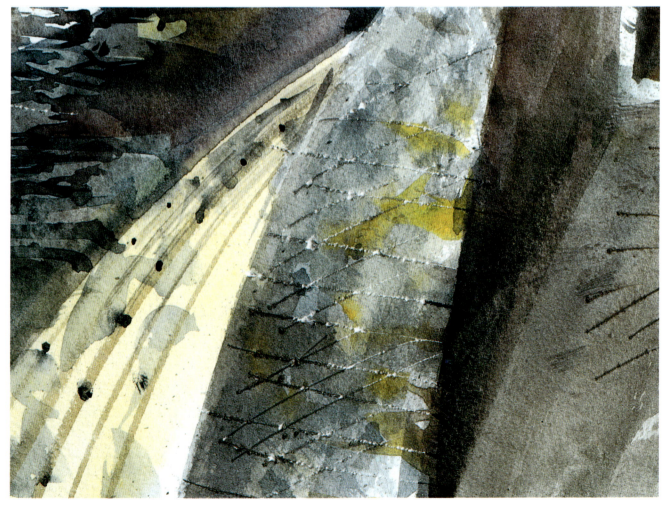

▽ **9** *The foliage of the tree is developed by adding blocks of mixed greens. Keep the forms simple and resist the temptation to overwork the image.*

▷ **10** *The final painting depends for its success on the rigorous composition, which exploits dramatic rhythms, strong linear qualities and the drama of massed tones. You start one-third in from the right-hand side, at a point which more or less corresponds to the golden section – a proportion very approximately of one third to two thirds, traditionally found to be particularly satisfying. From here the wall surges up to meet the right-hand edge at a point one-third down from the top – on the golden section yet again. From here the line springs back to the left, across the bridge, till it meets the strong vertical of the building on the left and its reflection. There it is stopped, leaps to the top of the painting, then down to the bottom and across to the starting point again.*

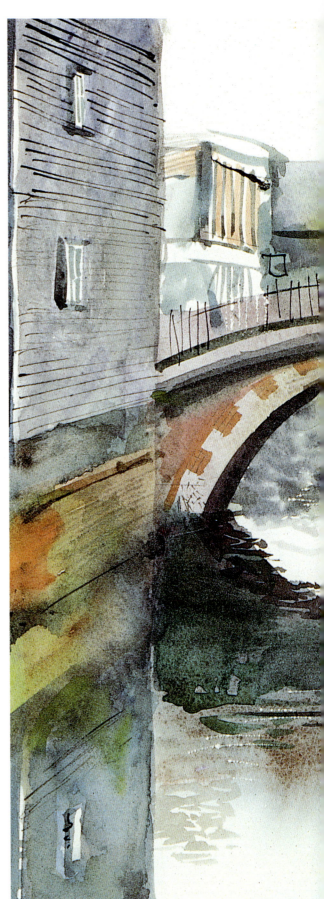

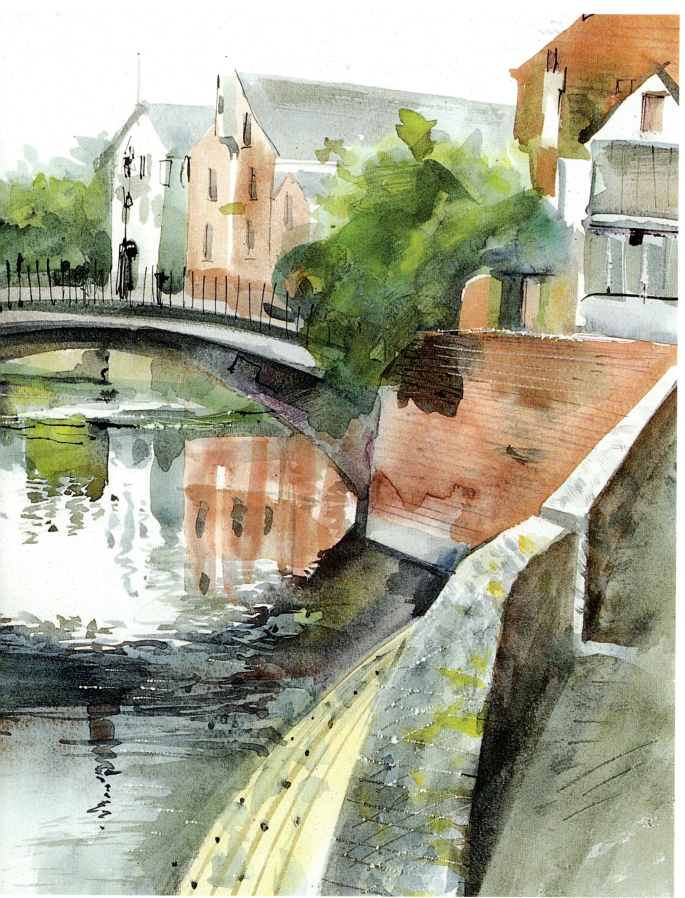

TECHNIQUES

LINEAR PERSPECTIVE

One of the problems which the landscape painter has to contend with is that of representing three-dimensional space on the two-dimensional surface of the support. Sometimes the artist will deliberately ignore the rules of linear perspective, or distort them in order to draw attention to the abstract or pattern-making qualities of a composition. But generally you want to create an illusion of depth, to trick the viewer into thinking that it would be possible to step through the frame of the painting and into three-dimensional space beyond it.

There are many ways in which artists achieve this feat, but the one which creates most anxiety in the bosoms of beginners is linear perspective. The trouble is that most explanations of linear perspective are supported by diagrams of amazing and confusing complexity.

One way to understand the concept of linear perspective is to imagine a piece of glass placed vertically in front of you, between you and the

▷ In this picture the bases and the tops of the line of trees on the right, and the top and the base of the wall, as well as the edges of the road, all lie along perspective lines which converge at the same point, the vanishing point. To help you understand this, lay a sheet of tracing paper over the picture and draw in the perspective lines as shown in the diagram on the opposite page.

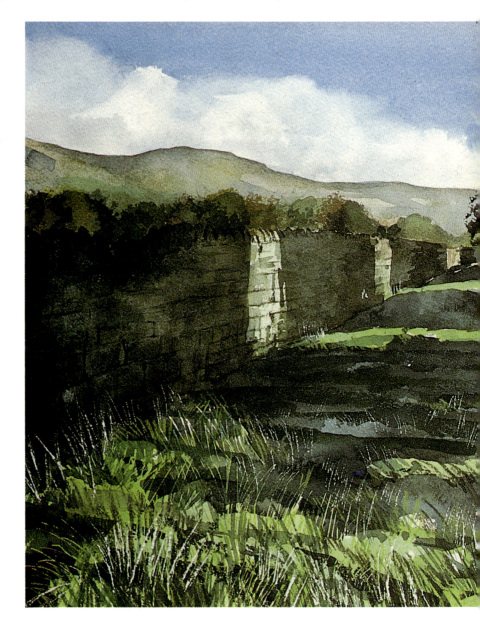

Perspective construction lines

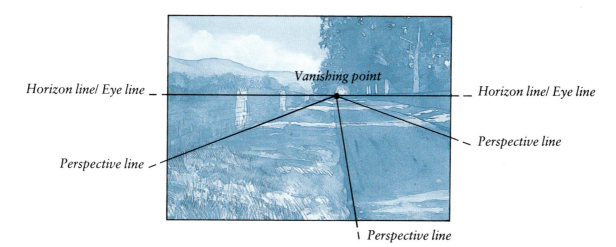

Horizon line/ Eye line

Vanishing point

Horizon line/ Eye line

Perspective line

Perspective line

Perspective line

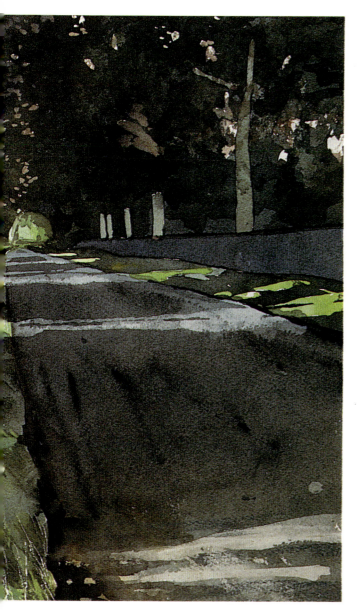

scene you are painting, at right angles to your line of vision. This is the picture plane, and it is a useful way of assessing the angles observed in the landscape (these can be checked against the horizontals and verticals of the frame).

Linear perspective starts by assuming a single viewing point – a point from which the artist, and the spectator, look towards the horizon. This is your eye level. The horizon line is at eye level and is established by taking an imaginary line from the eye to the horizon. You could draw it on the glass at your own eye level.

If you are seated, your eye level will be lower, and so too will the horizon. If you stand on a chair, your eye level will be higher, and so too will the horizon.

Vanishing points are the points on the horizon at which parallel horizonal lines appear to converge. Lines at right angles to the picture plane converge on the centre of vision, which is directly opposite the eye of the viewer.

Any plane parallel to the picture plane diminishes in size but retains its shape without distortion, so vertical lines remain vertical and horizontal lines parallel to the picture plane remain horizontal.

TECHNIQUES

SKETCHING

Sketching is a marvellous way to develop your drawing skills, and you'll find that professional artists draw constantly. But, more importantly, drawing sharpens your powers of observation. A good artist needs good technical skills, but the eye is even more important than the hand. If your work is to improve, you must learn to look at the world with the selective, discerning eye of an artist.

Drawing forces you to concentrate. With a pencil in your hand, it is difficult to fudge things. You have to make decisions about precisely where that tree is, for example; how big it is in comparison with the other tree; and even whether it should be in the drawing at all. Does it contribute to the composition, or would the image be more satisfying if the tree were moved, or shifted to another position? You can erase, scribble and redraw. It

Pages from a sketchbook
These drawings are from Gordon Bennett's sketchbook. In the picture of the house by a bridge he is exploring the compositional possibilities of a scene. In others, such as those of the branches of a tree, he is analysing details.

doesn't matter, as long as you clarify your ideas and understand what you are seeing.

A sketchbook should be treated as a working tool, not as something precious. You can be uninhibited in your sketchbook – free to make mistakes, to explore and to experiment.

Use it to make drawings of scenes to be worked up into paintings later, and to record details – the texture of a tree trunk, for example, or the way an old gate hangs drunkenly off its hinges.

Written notes can provide a useful jog to the memory. On one of these sketches the artist has jotted the pigment colours which are closest to the colours he sees.

You can even sketch and hone up your observational skills without pencil and paper by forcing yourself to find exactly the right words to describe a colour or form. If you are out and about without your sketchbook, try talking your way round the scene. Describe the shape of a roof, the exact colours of slates and tiles, the way light and dark tones are massed on a tree. This is a difficult but wonderful way of forcing yourself to look and really 'see'.

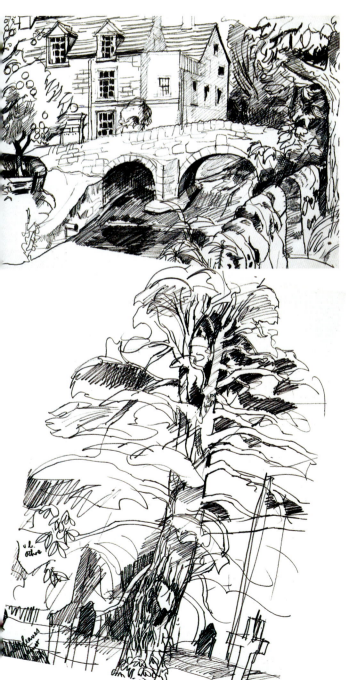

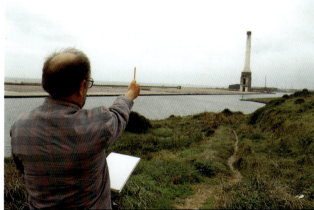

Measuring with a pencil
A pencil provides a simple means of estimating and comparing proportions, particularly vertical and horizontal distances, and angles. Select the object you want to use as a yardstick for your drawing. Hold the pencil out, making sure your arm is fully extended. Align the top of the pencil with the top of the object and use your finger to mark the bottom. This is the basic measurement against which all the others will be compared. Make sure the pencil is absolutely vertical. When estimating angles, start with the pencil horizontal and then rotate it until it lies along the line to be measured.

199

TECHNIQUES

RESIST

You can take advantage of the incompatibility of oily substances and water to create resists with candle wax, crayon and oil pastel. When watercolour is applied over a waxy or oily area, it forms droplets and tends to run off, because there is a mutual antipathy between oil and water. Sometimes the droplets don't run off but dry on top of the oily passage, giving the surface a speckled effect.

White wax candle can be used to reserve the white of the paper and to introduce interesting textures. Apply the wax to the paper. It can be used descriptively to stand for light tones on a grassy area, the silvery bark of birch trees or pale reflections on the surface of a stream. It can also be used to add surface interest – in a rocky headland, for example.

As a painter you are constantly looking for ways of creating exact descriptions or equivalents, but your painting is also an entertainment. Wax resist can be used to produce surfaces which are rich, decorative or expressive.

Oil pastels can also be combined with watercolour, this time combining the resist quality with colour. On this page oil pastels have been used to introduce a linear element, to add texture and to draw some of the trees. In the painting 'The Old Power Station' on page 202, it has been used to introduce an abstract textural quality which implies the vegetation in the foreground rather than describing it exactly. By introducing texture in this area, the artist emphasizes the foreground, bringing it forward in comparison with the background. This aids the illusion of space in the painting.

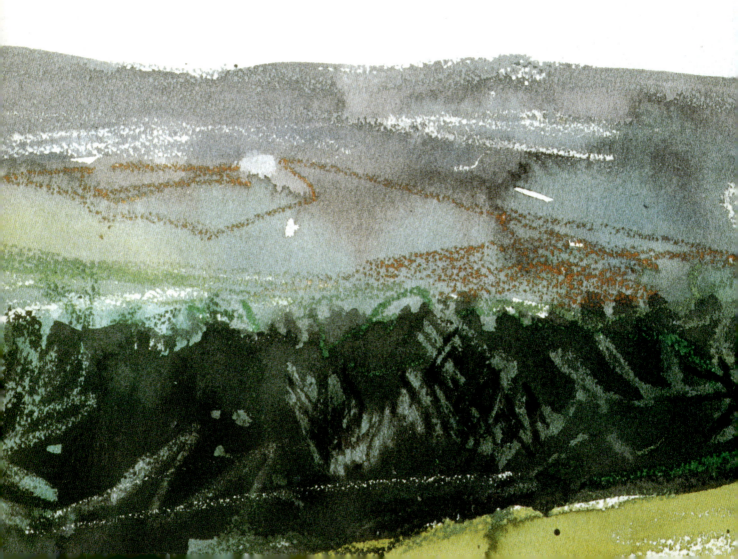

△ 1 *Oil pastel and candle wax have been applied to the paper surface. A wash of colour is then added.*

△ 2 *Here the artist applies candle wax over dry colour. In this case the wax is used to reserve colour.*

◁ 3 *Another wash of colour is added. You can see very clearly the way in which the wax repels the paint.*

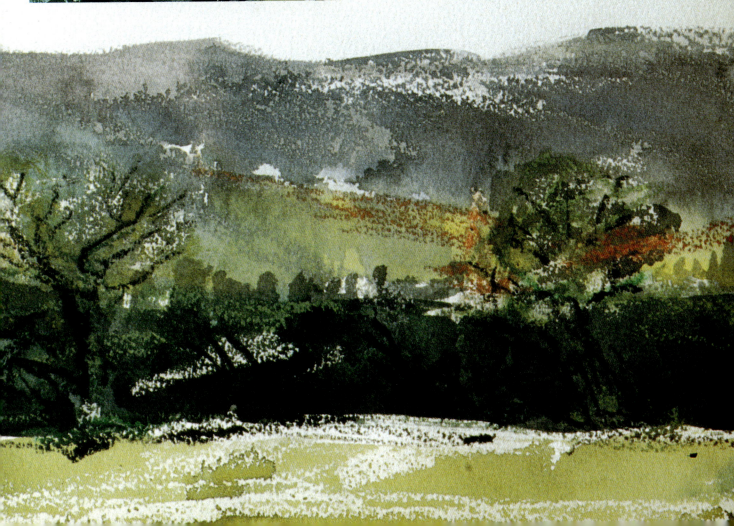

PROJECTS

THE OLD POWER STATION

This may not be your idea of landscape, but landscape isn't simply about romantically winding roads, babbling brooks, hump-backed bridges and sheep peacefully grazing. You can find absorbing material in the most unlikely spots.

Located on the outskirts of a coastal town, this chimney is all that remains after the demolition of a power station. Seen in silhouette against the sky, it had a majestic and brooding quality. The artist was captivated by the starkness and drama of this huge, monolithic structure, splendidly isolated in a barren wasteland.

The composition was carefully contrived to capture these qualities. The tall, 'portrait' format leads the eye up the picture area, drawing it towards the chimney. Scale is important, and the picture calls attention to the way the chimney dwarfs the ships, factories and warehouses around it.

The underlying geometry of the picture is important. The chimney divides the picture more or less on the golden section; the path in the foreground is deliberately offset to avoid the chimney and path together splitting the painting into two.

Contrast is a useful compositional device. The reflection of the chimney in the water carries a strong vertical down into the lower half of the painting. The path echoes the shape and size of the chimney, but its natural feel is contrasted with the man-made, constructed nature of the chimney. In the top half of the painting the wharves and buildings are described accurately with a remote detachment, while in the lower area the artist has used a variety of media to produce highly textured passages which have an expressive and abstract quality.

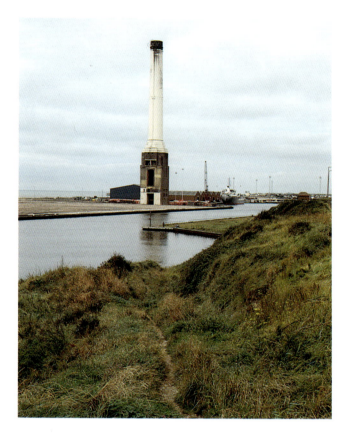

△ **1** *Not a candidate for the 'chocolate-box' school of landscape painting, this remnant of industrial architecture inspired an imaginative and satisfying image.*

△ **2** *The artist used a viewfinder to frame the image. He decided that a vertical or 'portrait' format would enhance the drama of the scene.*

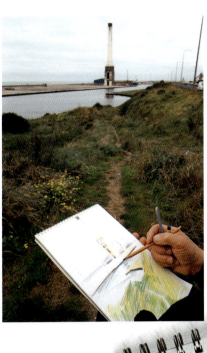

◁ **3** *The artist made a drawing to explore the possibilities of the composition.*

▽ **4** *The artist used colour pencil to record the colour and tonal relationships within the composition. The sketch performs two functions – it is both an exploration of the subject and a record which will be useful if he wants to continue in the studio.*

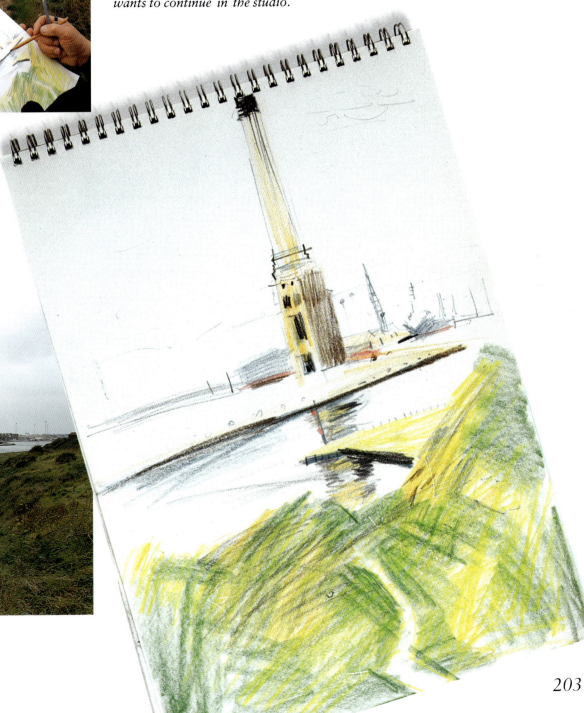

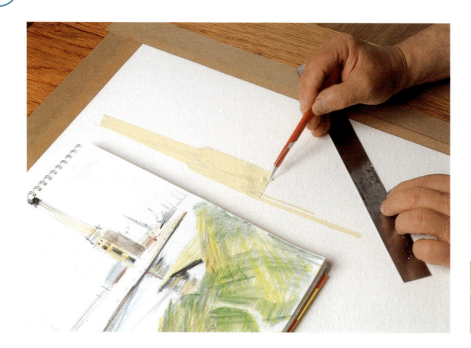

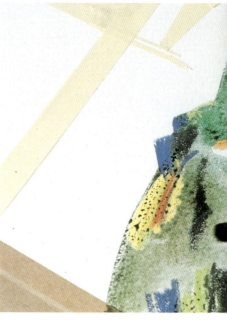

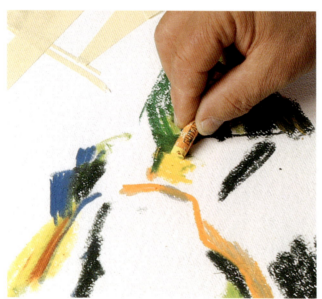

△ 5 *The chimney will be the lightest area of the painting. The artist reserves it with masking tape, and by cutting the shape of the chimney with a knife is able to capture its crisp, man-made silhouette.*

△ 6 *To make the painting more dramatic and interesting, the artist developed the foreground in a rather abstract way, using oil pastels to create textures. These textured passages perform several functions. They describe the vegetation without painting every leaf and blade of grass, and provide a decorative surface which is entertaining. They also enhance the sense of space in the painting by bringing the foreground forward.*

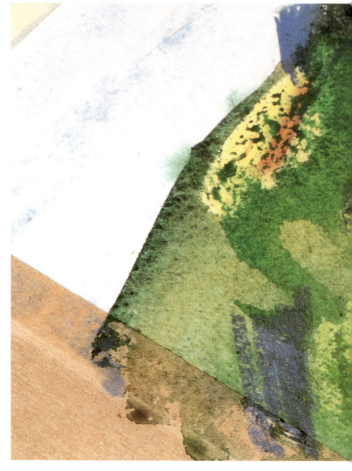

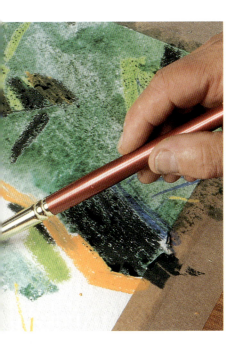

◁ **7** *Watercolour is flooded over the oil pastel, which acts as a resist.*

▽ **8** *Colour is spattered on to the painting, adding more texture to the foreground.*

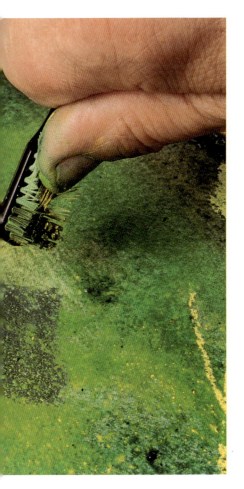

▽ **9** *The blue of the sky was flooded in, using a wet-in-wet technique. To do this the artist turned the painting upside down, loaded a brush with water and dampened the sky area, working carefully along the skyline. Then he tipped up the board – still upside down – loaded a brush with cobalt blue and laid a wash, working backwards and forwards across the paper.*

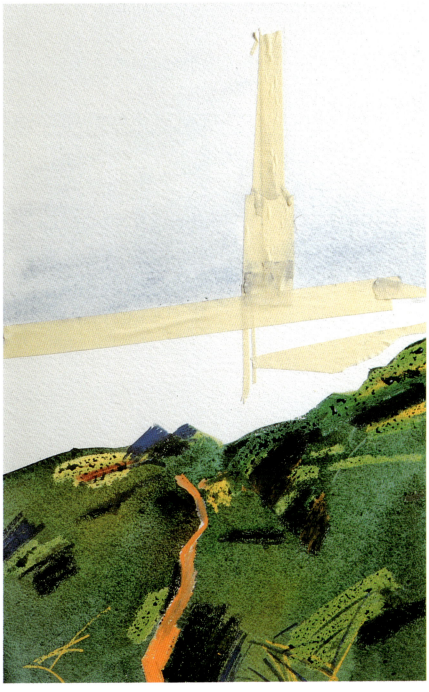

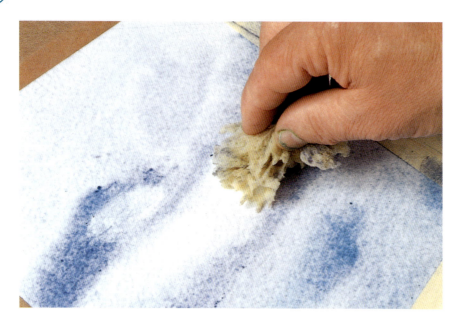

◁ **10** *Another wash of colour is added to the sky, then colour is blotted off with a sponge to create the variegated appearance of a cloudy sky.*

▷ **11** *The masking tape is removed to reveal the neat white area beneath.*

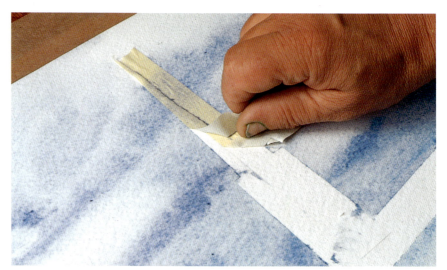

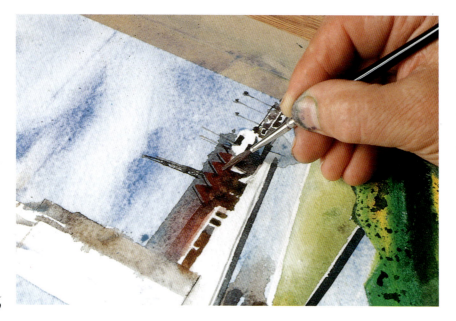

◁ **12** *The artist sharpens up the detailing in the middle distance. He develops the cranes, buildings and factory roofs, using close tones to ensure that they take up their correct position in space. If he used bright colours or sharp contrasts, this area would move towards the front of the picture plane, destroying the illusion of recession. He uses warm and cool colours, but the reds are relatively cool, because warm colours are inclined to advance. If he had used hot reds for the roofs, they would have jumped forward.*

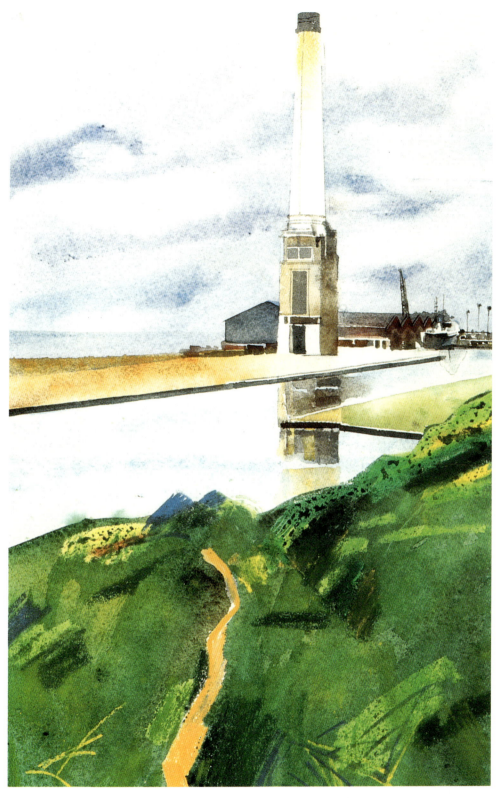

△ **13** To complete the painting, the artist added a touch of yellow ochre to the top of the chimney stack, so that it becomes ochre against blue at the top and white against blue lower down. The local colour – that is, the 'actual colour' of a surface rather than the 'perceived colour' – of the chimney is a creamy yellow, but if it was rendered in a single colour it would appear flat and insubstantial.

The pathway is rendered as a jagged gash of bright colour which forces the eye up into the upper part of the painting, which is restrained and cool.

PROJECTS

BRIDGE AT ALFRISTON

The artist worked on this painting over two sessions on different days. If you don't manage to complete a painting in one session – perhaps the light has changed or the weather is unkind – you can return to it later. Make sure, though, that you choose the same time of day, or otherwise the light will be different. If you have sketches or even a photograph, you can develop the painting in the studio, returning to the location to refresh your memory and add the finishing touches.

A bridge provides the painter with some interesting compositional possibilities and the opportunity to play off the hard edges of a man-made structure against the soft, sinuous forms of nature. In the study of a bridge on page 190 the artist focused on the view through the bridge, working with the curves of the structure and its reflection in the water, creating an image which is essentially romantic.

The view of the bridge here explores a different quality – the way the wide sweep of the road invites you into the painting and dips over the bridge, leaving a query about what you might find on the other side. Another trigger point was the complex rhythmic pattern of the man-made fencing leading up to the bridge, the geometry of the fencing contrasting with the massed foliage of the trees beyond but linked to it by the natural, weathered timber from which it is constructed. The artist has managed to express the individual qualities of the different parts – the fence posts, the wall, the branches and the tree trunks – and, at the same time, integrate them beautifully.

An interesting problem for the artist to contend with – one that you will encounter too – was how to render the metalled surface of the road. Painting 'nothing', whether it is a flat road, a flat field or a large expanse of water, is a real challenge. Remember

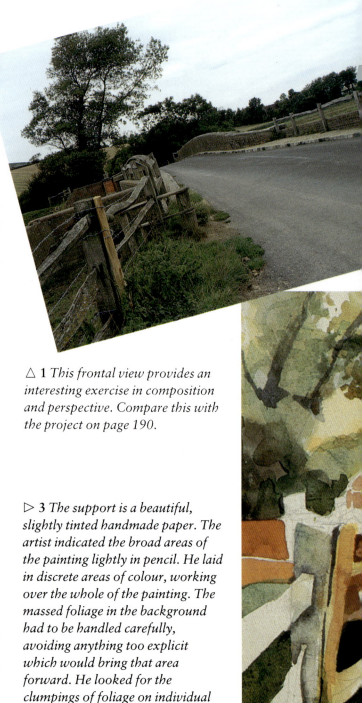

△ **1** *This frontal view provides an interesting exercise in composition and perspective. Compare this with the project on page 190.*

▷ **3** *The support is a beautiful, slightly tinted handmade paper. The artist indicated the broad areas of the painting lightly in pencil. He laid in discrete areas of colour, working over the whole of the painting. The massed foliage in the background had to be handled carefully, avoiding anything too explicit which would bring that area forward. He looked for the clumpings of foliage on individual boughs, branches and twigs, and laid down these areas. He let the painting dry in the sun and then overlaid more colour, trying to find a visual equivalent for the trees. He mixed a huge variety of greens, creating others by overlaying one colour with another.*

that anything horizontal and parallel to the sky reflects light from above and tends to be light, in contrast with vertical surfaces like trees and bushes, which tend to be dark. You need to look at the 'empty' passage as an important compositional element, a shape against other shapes and an area of colour and tone. View the picture through half-closed eyes to see if the separate elements knit together satisfactorily. If they don't, go back to the subject to see if you can find any clues there. And don't be afraid to put things in or leave them out if the composition demands it. Make the painting your own.

◁ **2** *The artist returned to the painting for a second session. Working without an easel, he uses the fence posts to balance his equipment.*

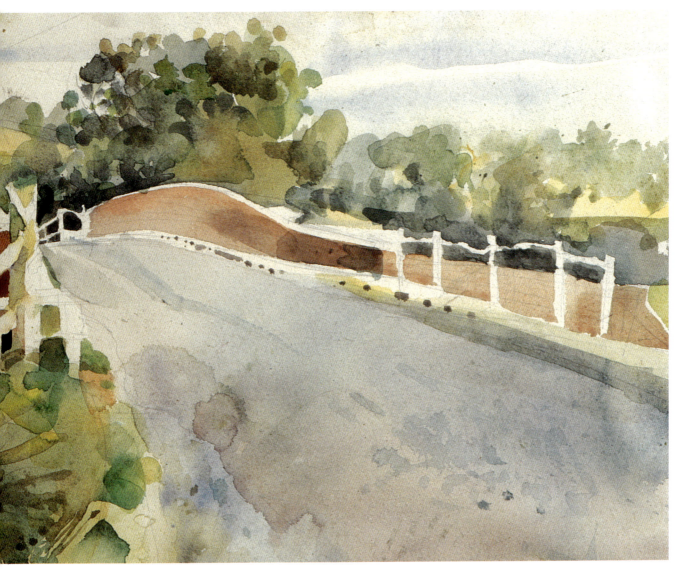

▽ **4** *The tones of the fence were laid in with great care. This is an important element in the design, leading the eye into the composition and across the bridge. Darks were added, mixed from raw umber and cobalt so as to retain a transparent feel.*

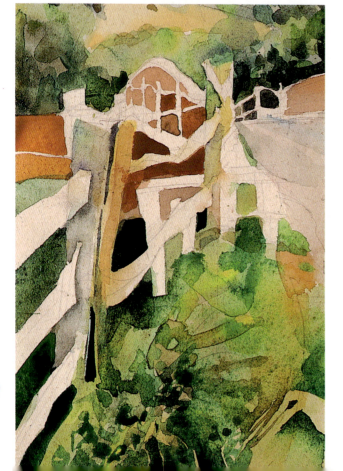

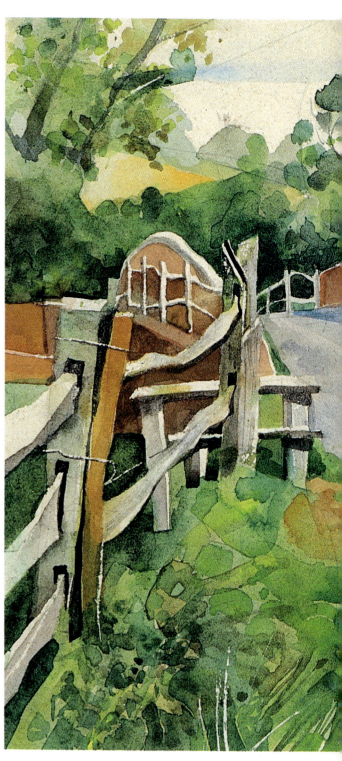

◁ **5** *Using a wash of Hooker's green, the artist adds more detail to the vegetation on the verge. The paint is laid wet on dry and allowed to dry with crisp edges, which describe the complex forms of grasses and other plants. By adding more detail to this area you will* bring it forward on to th[e] plane, creating a sense o[f] You have to judge just h[ow] detail to add – enough t[o] convincing illusion with[out] distracting attention fro[m] the painting.

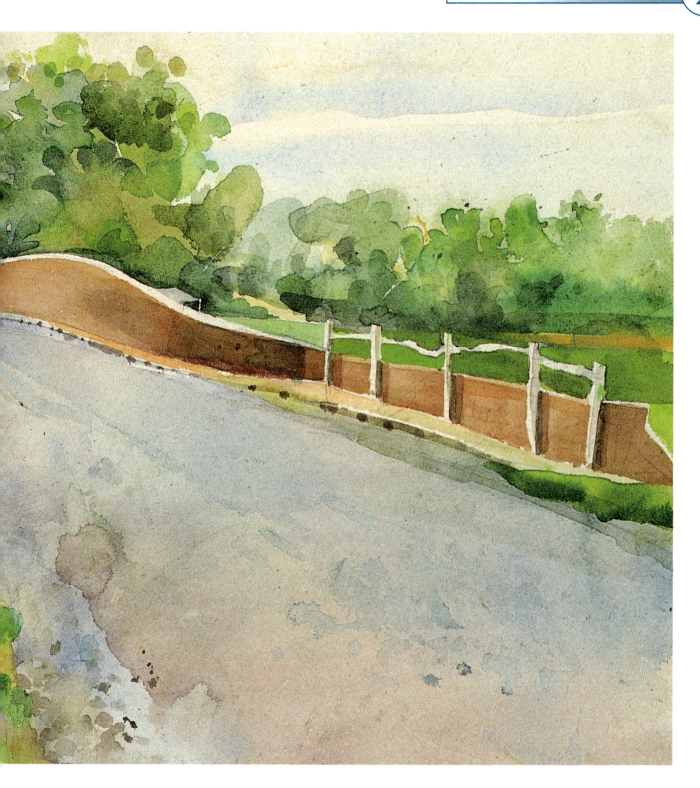

△ **6** Some more washes were laid on to develop the trees and foliage.

Warm colours, sharp tonal contrasts and bright colours tend to advance, while cool colours recede, so the artist puts the warmer and brighter colours in the foreground –

lilacs, purples and brighter blues – to create a sense of recession. As the road moves towards the crest of the bridge, the colours he uses are pale blues and bluey greens.

A dry brush was used to add detail to the stile and foreground

timbers. Finally, a quill pen, charged with a mixed neutral tone, was used to draw the wire attaching the foreground posts.

MASKING

The white of the paper is important in pure watercolour. It gives you whites, light tones and highlights. In paintings where the local colour is white – a white building, for example, or the chalk figure in the next project – whites are particularly important. The effort of remembering not to stray into those areas can be very restricting, and prevent you working freely with the gestural marks and experimental textures which give watercolour character. This is where masking fluid comes into its own.

It is a milky liquid which can be applied to paper with a pen or a brush. It dries to a thin, rubbery film which protects the painting while you work. When the painting is finished, or when you want to develop the masked area further, remove the mask by rubbing the area gently with your fingertips or an eraser. The mask comes off as a thin film and rubbery crumbs, revealing the clean white paper beneath.

Masked areas have a special crisp edge which lends itself to certain applications – to rendering buildings, fence posts and other structures, for example. Sometimes, however, you don't want the paper to stay brilliant white and there is no reason why you shouldn't work over the masked area. In the example on this page, the artist has used the masking fluid in a variety of ways. It has been applied with the tip of a fine brush to reserve the delicate tracery of the flower stems, while a larger brush has been used to 'paint' the silhouettes of the flower heads. In some areas the mask has been applied over a previously painted area to reserve a

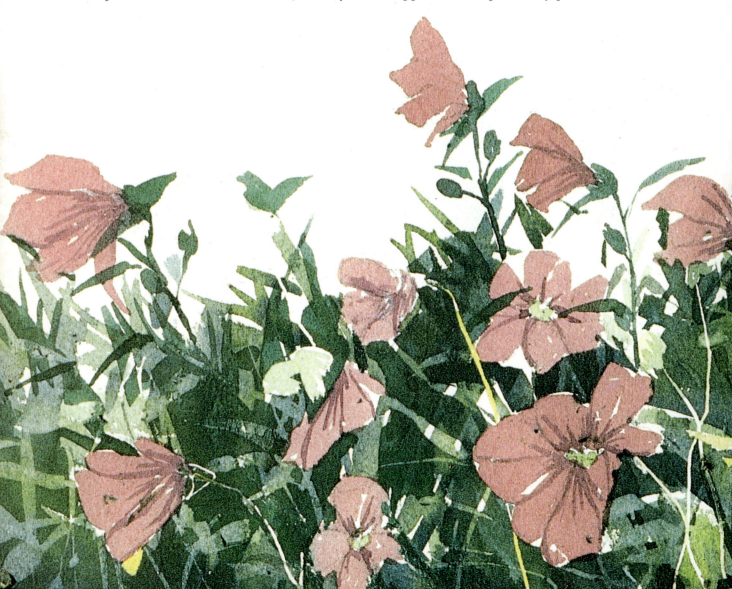

shape in a light tone, allowing the artist to work freely in a darker tone which will ultimately define the masked form – the mask allows him to paint the 'negative' of a flower stem.

The mask was removed and the masked areas treated in a variety of ways. The white of the paper has been left to stand for stems, but the flower heads have been painted in a magenta mix, in the crisp masked shapes.

Masking fluid is generally available in two forms. One is pure white, but it is a bit difficult to see against the white of the paper. A slightly creamy version is easier to see, but it can stain certain papers if it is left on for too long.

Masking fluid can be used in a precise way to mask forms accurately. It can also be used more freely – splashed on, dashed, daubed and dotted to create interesting textures. You could, for example, splatter masking fluid on to a watery area to create sparkling highlights.

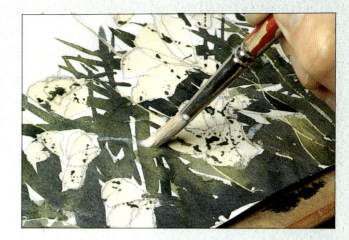

△ **1** *The bold shapes of the flowers and the delicate lines of the stems have been masked with creamy fluid. Here a masked line is applied over green foliage.*

▷ **2** *The mask can be removed by rubbing gently with your fingertips. Here you can see how thin the film is.*

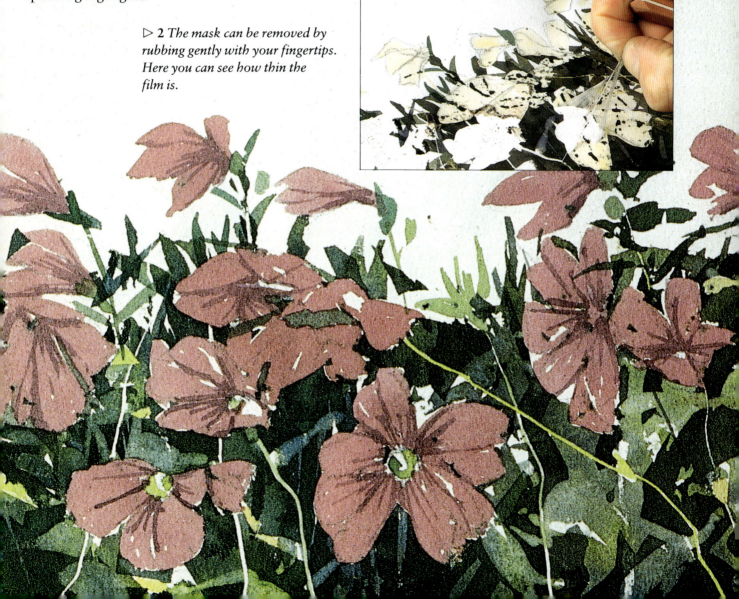

Working in the studio

•

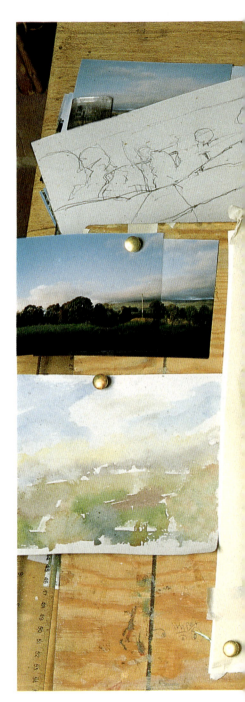

WORKING IN THE studio is a very different process to working out of doors. When you paint directly from the subject, you generally aim to complete a painting in one sitting, recording your impression of the scene rapidly. You are keyed up, focused and concentrated, aware of even the slightest change in the light, making compromises all along, the limited time available forcing you to act decisively.

In the studio you can work in a more considered way, allowing the picture to evolve slowly. You can take it so far and then set it aside, living with it for a while before you work on it again. In many ways the artist has more control when working in the studio. Away from the subject, you lose the immediacy of the direct response but you can develop your own themes, impose your ideas and take time to let the painting evolve.

You will need good reference material. There is nothing to replace sketches and drawings made on the spot – these force you really to look at the scene and analyse it, to store it away in your memory. Colour sketches, colour notes and photographs will all prove invaluable when you return to the studio.

Pencil sketches, colour sketches, watercolours and photographs collected on location to be developed in the studio. On the right is a collection of ceramic

palettes. In the studio you inevitably have more space for mixing colour, so it is easy to work on a large scale.

215

PROJECTS

BLUE CRANE

More than anything this painting is about colour – the wonderful burnt orange of the piles of sand and gravel sizzling against the cerulean blue of the crane. This scene was found in a dockyard area, not far from the location of the power station which was the subject of the painting on page 202. Again, an unlikely urban landscape has thrown up an exciting subject.

The artist played visual games with the colour, pushing the natural colours towards the true complementary relationships. Complementary colours occupy positions on opposite sides of the colour wheel and when placed side by side they enhance each other, setting up a lively resonance.

The other theme developed in the composition is the geometry of forms, and the contrast between man-made and natural ones. The shapes of the buildings were carefully plotted against horizontal references, using a plumb line. The artist worked precisely, ruling lines to create crisp edges, masking others with tape – the bird-like profile of the crane, for example. These geometric shapes contrast with the more natural forms of the piles of sand, but even these have the sculpted appearance of wind-blown sand dunes. Rendered in exaggerated light and dark tones, they have a surreal, fantastical quality.

The artist used a variety of techniques, flooding glorious oranges into wet paper for the dunes but working in a more controlled and precise way as the painting progressed.

△ **1** *The blue crane set against the ochre of the pile of sand gave the artist the motif for this painting.*

▷ **2** *In this pencil sketch the artist recorded the scene and sorted the information for later use. Notice the detail of the jib of the crane at the bottom of the page.*

△ **3** *In the studio the artist 'drew' the shapes of the sand piles in water, flooding a range of golden tones on to the damp paper.*

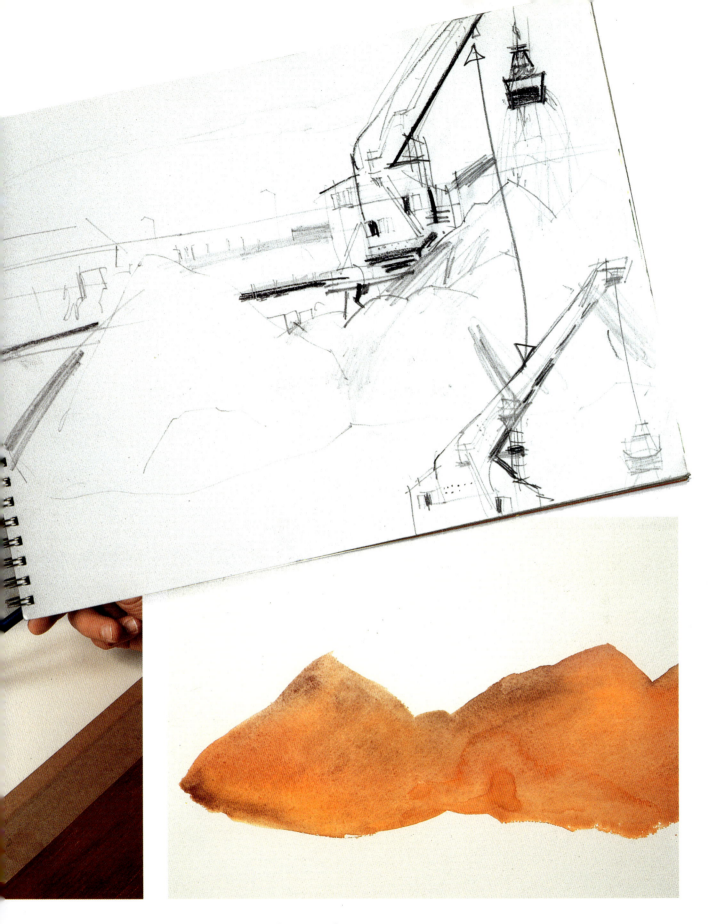

△ ▷ **4** *At this stage the painting consisted of a series of orange pyramids. The work itself suggested the way the artist should go, emphasizing the brilliant colours.*

△ 5 *The artist laid in the dark tones, using a rich, warm colour. He worked with a hairdrier to speed up the drying process and also to cause the colour to puddle and dry with a hard, crisp edge.*

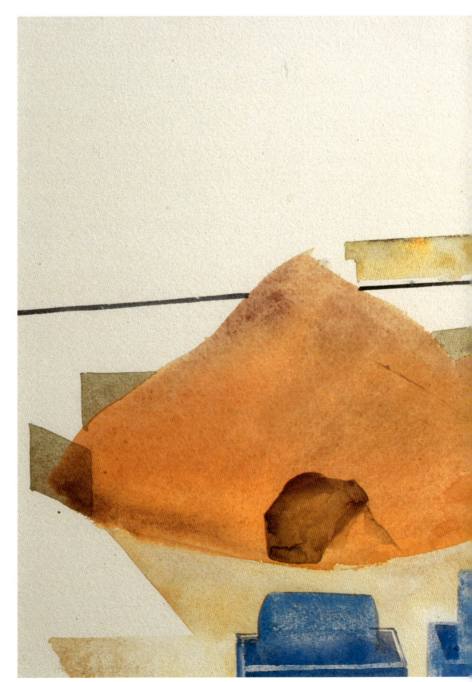

◁ **6** *Working in the studio allows you progress in a more deliberate, controlled and experimental way. Here the artist uses the edge of a piece of card to add linear detail and interesting texture to the sand.*

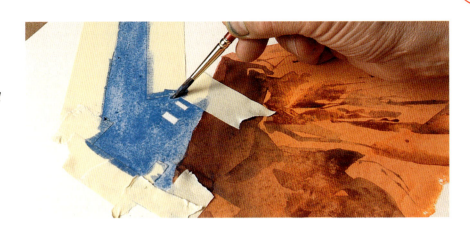

▷ **7** *The outline of the crane is masked with tape to give it a crisp, hard edge.*

◁ **8** *The forms are geometric. They are rendered with crisp edges, which give them an abstract quality, but they are nevertheless descriptive and realistically portrayed.*

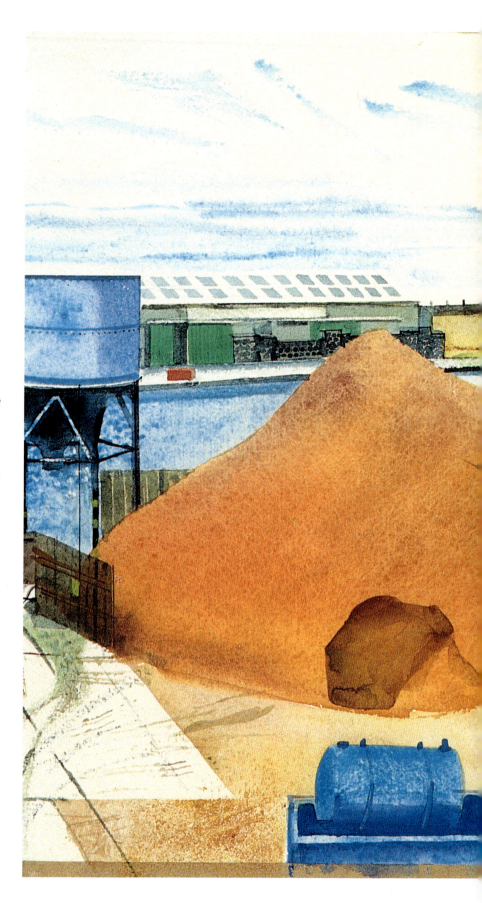

9 *The artist rendered the image with accurate detail, returning to the scene to collect further information. The complementary theme is carried on at the top of the painting where a startling red shape is set against some doors in green to echo the blue–orange relationship. Elsewhere the colours are muted – neutrals, greys, reduced yellows and drab greens.*

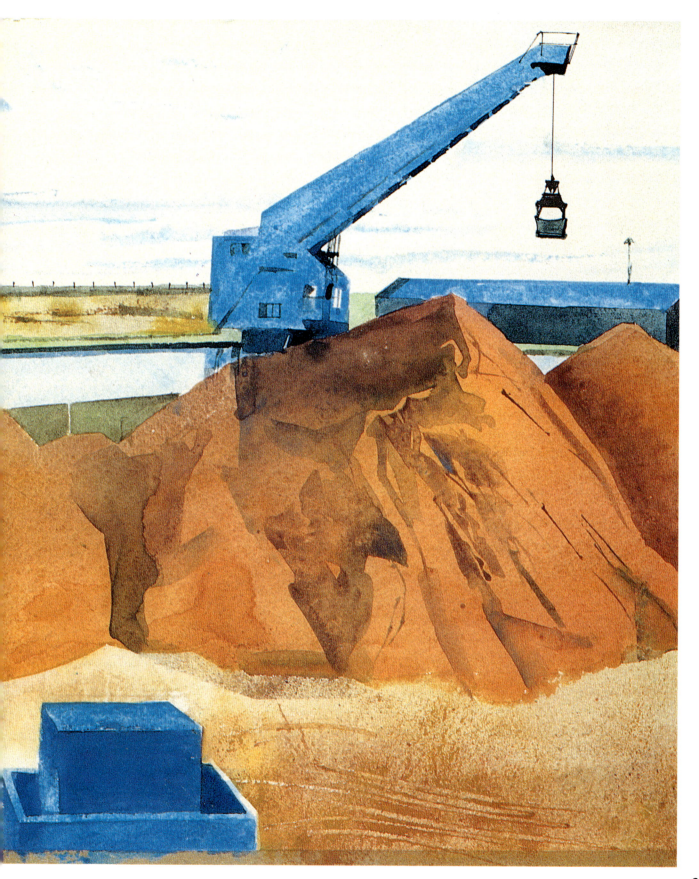

PROJECTS

JACK AND JILL

This pair of windmills, named after the characters in a nursery rhyme, stands sentinel on the chalk downs which loop along the south coast of England. Jill, the white post mill, was built in 1821 in Brighton and contemporary prints show it being drawn across the downs by huge teams of oxen. Post mills are built on a single vertical post so that the whole structure can be turned to face the prevailing wind. Later it was realized that the whole building need not rotate, and tower mills such as Jack were built. These had rotating caps to which the sails were fixed. Jack, the brick tower mill, was built on site in 1896, and both Jack and Jill worked until 1907.

The artist visited the site towards the end of the day. The sky was threatening and he was buffeted by squally winds. But it was too good an opportunity to miss, so he made a quick sketch using conté pencil and watercolour pencil. As he worked, the weather broke and it began to rain. The spatters of raindrops caused the watercolour and the conté pencils to dissolve and bleed, the wet conté in particular creating a very dramatic effect.

The artist worked up the image in the studio and returned to the location the following day to add more detail. It was extremely windy – the conditions were, if anything, even more difficult than they had been on the previous day. He was surprised by the number of changes that had taken place. The white post mill had moved round, so he had to work from several locations in order to reconstruct the original view. The sky, too, was entirely different. He laid in large washes in warm blues with a little crimson, but still felt that a more atmospheric effect was required. He turned and found a magnificent lowering sky behind him, with scudding clouds. He didn't paint that sky, but carried the memory of it in his head so that it influenced the sky in his painting.

▷ **1** *The bold shapes of this pair of windmills presented the artist with an interesting study of structures within the landscape.*

△ **2** *A sketch in pencil, coloured pencil and conté, executed in dreadful weather conditions, provided him with material to work from in the studio.*

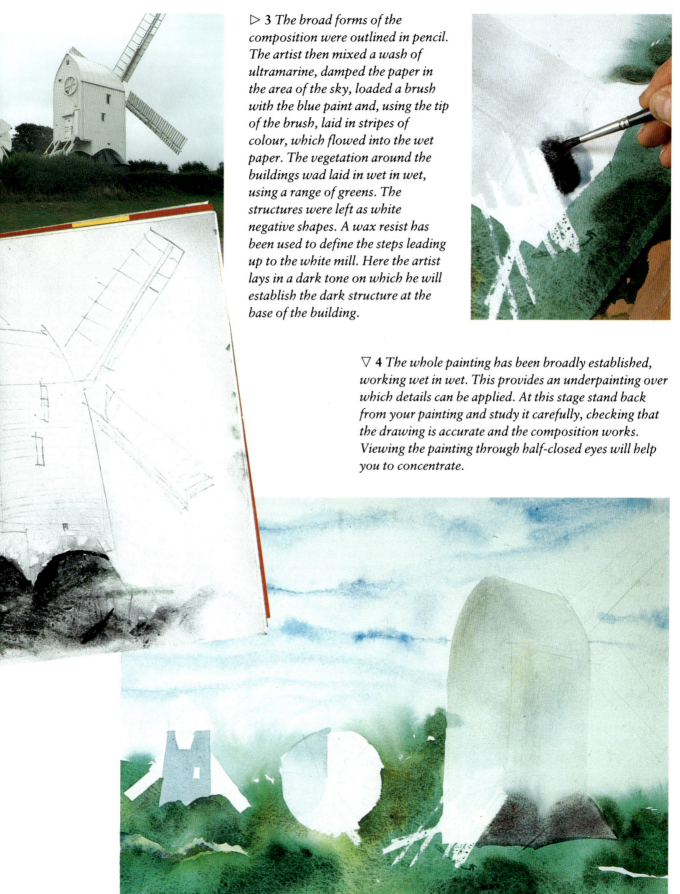

▷ **3** *The broad forms of the composition were outlined in pencil. The artist then mixed a wash of ultramarine, damped the paper in the area of the sky, loaded a brush with the blue paint and, using the tip of the brush, laid in stripes of colour, which flowed into the wet paper. The vegetation around the buildings wad laid in wet in wet, using a range of greens. The structures were left as white negative shapes. A wax resist has been used to define the steps leading up to the white mill. Here the artist lays in a dark tone on which he will establish the dark structure at the base of the building.*

▽ **4** *The whole painting has been broadly established, working wet in wet. This provides an underpainting over which details can be applied. At this stage stand back from your painting and study it carefully, checking that the drawing is accurate and the composition works. Viewing the painting through half-closed eyes will help you to concentrate.*

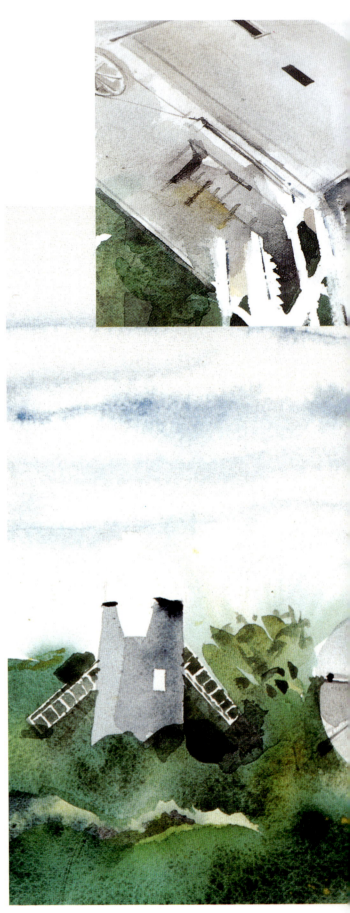

△ 5 *Once the underpainting is established, you can begin to develop the painting, adding colour and texture in the foreground – for example, describing the white windmill with a series of pale washes, and adding fine detail. Don't focus on one part of the painting, but develop the entire surface at the same time, constantly checking one area against another to ensure that they work together. Here the artist adds architectural detail with a quill pen.*

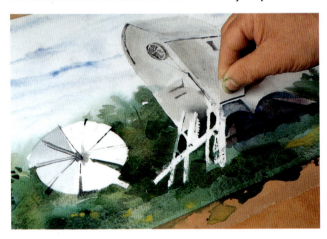

△ 6 *The marks that you make perform two functions. Not only do they describe the subject, but they can also be seen as abstract components of the picture surface. By varying the quality of these marks, you can enhance the decorative quality of the painting. Here a piece of card is used to 'draw' linear detail.*

◁ 7 *Here a knife is used to 'draw' detail, scratching the paper surface to create a soft, broken line.*

▽ 8 *Compare this stage with picture 4 on the previous page. You will see that the painting is gradually becoming more detailed and focused. With every painting, you have to decide how far to take the image; knowing where to stop is as difficult as getting started. At this stage the artist decided he wanted to add more detail.*

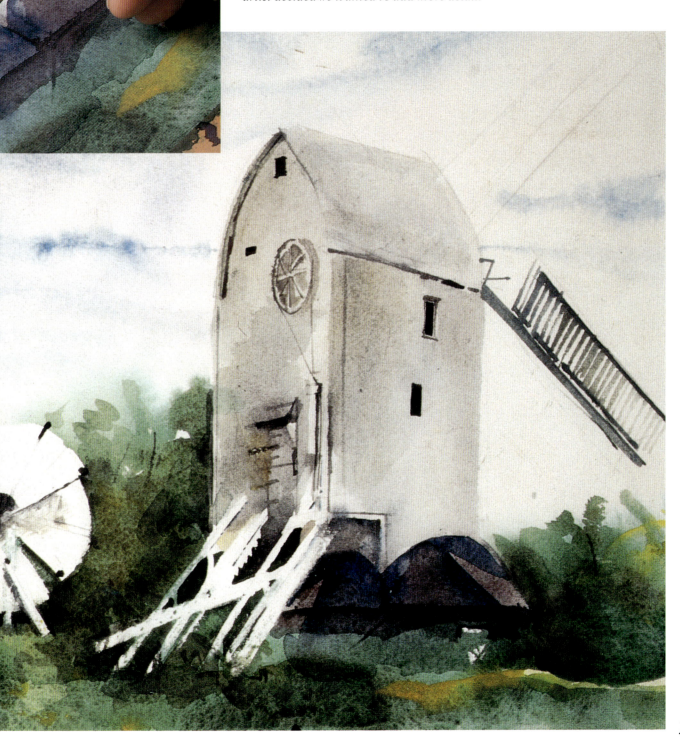

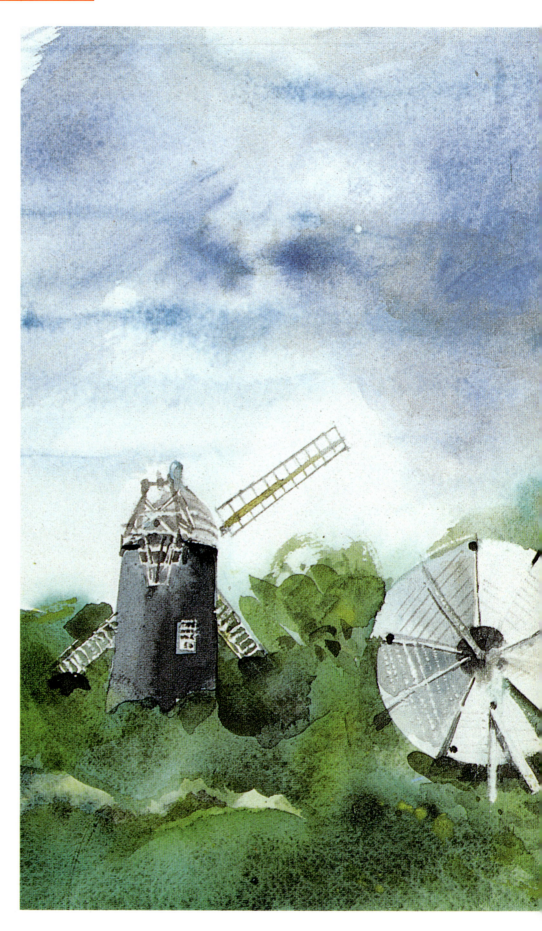

9 *He decided that the painting looked a bit stark. The pattern of whites and blacks against the greens makes a pleasing colour harmony, but the sky doesn't have much presence. He developed the sky with a series of washes to give it more impact. He used a brush-ruled line and sgrafitto (scratching through the top layer of paint) to get the texture on the rear wheel sail.*

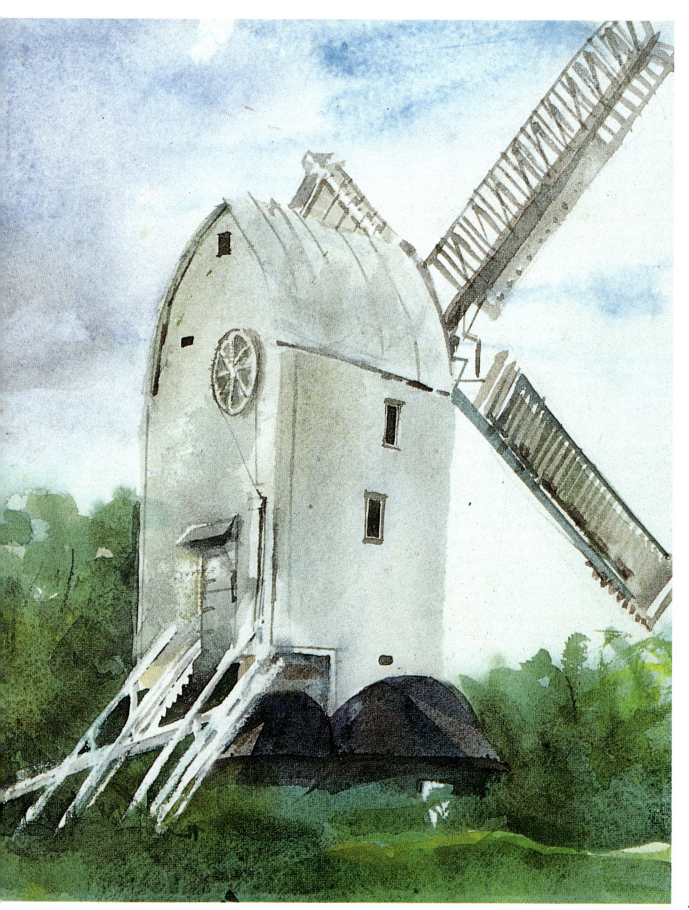

TECHNIQUES

AERIAL PERSPECTIVE

Aerial or atmospheric perspective is a technique which allows the artist to create an illusion of depth in a painting. Whereas linear perspective depends on an understanding of the structure of things and the way our perception of this is affected by distance, aerial perspective relies on contrasts of tone and colour.

As we look towards the horizon, several things happen. First, objects look paler the further away they are. So a tree near to you will look darker than a tree seen in the distance. The contrast of tones also diminishes with distance. Seen from close to, there may be a sharp contrast between the light and dark areas of the tree; the further away it is, the less contrast there will be. If a painting feels flat, you can increase the sense of space by adding crisp details in the foreground and blurring images in the distance. In watercolour this can be achieved simply by working wet in wet in the distance and adding details wet on dry in the foreground.

Colour is also changed by distance. Look at a tree close to you and you will be able to distinguish several distinct shades of green. Now look at a clump of trees in the middle distance. They will be paler and bluer. Hills seen a long way off on the horizon will look distinctly blue.

Warm colours like reds and red-browns are said to advance, while cool colours like blue appear to recede. To increase the sense of atmospheric perspective in your paintings, use blues and blue-greys in the distance and warm colours in the foreground.

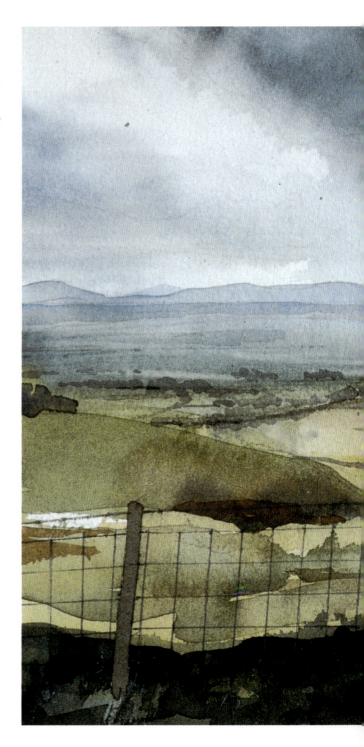

▷ *The foreground is richly coloured and highly textured. This, and the crisply rendered linear detail of the fence posts and the wire, contrast with the landscape beyond, creating a sense of precipitous recession. Warm greens and ochres bring the middle distance forward, while the distant hills are blue.*

◁ *In this photograph you can see the way the trees in the distance appear blue-grey, while the distant hills are distinctly blue.*

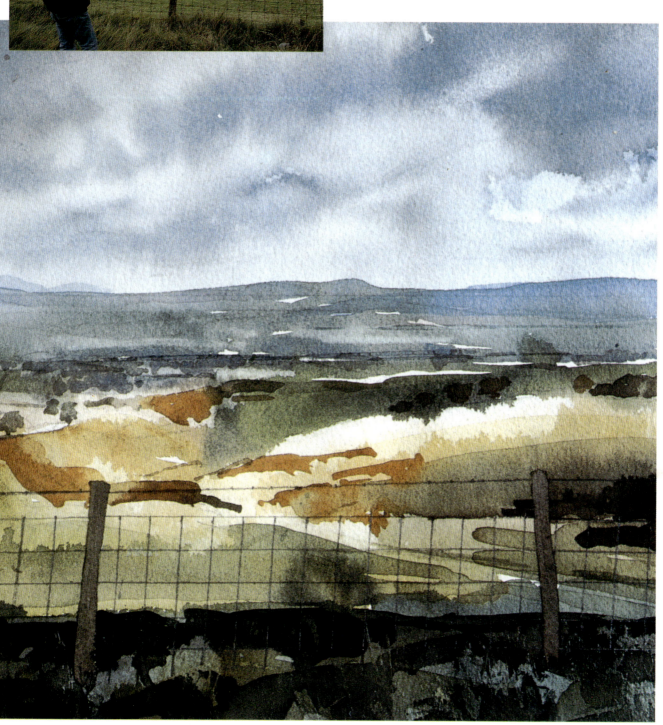

PROJECTS

BROAT'S FARM

One of the unkindnesses perpetrated by 'how to' painting books is to imply that professional artists never make mistakes. They show projects progressing in measured stages, always ending up with a pleasing image. But real life isn't like that. Things do go wrong, even for the most experienced artists. But while good artists know when something isn't working, and, more importantly, know what to do about it, inexperienced artists don't always recognize a mistake, and are inclined to struggle on because they can't face wasting all that effort.

This location was glimpsed through a field gate as the artist drove along a country road in Cumbria. He decided to work on a large scale and returned to the location with a 30 × 22 in (76 × 56 cm) sheet of Winsor & Newton paper, rough-stretched on a board. He set up his easel just inside the gateway, which gave him a view across a field to a farmhouse and outbuildings snuggling under the Cumbrian fells. He did a few pencil sketches to sort out the composition, then started by applying a series of broad washes, adding colour wet in wet. He worked fast, trying to capture the essence of the scene.

When he had got as far as he could without overworking the picture, he returned to the studio and continued on it there, using notes, photographs and his recollections of the scene. When it was finished, he studied the painting carefully . . . and decided he didn't like it. The problem was the composition. There were three bands – the sky, the hills and the foreground – and too much horizontal emphasis. The balance just wasn't right. There was too much foreground, for example.

He decided to start again and this time used L-shaped masks to explore compositional possibilities by cropping in to different parts of the picture. The next version – illustrated overleaf – came together easily, and he was much more pleased with it.

The lesson is that you never stop making mistakes, but equally you never stop learning from them. So don't be afraid to take risks.

▷ **1** *The artist working at Broat's Farm.*

▽ **2** *Adrian was dissatisfied with his first composition.*

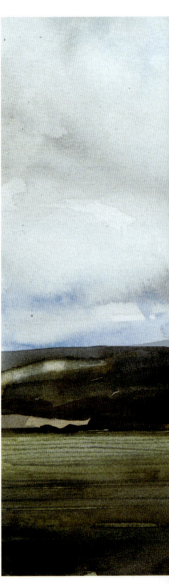

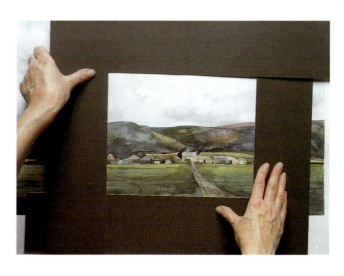

△ 3 *He used masks to explore different 'crops'.*

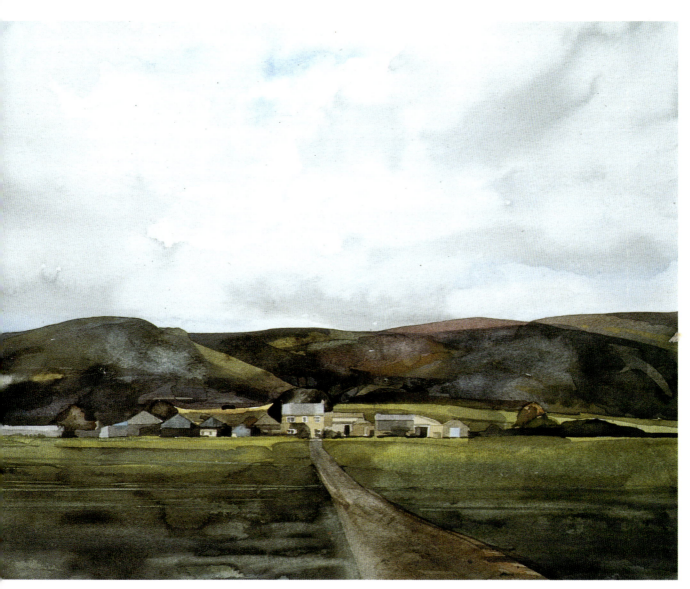

4 *For the final version the artist used a 'not' surface (so-called because it is not hot-pressed and has a smooth surface with a slight texture) and worked on a much smaller scale – the painting is reproduced here at its original size. The artist applied the paint loosely, working wet in wet to start with, leaving the painting to dry before laying on more colour wet on dry. Notice the way patches of colour are allowed to dry with hard edges, which then become an important part of the finished image. The colour in this version is altogether more lively.*

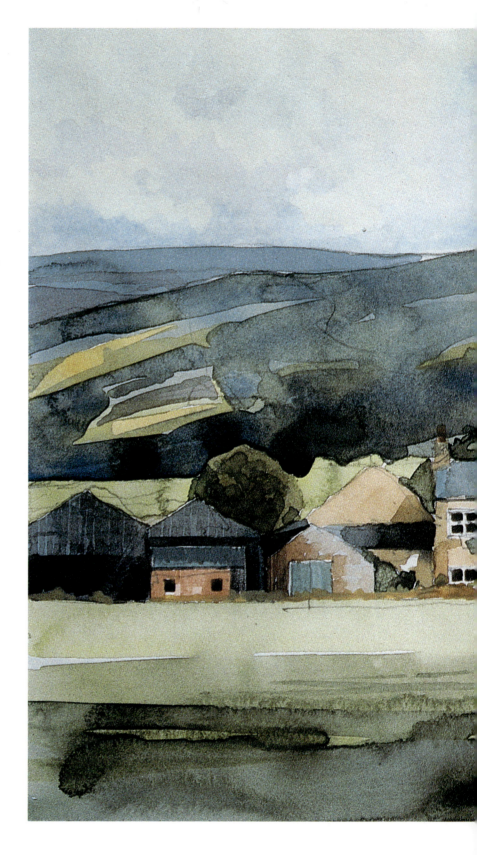

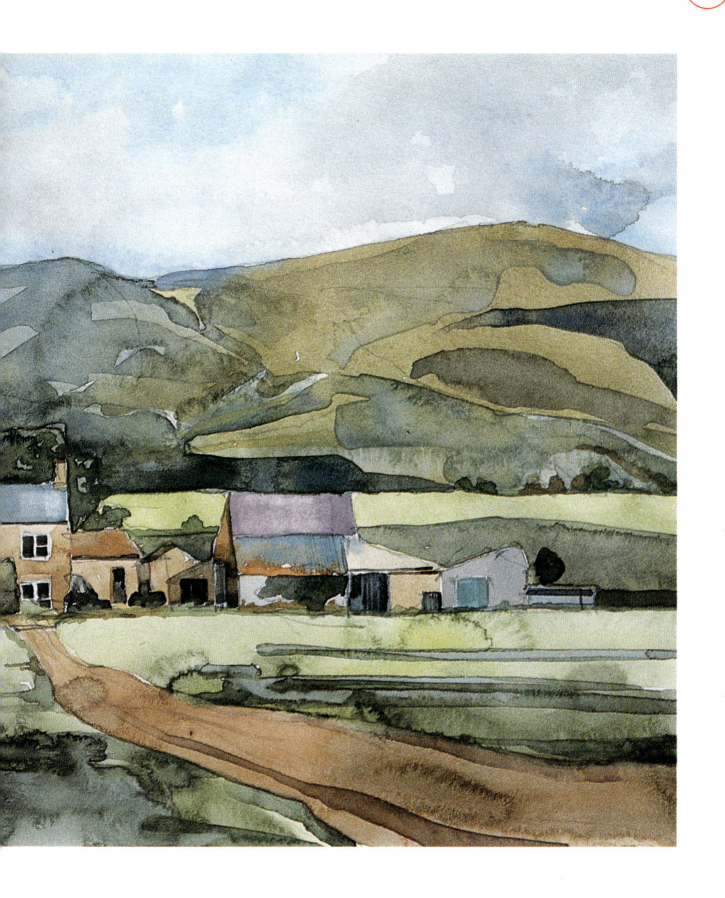

CUMBRIAN LANDSCAPE

The artist worked fast and furiously to collect materials to work from in the studio. He made several compositional studies in his notebook, a pencil drawing on recycled paper, a very loose watercolour on the same recycled paper and the lively watercolour illustrated on this page.

He was particularly interested in the vivid tones of the autumnal colours. He likes to work wet in wet and then, once the painting gets to a certain stage, leave it to dry. He usually works on more than one watercolour at a time, so that while one is drying he can work on another. A technique Adrian uses to keep the colours fresh is to leave white channels between areas of colour. In this way the wet paint will bleed in a controlled area.

He took this rich harvest of material home and worked on it over a period of time. In the painting on the next page he took the image towards abstraction, breaking the colour into blocky areas, formalizing the areas of tone and colour. By simplifying the forms and colours he brought out the decorative qualities of the subject.

In the final study he moves back towards realism, but the formal qualities of the previous painting nevertheless permeate this work.

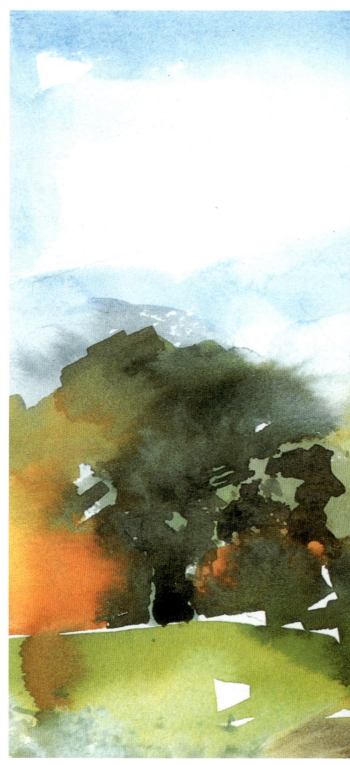

234 △ **1** *The artist gathering material on location.*

▷ **2** *A pencil sketch made on recycled paper on location.*

▽ **3** *A painting completed on location. The artist worked wet in wet. Notice the white gaps between areas of colour. This allowed him to keep the paint fresh.*

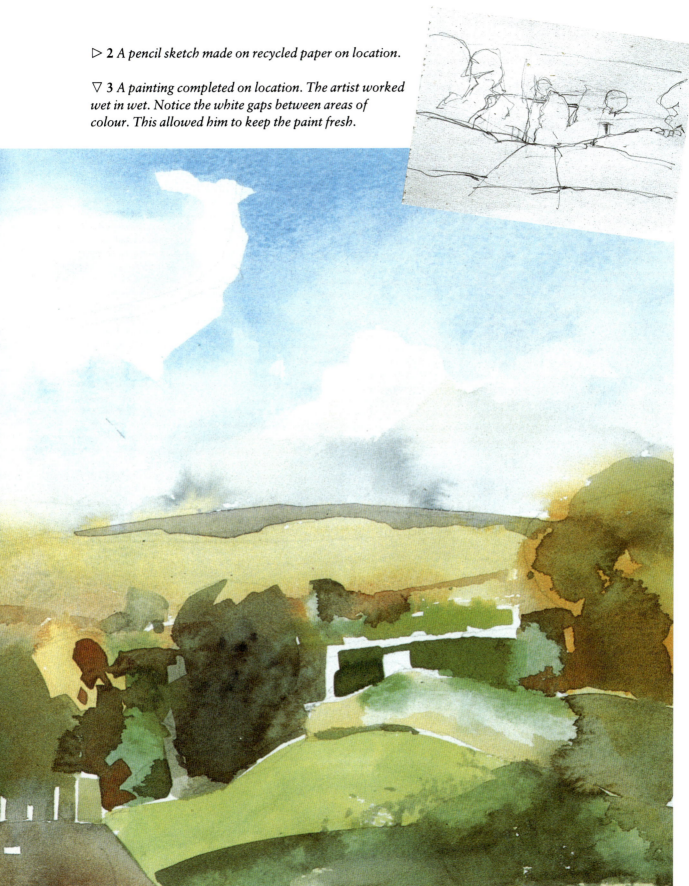

▽ **4** *In the studio, with his reference materials around him, the artist starts a new painting.*

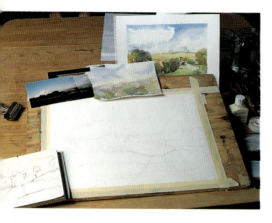

▷ **5** *In this study the artist explores the formal, pattern-making qualities of the subject.*

236

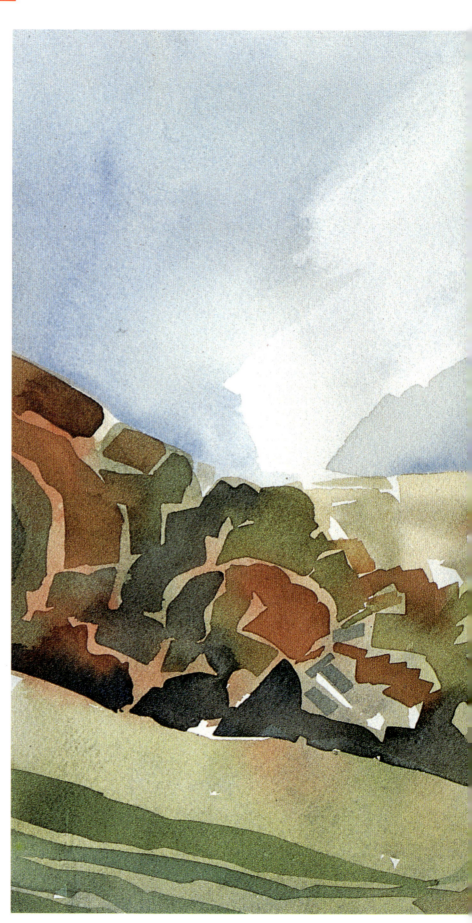

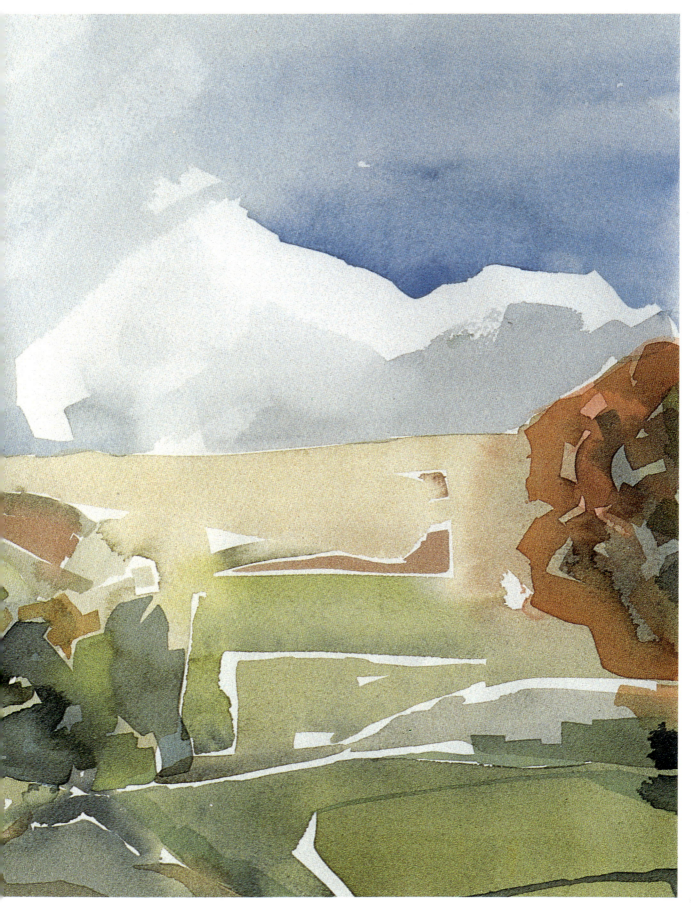

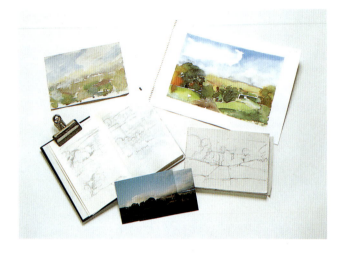

△ 6 *References, including some detailed studies in his sketchbook.*

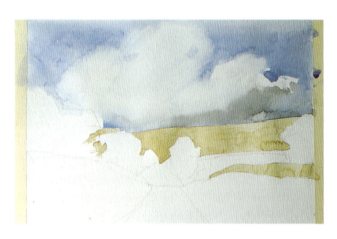

△ 7 *For the final painting, the sky was laid in with a bold wash applied wet in wet.*

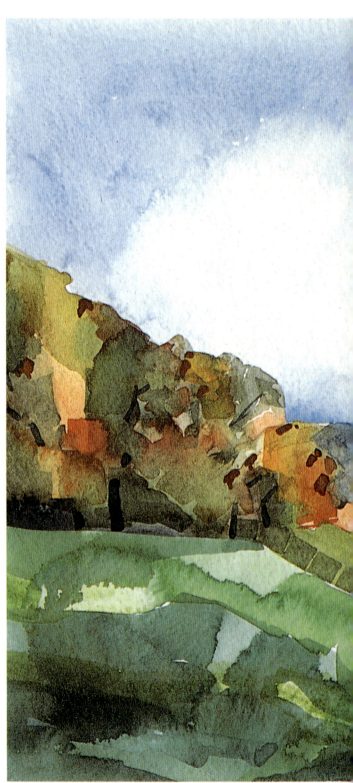

▽ **8** *The finished result combines elements of the other two. Don't be afraid to experiment, and never think you have said all there is to be said about a subject.*

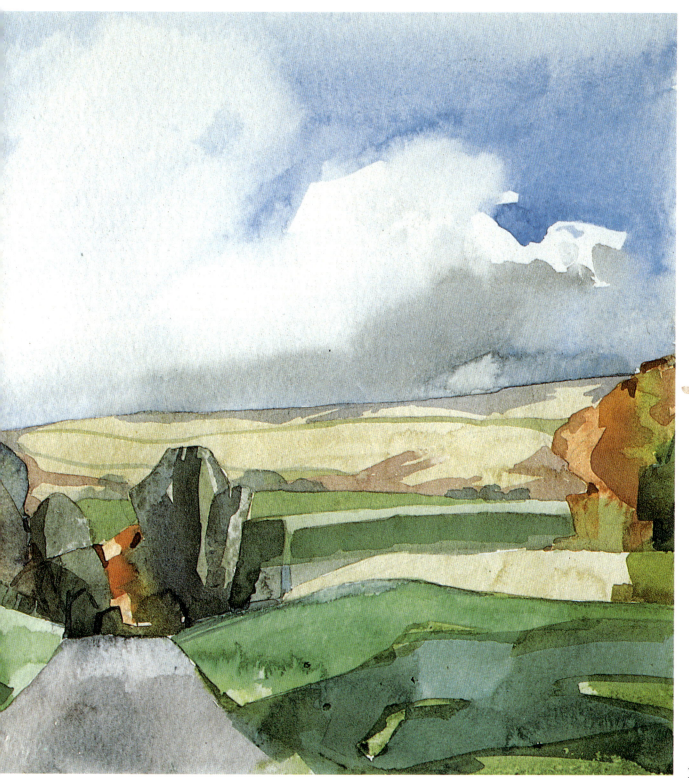

Approaches to landscape

I HOPE I HAVE convinced you that landscape is a fascinating and worthwhile subject, with a great deal to offer the inquiring artist. In this chapter I want to suggest that it is *your* vision of the landscape which is important. You can treat landscape as a jumping-off point for paintings which are as realistic, impressionistic or abstract as you want.

I have talked to three artists who paint landscapes in watercolour. They have different painting styles, but, more importantly, they also have different intentions and concerns. Put all three in front of the same subject and you would get three entirely different paintings – each unique, true to the subject and reflecting the concerns of the individual artist.

Once you have got a few techniques under your belt you can go on to explore and develop your own particular vision. Feel free to make the painting your own. Compose, edit, move, interpret and add as you see fit. Do whatever is necessary to make the picture work for you.

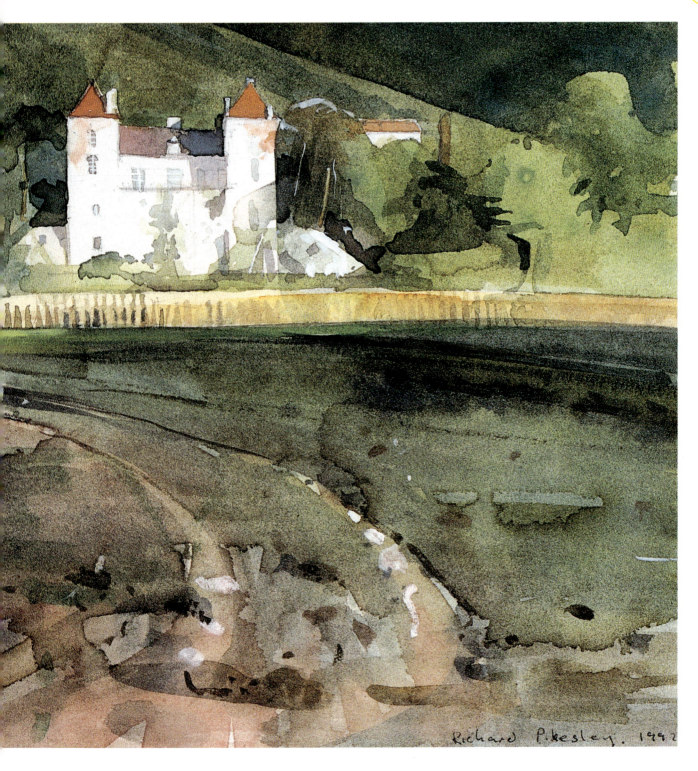

'Château on the Lot' by Richard Pikesley. The artist was captivated by the contrast between the brilliant white of the grand building and the muddy, churned-up texture of the field of maize stubble. The tracks made by a tractor lead the eye into the painting.

TONE AND COMPOSITION

Bill Taylor lives in Cumbria, a spectacularly beautiful upland region of northern Britain. He works in watercolour, gouache and acrylic, and concentrates primarily on landscape – local landscapes in particular, often featuring derelict buildings and broken-down walls.

Bill works in the studio from sketches made out of doors. Often these are quite rough. 'I use a sort of visual shorthand,' he says, 'and I depend an awful lot on my memory. It's got to be exceptionally good weather to encourage me to sit there all day and do a drawing.'

He doesn't paint finished watercolours out of doors because the immediacy and directness required when working in those conditions don't allow him time to consider the composition fully. As he says: 'There is generally something which I would have changed quite radically had I had time to sit and think about it a bit more.'

He thinks about the composition as he sketches, frequently moving his vantage point so that he can take in slightly different views, and takes lots of detailed notes. The time between getting the notes down and actually beginning the painting gives him a useful 'cooling-off period' which allows him to think about how he is going to interpret the subject. Before starting on the painting, he does a number of

◁ *Bill Taylor works directly from the landscape, drawing and painting in sketchbooks. His finished landscapes are worked up in the studio.*

▷ *This pencil study of Glencoyne was made when Bill Taylor was working on location with a group of students. Notice the details in the right margin, the annotations on the drawing and the way he has used the full width of the two open pages.*

thumbnail sketches in which he explores the composition and tonal values, and shuffles things round.

I asked him what was likely to trigger a project. 'It's usually the tonal values that hit me. I can frequently pass a subject several times and not notice it, and then on a particular day, when the light is of a particular quality and from a certain direction, it will give me a shunt. I can pass the same thing time and time again without noticing it.'

He uses pure watercolour, often combining it with pen or coloured pencil. He uses an old-fashioned dip pen, having been given a box of beautiful old nibs by a pupil whose husband was a retired bank manager. He likes to think of pens intended for work on ledgers finding such a creative use. He uses pen with paint rather than with ink,

loading it up with watercolour from the brush. He can make better lines with a pen than he can with the brush.

He also uses a reed pen, having collected some excellent reeds from a lake in southern France and sharpened them with a razor blade.

Bill uses a very limited palette of colours: quinacridone rose, cadmium red, cadmium yellow, cadmium lemon, ultramarine and cerulean blue. He encourages his students to stick to those six, but, as he says, 'I allow myself the luxury of Prussian blue, because it is so radically different to the ultramarine and the cerulean. I also use raw sienna, although I could mix it from one of the reds and one of the yellows, but I use a lot so I can justify buying it.'

△ *This painting was started as a demonstration and finished later. It is primarily watercolour with a small quantity of gouache in the foreground.*

◁ *This detail of the farm building was also made on site. He worked in pencil and then dropped some watercolour washes on to the paper. This was one of a series of four sketches made on location.*

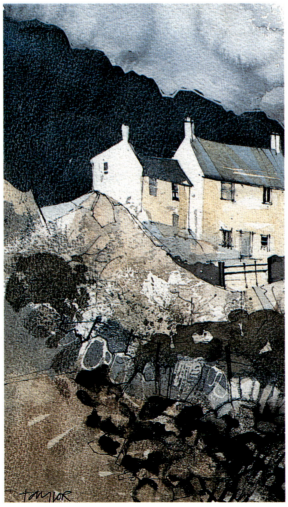

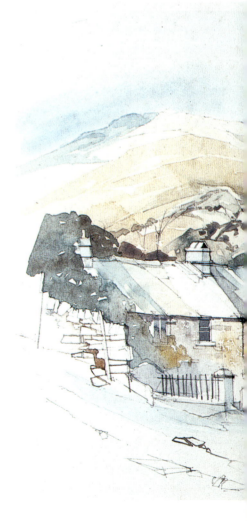

◁ *Tyne Head, in the Pennines, is the subject of this wintry study. Bill used watercolour, and gouache mixed with acrylic medium as a glaze in the foreground. He has managed to capture the crispness of the frosted grass in the foreground. The picture is about 20 × 35 inches (50 × 87.5 cm) and is on illustration board.*

◁ ▽ *This small study, 10 × 4 inches (25 × 10 cm), of Boardale in the Lake District, was made on Bockingford paper. Bill masked out the white of the buildings so that they showed against the dark hill in the background. He also masked some of the line work in the foreground, adding some ink in this area.*

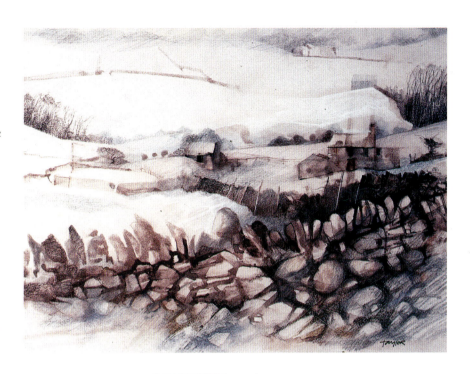

△ *For this painting of Alston Moor under snow the artist used illustration board. He laid in the broad forms of the painting in sepia, using brush and pen, and then worked into that with a water-soluble pencil. In the foreground he scratched the surface, using a coarse sandpaper to create textural interest.*

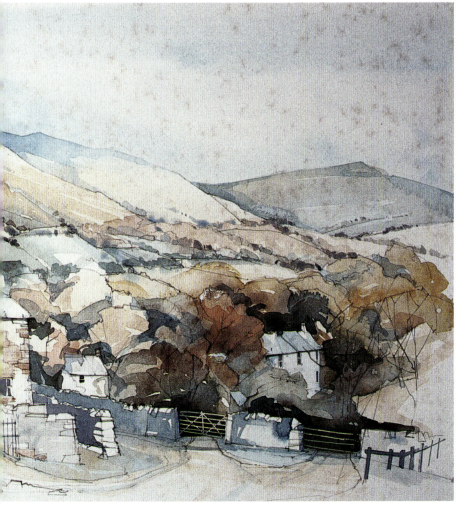

◁ *Sandwick is a tiny hamlet in the Lake District. The artist painted this in autumn, again while working with one of his student groups. He used delicate washes of watercolour to create a light, airy, autumnal feel with very little tonal contrast. Compare this with the Tyne Head study, which is much bolder and more contrasty. Here he used Fabriano hot-pressed paper, which allows him to achieve delicate blends of washes.*

STRUCTURE, COMPOSITION AND DESIGN

Ian Sidaway works in watercolour and oil. In his large oils he generally deals with figurative and still-life subjects. In his watercolours he covers a wide range of subjects, but landscapes form a considerable part of his work.

He enjoys watercolour for its subtlety, for the range of effects it allows him to achieve and for the speed it gives him. As he says, 'You can get a picture finished in a day.' His favourite additive is gum arabic, which intensifies the colours and enables him to lift off the colour by rewetting the paint and blotting it off. 'It's terrific for highlights and texture and fine lines.'

His watercolours are created as an end in themselves, often as a record of places he has visited, but they may also be used as a preparation for large oils. He thinks of them as 'moments caught in time, snapshots, glimpses of an event or a scene'.

'All my preparatory work for paintings is done in watercolour. It's good for working up variations of things, for working out colour and how things are going to look before I get down to painting a large canvas. I can do two or three alternatives.'

He works from photographs taken with a view to building them up in watercolour later. If he finds a subject that interests him, he takes several photographs, framing them in different ways. 'Sometimes I go through the photographs and see absolutely nothing that hits me. Then I go back to them, and go through them again, and find that there are things shouting out to be painted,' he says. He may create an image from an amalgam of several pictures.

Ian is interested in series paintings – images created over a period of time. 'You keep seeing different things.'

He uses a limited range of colours: Payne's grey, cobalt, cerulean blue, ivory black, cadmium yellow and yellow ochre, brown madder alizarin ('which I

▷ *In this lovely formal painting of an olive grove Ian Sidaway has created an image which captures the contrast between the cool under the trees and the heat of the sun above. His crisp paintwork emphasizes the decorative quality of the repeated forms of the foliage, but he has found a way of rendering the foliage without drawing it leaf by leaf.*

◁ *Here bold, dark trunks of the trees in the foreground and the foliage cut the edge of the painting at the top. Athough this is a landscape composition, it has an architectural feel, and the artist has emphasized the strong verticals and horizontals.*

247

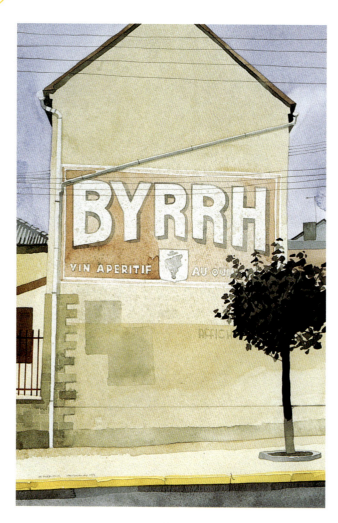

△ *In this study the gable end of a building is seen flat on, so that there is no linear perspective. The way that the apex of the roof is clipped by the edge of the picture area divides the sky into two geometric blue shapes. The lettering of the advertisement on the end of the building is an important component of the painting.*

use for red'), cadmium red, chrome orange and sepia. He also uses sap green and viridian. 'I'm not averse to using anything – if I want a purple I'll use it. I'm not strict about sticking to this palette.'

He is interested in design and composition, and all his images are very solidly and often surprisingly constructed. He has an absolutely instinctive feeling for design. In some of his paintings he makes brilliant use of space, treating it as an integral part of the image rather than just 'emptiness'. He is also interested in the graphic qualities of architectural drawings and prints, and this shows through in his own work. When he does undertake an architectural subject, he often chooses an end-on view which has no perspective, and crops in to it so that it fills the picture area, emphasizing the abstract, pattern-making qualities of the subject.

Another recurrent theme in his painting is the quality of strong light and the way it emphasizes, exaggerates and sometimes dissolves forms.

◁ *This painting illustrates the artist's love of architecture, formal composition and the qualities of light. Here the brilliant light provides wonderful, harsh contrasts, and the shadows of the pot plants become strong, dark shapes, as important as the pots themselves.*

▷ *The artist studies the play of light across a stone and broken plaster facade. The building and the car are seen straight on, minimizing the spatial elements in the picture and emphasizing the abstract geometry. The painting is primarily neutral so that the flowers in the window-boxes look brilliant by contrast.*

249

TOWARDS ABSTRACTION

Adrian Smith came to landscape via a circuitous route. He trained as a theatre designer and now works freelance in the film industry. He realized that he needed to get ideas down on paper very quickly, and to represent what he was constructing accurately so that he could communicate his ideas, and found that watercolour was ideal for this. Portable, quick and very expressive, it is also a marvellous medium for capturing light and shade – a major component of the design of any film.

From this very practical application, he became interested in the possibilities of the medium. He went right back to basics, teaching himself all the different watercolour techniques, and now he is so comfortable with the medium that he can concentrate on the process of picture-making.

He became increasingly interested in landscape and seascape. Most of his early work was fairly literal, but, over the last seven or eight years, he has become more concerned with exploring the landscape rather than merely describing it. 'I have been really pushing the landscape, exploring aspects of it, looking at things like colour, form and tone.'

This interest culminated with Adrian's move out of town and into the countryside. 'Now it is a question of looking out of the window and there it is. I am beginning to see the landscape in a very different way now, exploring the hidden elements and the geometry.' He likes this complex, layered approach, which brings in elements of art history, sacred geometry, the concept of wilderness and man's influence upon the landscape.

His concerns are constantly changing, as he

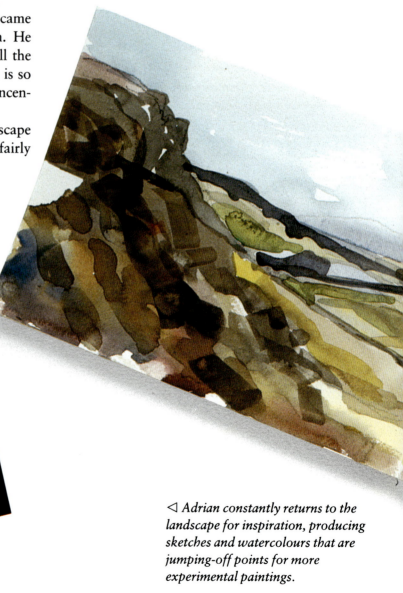

◁ *Adrian constantly returns to the landscape for inspiration, producing sketches and watercolours that are jumping-off points for more experimental paintings.*

explores first one theme and then another, taking an idea as far as he can push it. Though his paintings are always rooted in the landscape, they often develop into abstract and semi-abstract interpretations, expressed as pure colour and form. But this is a cyclical activity, for he always returns to the landscape, working directly from it in a conventional, representational way. His heroes are artists like Samuel Palmer (1805–81), who imbued the landscape with his own mystic vision, and Turner (1775–1851), who also distilled his own unique and magical vision of the landscape.

Adrian's basic palette includes cobalt and cerulean blue, indigo, Payne's grey, aureolin (a light yellow), which he uses to warm skies and create clean greens, cadmium yellow, lemon yellow, yellow ochre, raw umber, burnt sienna or Indian red, burnt umber, olive green or sap, alizarin crimson, vermilion and cadmium red. He also uses viridian which can't be mixed from any other colours on your palette but is useful mixed with other colours. 'You have to watch it, though. It creeps and tends to alter the whole balance of the thing.'

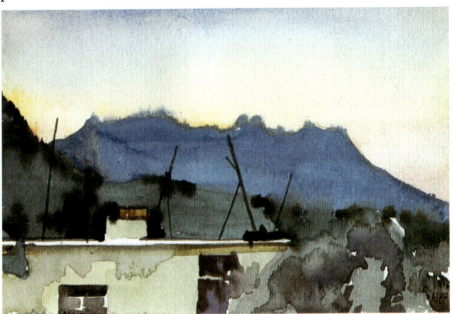

▷ *This view of Mount Hilarion in Cyprus is one of a series made on holiday. The artist had to work quickly to capture the fleeting light effects as the sun went down. He made several paintings at once, so that he could work on one as the other was drying.*

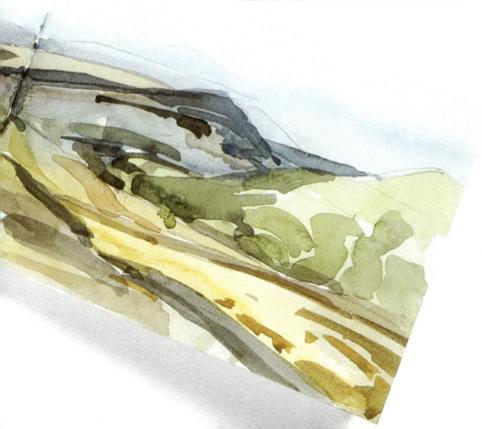

◁ *This colour sketch of the Derbyshire countryside near the artist's home was made directly from nature on a hot, sunny afternoon. He used a wet-in-wet technique, but the hot sun dried the wet washes, allowing him to work quickly.*

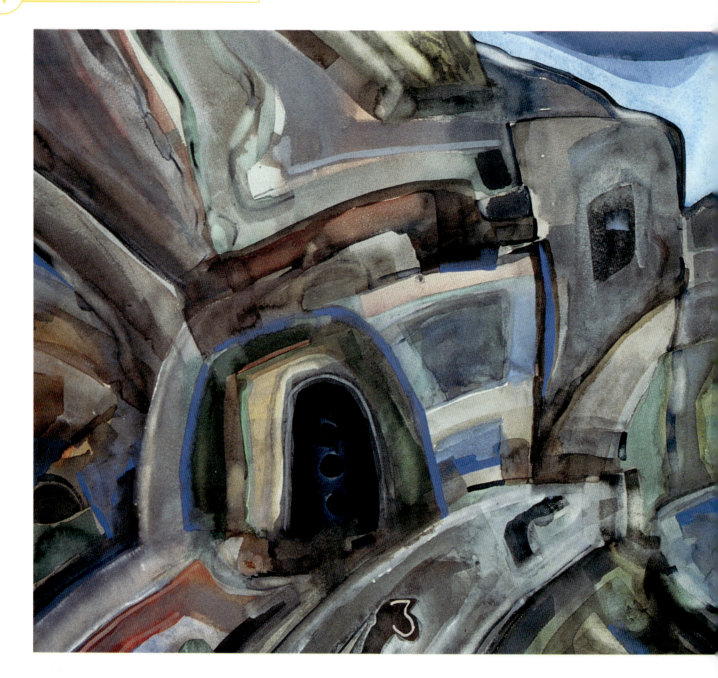

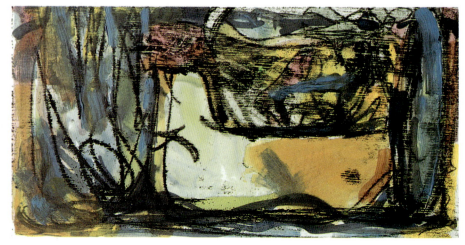

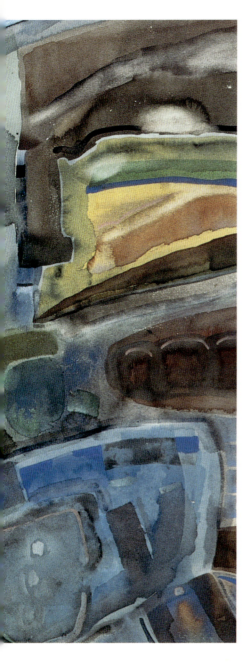

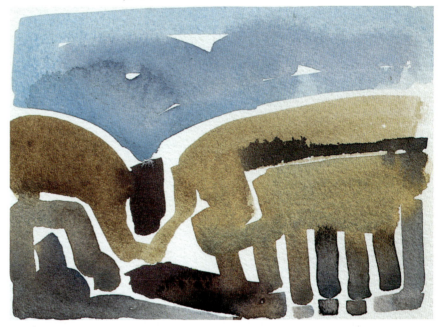

◁ This image is based on a view of the garden at the artist's home. The initial drawing was done with printer's ink and oil paint on a rough wooden block; he made a monoprint, the rough wood giving the image a textured quality. Thin washes of watercolour were then applied over the oil and ink, which formed a resist.

△ This is a working sketch for a larger watercolour painting. The artist used it to work out the composition and colour.

▽ In 'Nocturnal Landscape', a working sketch for a larger painting, the artist investigated the contrast between natural and man-made forms.

◁ This painting, 'Odin Mine 3', is the third in a series of studies based on ancient Roman lead mines which were worked by slave labour. Adrian was interested in both the physical landscape and the historical background. The colours and compositions were designed to reflect the oppressive atmosphere of the subject. This painting is moving towards abstraction – later paintings in the series become totally abstract.

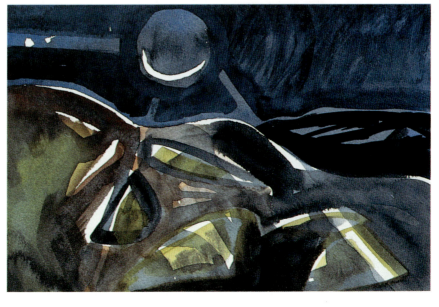

253

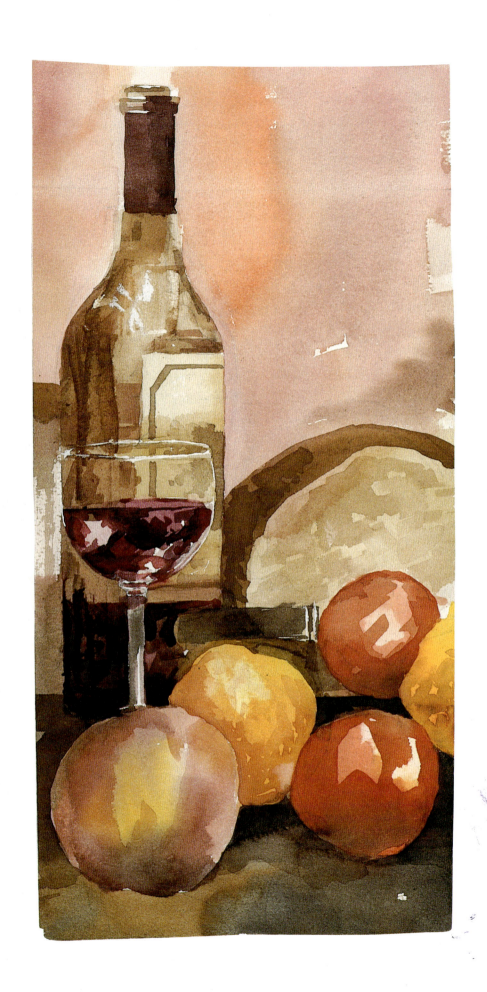

INDEX